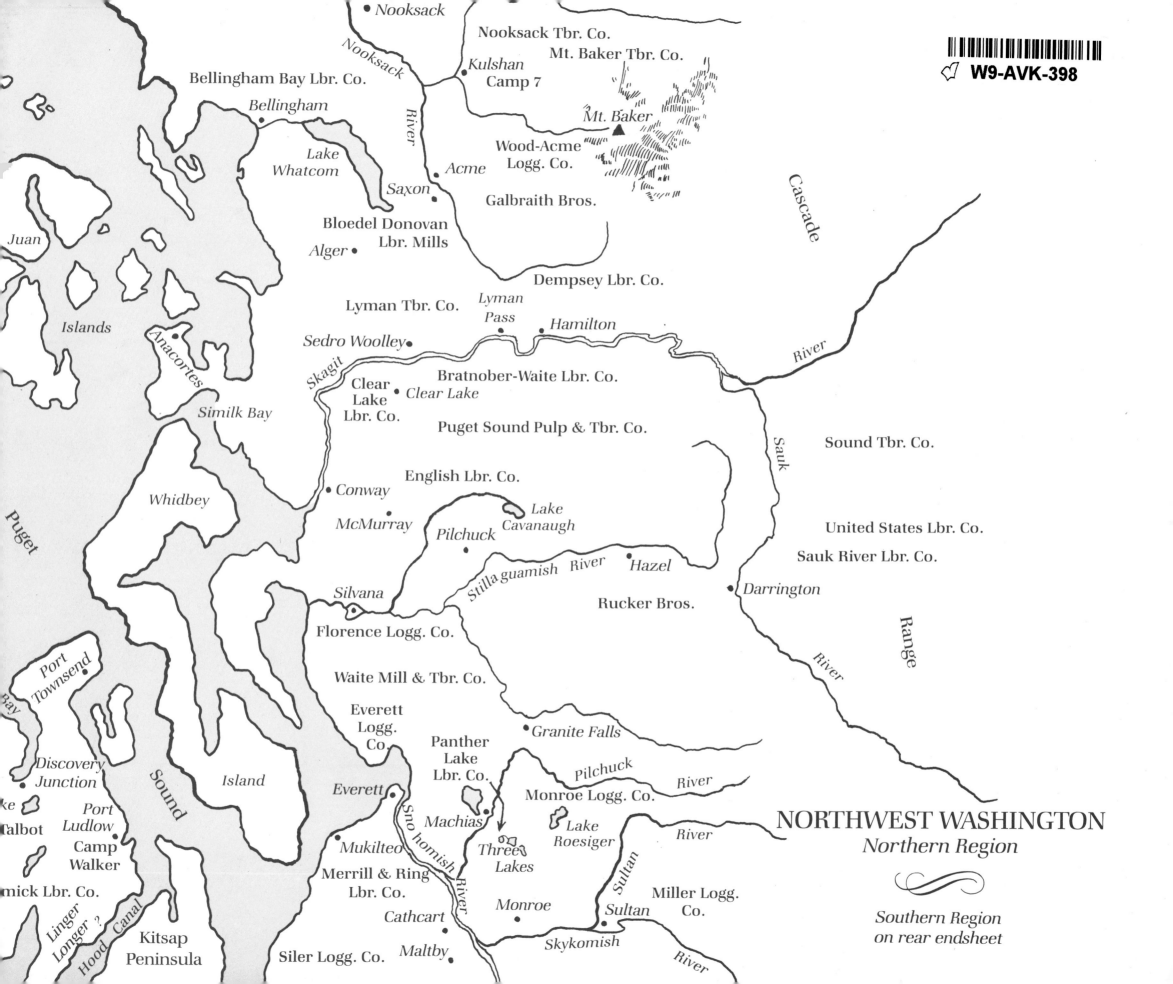

Nooksack

Nooksack Tbr. Co.
Mt. Baker Tbr. Co.

Kulshan
Camp 7

Bellingham Bay Lbr. Co.

Bellingham

Mt. Baker ▲

Lake
Whatcom

Wood-Acme
Logg. Co.

Acme

Saxon

Galbraith Bros.

Bloedel Donovan
Lbr. Mills

Alger

Dempsey Lbr. Co.

Juan

Islands

Anacortes

Lyman Tbr. Co.

Lyman
Pass

Hamilton

Sedro Woolley

Cascade

Skagit

Clear
Lake
Lbr. Co.

Clear Lake

Bratnober-Waite Lbr. Co.

Similk Bay

Puget Sound Pulp & Tbr. Co.

Sauk

Sound Tbr. Co.

Whidbey

English Lbr. Co.

Conway

Lake
Cavanaugh

United States Lbr. Co.

McMurray

Pilchuck

Sauk River Lbr. Co.

Puget

River

Stilla guamish

River

Hazel

Darrington

Silvana

Rucker Bros.

Range

Florence Logg. Co.

Port
Townsend

River

Waite Mill & Tbr. Co.

Everett
Logg.
Co.

Granite Falls

Discovery
Junction

Island

Panther
Lake
Lbr. Co.

Pilchuck

River

Sound

Everett

Monroe Logg. Co.

River

Port
Ludlow

Machias

Lake
Roesiger

NORTHWEST WASHINGTON
Northern Region

Talbot

Camp
Walker

Sno homish

Three
Lakes

Mukilteo

River

mick Lbr. Co.

Linger
Longer ?

Hood Canal

Merrill & Ring
Lbr. Co.

Cathcart

Monroe

Sultan

Sultan

Miller Logg.
Co.

*Southern Region
on rear endsheet*

Kitsap
Peninsula

Siler Logg. Co.

Maltby

Skykomish

River

Kinsey PHOTOGRAPHER

The Locomotive Portraits

"Do you remember Darius Kinsey taking this picture?"

"Yes."

"Where was he when he took it?"

"He was out there on a stump."

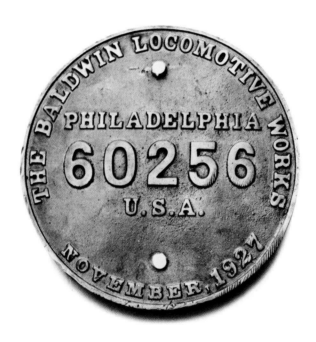

Builder's plate from
the Bloedel Donovan number 14
Courtesy Pete Replinger

Each steamer is a little different. The feel of the throttle. They're different, every one of them. A diesel, they're all the same, but every steamer is different. When I was manager at Tacoma's Camp Six Logging Museum, in Point Defiance Park, I had some of the oldtimers—the ones that used to run the logging trains—up there running locomotives. We used to oil the rails. The curves were so sharp up there that we'd oil the rails for wear, which made it slippery. Well, this one locomotive had a real touchy throttle. You'd pull the throttle back and you could slip the wheels real easy. Just pull the throttle back and you'd start slipping. Most of the engineers that had started running that locomotive would get it slipping until they caught on to it.

So one day I had Buster Corrigan come up. He'd never run that engine in his life, right? He'd never run that engine in his life but I should have guessed...he never slipped a wheel on the thing. He'd never run that engine in his life and he never slipped a wheel. He's been doing it for so long. He's good at it, see.

Pete Replinger
Shelton

Those old bad-looking engines were the ones that could really haul and do the work. I was shining up an eighty-five-ton Shay one time, a three-trucker up at Clear Lake. The foreman comes out and says, "What are you doing?" I guess he thought I was turning in overtime. I had painted the smokebox and this and that. It was after supper and I was doing it on my own time. "Oh," I says, "I thought I'd make her look nice." And he says, "I never saw a goddamned engine that was worth a damn that wouldn't pack its own dirt."

<div align="right">

Rex Everett
Burlington

</div>

It had a beautiful whistle, that number 14. But I used to have a terrible time when they were all tying up at Sappho and it was time for Rex to come home. I was new to logging, and I'd hear a train whistle way out someplace. So I'd put some potatoes on the big Monarch range because it was time to get supper. But the whistle would be from another train, or else they'd go clear through, so I'd pull the potatoes back. I was cooking supper from the first whistle that blew. I'd start supper for every train whistle that I heard. But then I got used to it.

Louella Everett
Burlington

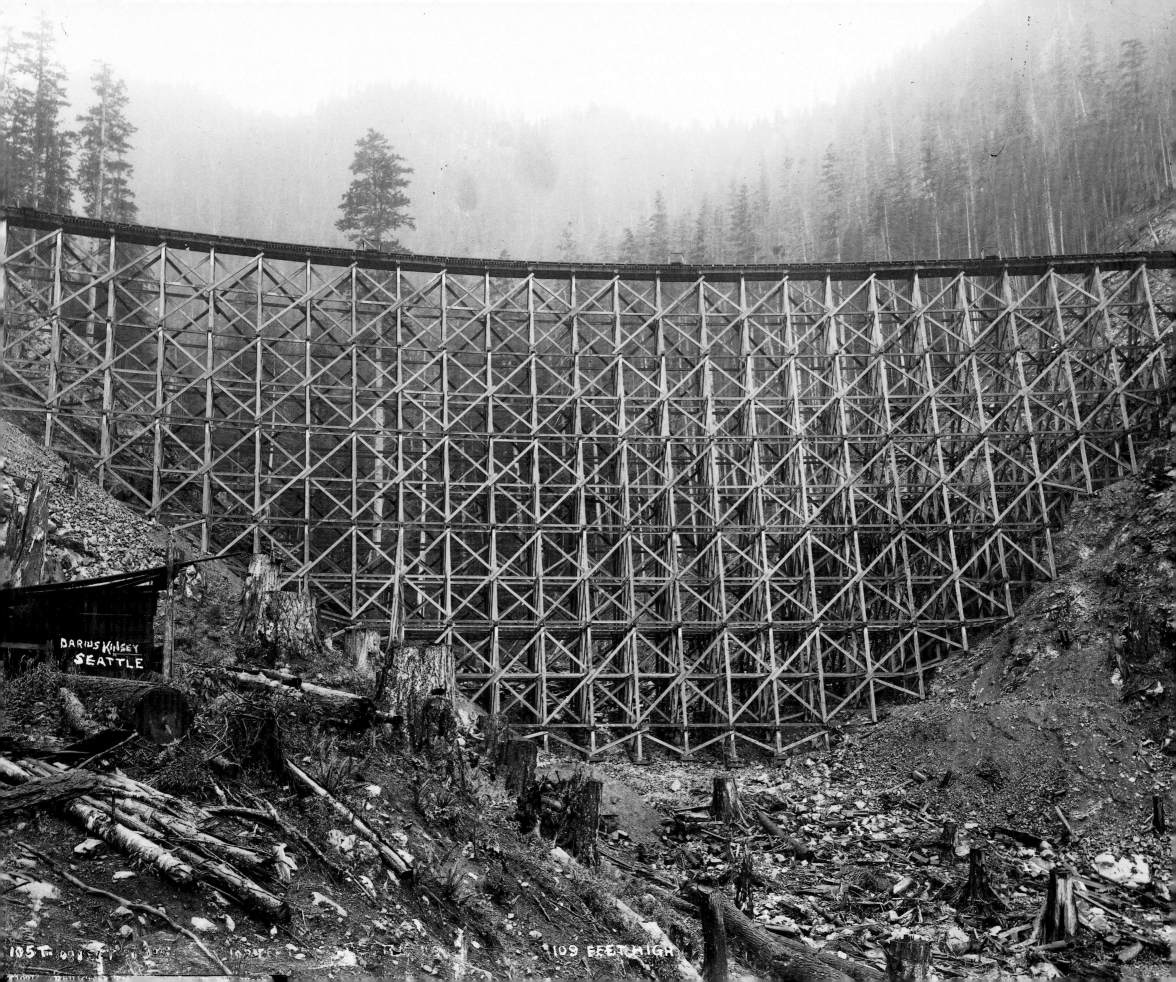

DARIUS KINSEY
SEATTLE

109 FEET HIGH

Kinsey PHOTOGRAPHER

A half century of negatives by Darius and Tabitha May Kinsey / Volume Three

The Locomotive Portraits

by Dave Bohn and Rodolfo Petschek

Locomotive essays by John T. Labbe
Coordination and oral history by Mary Millman
Technical assistance by the Whatcom Museum
of History and Art, Bellingham

BLACK DOG
& LEVENTHAL
PUBLISHERS
NEW YORK

An earlier edition of this book was published in 1984 by Chronicle Books under the title *Kinsey Photographer: The Locomotive Portraits.*

The Kinsey, Photographer logo was prominently displayed on the large handpainted sign that stood in front of the Kinseys' portrait studio (pp 56-57, Volume One) in Sedro Woolley at the turn of the century / The number 8 spot plate courtesy Pete Replinger / Frontispiece is Hull Creek Trestle, ca. 1910. Location has not been determined. Design by Dave Bohn.

Published by

Black Dog & Leventhal Publishers, Inc.
151 West 19th Street
New York, NY 10011

Distributed by

Workman Publishing Company
708 Broadway
New York, NY 10003

Printed and bound in China

ISBN: 1-884822-65-7

h g f e d c b a

Library of Congress Cataloging in Publication Data

Bohn, Dave.
Kinsey, photographer : a half century of negatives by Darius and Tabitha May Kinsey, with contributions by son and daughter, Darius, Jr., and Dorothea / produced by Dave Bohn and Rodolfo Petschek.
p. cm.
Originally published: San Francisco : Prism Editions, 1978 Includes bibliographical references.
Contents: v. 1. The family album & other early work. ISBN 1-884822-22-3 (v. 1)

1. Kinsey, Darius, 1869-1945. 2. Kinsey, Tabitha May, 1875-1963.
3. Photographers—United States—Biography. 4. Lumbering—Washington (State)—Pictorial works. I. Petschek, Rodolfo.

II. Title.

TR140.K45B64 1995 770 '.92'2—dc20 95-376 CIP

Contents

Scattered here and there among the pages are reminiscences of some of the men and women whose lives were bound up with the steam locomotives of logging operations in northwest Washington. These affectionate stories were shared during long discussions and are passed on to the reader in conversational form. Occasionally, crew members were recognized in the photographs, and these identifications—albeit spelled phonetically at times—appear on the appropriate pages, listed left to right. The essay on the Kinsey Collection by George Thomas of the Whatcom Museum appears near the end of the book, along with John Labbe's Postscript and the authors' acknowledgments.

The locomotive portraits are loosely sequenced by location of the outfit the locomotive served. Commencing with Olympic Peninsula operations that dumped in the Strait of Juan de Fuca, the lineup proceeds south along the Hood Canal shoreline. With Bloedel Donovan, which operated east and west of Puget Sound, the lineup moves to the east shores of the Sound—through King, Snohomish, Skagit and Whatcom counties. Only six of the images bear Kinsey's date, but the time frame for the others may be established from the essay accompanying each locomotive. In general, the Olympic Peninsula images were made in the 1920s, while the east of Puget Sound images were made in the 1930s.

In the captions set above each paragraph, geared engines are listed by "model weight"—as catalogued by the builder—except for Pacific Coast Shays, which did not have a model weight but all of which weighed in at about 90 tons. For rod engines, wheel arrangement (Mikados 2-8-2, most Mallets 2-6-6-2, etc.) is the model indicator, and actual operating weights—loaded with fuel and water—are given.

Thirty geared locomotives and eleven rod engines—which had the good fortune to be photographed by Darius Kinsey—appear in this book. Indeed, in several instances the Kinsey image is the only remaining visual evidence.

Was it the character of the locomotive or the spirit of the crews that caught Kinsey's eye? Or did he understand that we do not have one without the other?

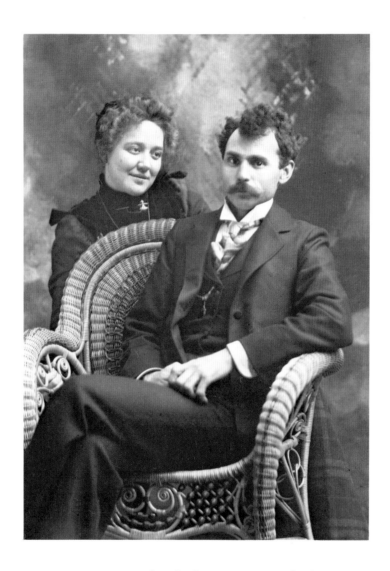

Darius and Tabitha Kinsey at their
Sedro Woolley studio, circa 1906

To Darius and Tabitha:

The legacy of your partnership is an archive of inestimable historical and artistic value. We are moved by the unpretentious manner in which you accomplished this work—in the course of earning a living.

DB and RP
May 1984

"It's a wonder Darius Kinsey lasted,

the way he climbed around in the woods."

Darius Reynolds Kinsey, 1869–1945
Tabitha May Kinsey, 1875–1963

When Darius Kinsey, then twenty-seven years old, married Tabitha Pritts, age twenty-one, a most remarkable partnership in photography was about to begin. The year was 1896.

Darius, second oldest of six children, born in Maryville, Missouri, had arrived at Snoqualmie with the family in 1889. Within a few months at most he was loaned a camera—a fateful introduction because Darius was thereafter, to the end of his life, obsessed with the medium of photography. (Brothers Clarence and Clark would also become photographers; Clark's work in the Yukon Territory, Washington, and Oregon is of great historical value.)

During the early years of his career, Darius traveled by horse and buggy and then by train, wandering the countryside making portraits of the homesteaders. In other words, an itinerant photographer who was also making some of his first visits to the logging camps. During one of these forays he met Tabitha at Nooksack. She disliked farm life and yearned for an urban future, but little did she know that most of the future would be spent in the darkroom in support of her husband's ceaseless picture-making. Throughout the first decade of the partnership Darius and Tabitha operated a photographic studio in Sedro Woolley. Darius became a superb craftsman and taught Tabitha the necessary darkroom skills. From this studio emerged some very beautiful portraiture, the best of which is reproduced in the first volume of *Kinsey, Photographer,* along with early logging scenes, homesteaders on site, the magnificent landscapes of the Cascades, even a locomotive or two.

When not home at the studio, Darius was in the field, always on the lookout for those who might want their picture taken, and certainly the logging camps were full of possibilities—the fallers and buckers, donkey crews, cookhouse crews, locomotive crews, speeder groups. Thus Darius was establishing the genre which would serve to earn him a living—the group portrait of working men and women, resulting in multiple orders for the print. And while he was at it he would also photograph pure landscape—especially the trees, moving water, and high mountains.

Then in December of 1906, Darius and Tabitha moved to Seattle, with Dorothea, by then six years old, and Darius, Jr. on the way. There would be no more studio portraiture since the business was to be geared toward "view publishing" under the name Timber Views Company. With Tabitha now running the darkroom and finishing operations, Darius was able to travel with his camera almost continuously, to take pictures "…every day in the year, rain or shine, except Sundays." During these Seattle years—1907 to 1940—he primarily used his 11x14″ Empire

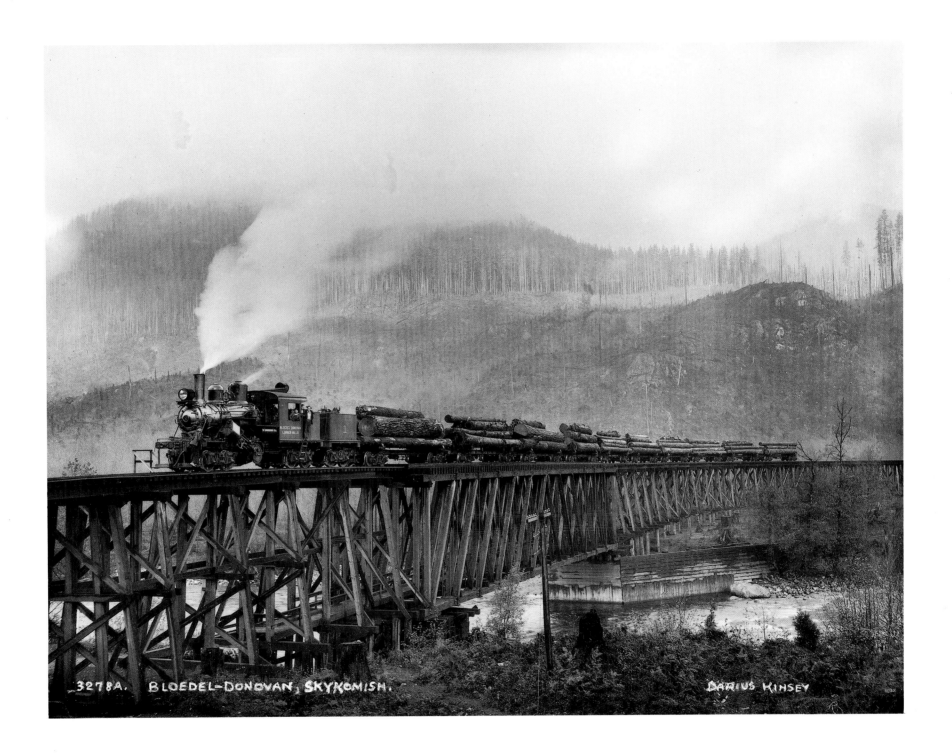

3278A. BLOEDEL-DONOVAN, SKYKOMISH. DARIUS KINSEY

State camera, complete with an ample supply of glass plates (film after 1914) and custom-built tripod, expandable to twelve feet in height. He carried close to one hundred pounds of equipment everywhere he went. Not only into the woods but to the lumber mills and machine shops, dairy farms and hydroelectric projects, fish hatcheries and schools—anywhere he might find something of interest to focus on his groundglass, but preferably an operation where a group of workers would be willing to take the time to pose. Invariably the individuals in these photographs seem spontaneously at ease, although there is little doubt that Darius made deliberate final adjustments in the arrangement. A favorite approach was to combine the image of a majestic object with a pertinent group—a large, partially undercut tree about to be dropped, flanked by the crew of fallers; a huge, unfinished trestle with construction workers scattered across the structure; a locomotive under steam with its basic crew of engineer, fireman, head brakeman and second brakeman. (The finest logging, group portrait and landscape photographs from the Seattle years are reproduced in the second volume of *Kinsey, Photographer,* along with a few more locomotives and the biographical essay on the Kinseys and their work.)

Meanwhile, the exposed glass plates were shipped to Seattle where Tabitha would develop by inspection, print the negatives, and pack the prints in large brown envelopes which carried Darius' eloquent promotional message. Two heavy bundles of envelopes were then carried three long blocks to the cable car, then five more blocks from cable car to Railway Express—and the prints were off to wherever Darius was expecting them. Shortly thereafter the next batch of plates would arrive and the cycle was repeated—year in and year out until October of 1940 when Darius fell off a stump, injured himself, and did not photograph again. One can imagine Tabitha's disbelief when she realized there would be no more film to develop, no more negatives to print, no more bundles to carry. "She just hated it," recalls Darius, Jr., "but she had no alternative, because my Dad had to make a living and she had to do her bit or the thing would have fallen flat." Daughter Dorothea recalls that, "In later years I began to understand that father never could have accomplished what he did without mother's loyal support and hard work. But I do not think father ever had any intimations of his greatness as a photographer."

Darius spent his last five years sorting and re-sorting his large inventory of images, unable to shake the obsession with photography even though the magnificent fifty-year odyssey was finished. Tabitha survived him by eighteen years and departed without realizing the significance of Darius' work or the enormity of her contribution to the enterprise.

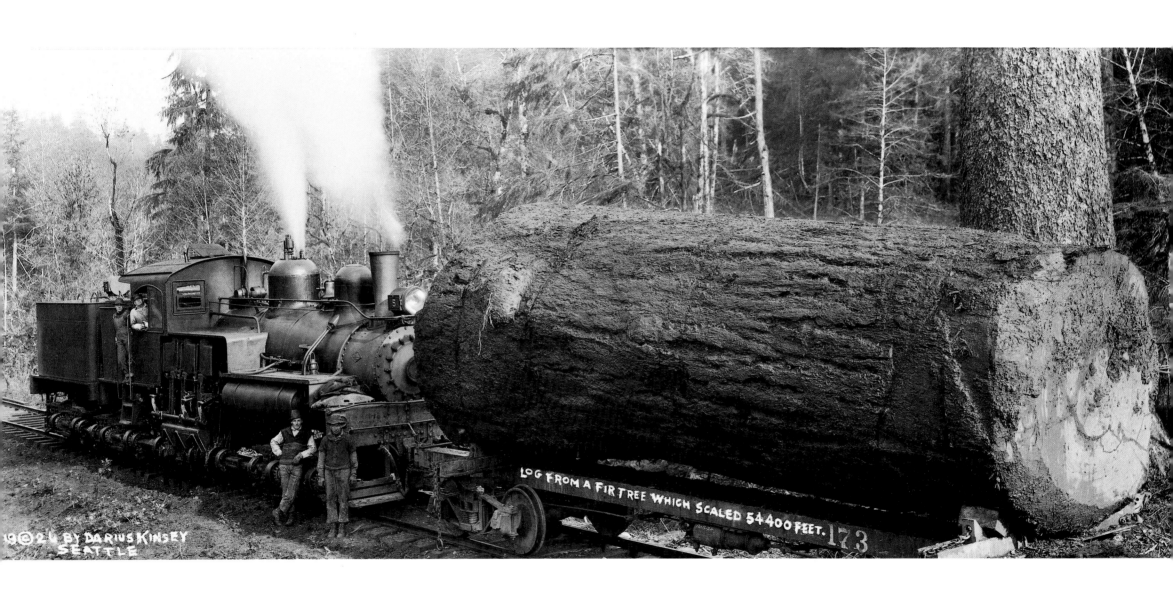

Within the image: LOG FROM A FIR TREE WHICH SCALED 54400 FEET. 173

19©24 BY DARIUS KINSEY SEATTLE

*Dwarfed by her load, Merrill & Ring's
road number 5—a 70-ton Shay—demonstrates
the value of the geared locomotive to the logger.*

Introduction

In the second half of the 19th century loggers across the country grappled with the problem of motive power. Using oxen or horse teams they had logged out the timber close to the streams and had opened the distances between standing timber and water to an extent that animals could not negotiate. With some reluctance, loggers cast about for mechanical alternatives. By 1875, they had settled on the steam locomotive. In the beginning — if they were well financed — they could purchase a conventional engine from the limited selection then available — mainline locomotives or the smaller industrial engines. Each of these relied on mainrods to transmit power from the pistons to one set of drive wheels, which passed the power on to other drivers by means of side rods. Later dubbed *rod engines,* these locomotives had not been designed for the increased gradient and curvature of track laid through forest terrain, nor for the raw power that the massive timber of the Pacific Northwest would demand. And since many early loggers couldn't afford to buy an engine at all, they built something for themselves. Often, home built locomotives used chains to transmit power from the engine to the axles. From here it was but a short step to the development of the gear drives that revolutionized the industry.

Back in 1877, Ephraim Shay, a logger from Haring, Michigan, built himself a locomotive following a new and radical design. It utilized a vertical engine which drove a shaft geared to each axle. The engines and shaft were mounted on the right side of the locomotive, and drove gears attached to the outside of the wheel on each of the axles in the truck. The shaft was provided with universal and slip joints to allow the trucks to turn independently. To offset the added weight on the right side of the locomotive, the boiler was shifted to the left of center, giving the engine

It was said of the Climax that it would follow
two lines scratched in the dirt with a stick.

a distinctive appearance. By its design, the entire weight of the locomotive was applied to the driving wheels, while the gearing provided greater power from less steam. The fact that speed was sacrificed had little consequence on the logging railroad of the earlier era.

In 1882 the Lima Machine Company of Lima, Ohio, decided to produce a line of light industrial locomotives, after having been called on to build one of Shay's geared engines. Impressed with the potential of the design, Lima made a deal with Mr. Shay to manufacture the new machine along with the light industrial engines. It was not very long before the Shay monopolized Lima's production. The success of the Shay inspired other designers to develop their own geared engines. Of these, only two proved successful enough to compete with the Shay. The first of these was the Climax, which made its appearance in 1888. This engine was driven by a central drive shaft geared to all axles and, while the design varied somewhat, the most common model utilized a pair of cylinders mounted at an angle on either side of the boiler. The cylinders drove a center shaft through a cross shaft beneath the boiler.

The second major competitor was the Heisler, which made its debut in 1894. Like the Climax it used a center drive shaft—but unlike the Climax it was geared to only one axle in each truck. Power was transmitted to the second axle by side rods. The engines were mounted in a "V" just ahead of the cab and drove the center shaft through a crankshaft mounted in line with the center shaft.

All three designs proved eminently successful, although each had its advantages and disadvantages. The Shay, with its deep boiler and outside gearing, was an easy machine to operate and to service and so it was generally preferred. Its one disadvantage lay in the fact that the outside drive line limited the flexibility of the truck. It also provided a few problems in heavy snow. The Climax, on the other hand, with both journals and bolsters fully sprung, would operate on almost any kind of

track. It was said of the Climax that it would follow two lines scratched in the dirt with a stick. But the motion of the spinning cross shaft made for a very rough ride. Also, the center shaft forced the firebox, and consequently the crownsheet, higher in the boiler thereby making it more difficult to fire. The center shaft was also more of a problem to service. Of the three, the Heisler was the fastest, and as the timber receded and the mainlines became longer, this engine gained favor. Its power derived from its two large cylinders, the only gearing being that in the trucks. However, the center drive caused the same problems with the boiler design as encountered in the Climax. The single set of gears in each truck allowed for a partial gearbox for lubrication and protection, which gave an advantage in deep snow but made servicing somewhat more difficult.

Geared engines were the mainstay of the industry—climbing the grades, maneuvering the curves and hauling down the timber on the spurs. In the early days, when the logging railroads terminated at a log dump near tidewater, there was no need for any other engine but a geared locomotive. However, timber continued to recede up the slopes and the distance to the boom grounds grew longer. The slower geared engines were inefficient on these long hauls; rod engines were better adapted to carry out the function. Nevertheless, the geared locomotive continued to work the feeder lines and collect the logs. In the later era they carried the loads to sidings on the mainline where the cars were assembled into trains.

For their size, rod engines were less powerful than the geared engines but they were considerably faster. As speed became an advantage on the longer mainline hauls, the loggers preferred the rod engine and many of the larger builders, such as the Baldwin Locomotive Works, began designing locomotives to fill the need.

Most popular were the designs having small pony wheels ahead and behind the drivers which allowed safe operation in either direction. The Prairie type,

with a 2-6-2 wheel arrangement, proved popular where a smaller engine was adequate, and for the heavier hauls the 2-8-2 Mikado was the logger's choice. Both designs came in either tank or tender styles. In the tank design, the water tanks were carried on or over the sides of the boiler, thus giving added traction and eliminating tender maintenance. Tank engines would operate on grades of seven or eight percent, bringing empties up and taking the loaded cars down. On the other hand, tender engines were favored for the longer mainline hauls since they carried more water and fuel. As a rule, they were limited to grades of six percent, although even a slope of one or two percent against a loaded train drastically reduced the efficiency of the rod engine, and the mainlines were designed to avoid adverse grades.

By the late 1920s the geared locomotive had reached the epitome of its mechanical development in the Willamette geared engine, Heisler's West Coast Special, and Lima's Pacific Coast Shay. The rod engine, as it had been adapted to the needs of loggers, had also attained its most massive and elaborate form in the articulated locomotive, which used steam from one boiler to power two sets of engines, the forward engine free to swing back and forth beneath the boiler for flexibility on curves. For all the efficiency and ingenuity, however, the end of the great stands of timber and thus the end of logging by steam locomotive was rather quickly at hand. The geared locomotives, scrapped on a wholesale basis in the early 1940s, were replaced by "gyppo" loggers whose trucks found ready access to standing timber on the old railroad grades. Mainline railroad logging operations lasted well beyond this point, but even here the steam locomotive was supplanted in the early 1950s by the diesels which you may occasionally see today. Mechanically supplanted, at least, but not philosophically: one old time steam locomotive engineer called the diesel..."a damned old yellow spot in the woods." Who may begrudge him his opinion?

John T. Labbe
Beaverton, Oregon

The Baldwin Mikado 2-8-2, #59284,
at Heber City, Utah, April 1984

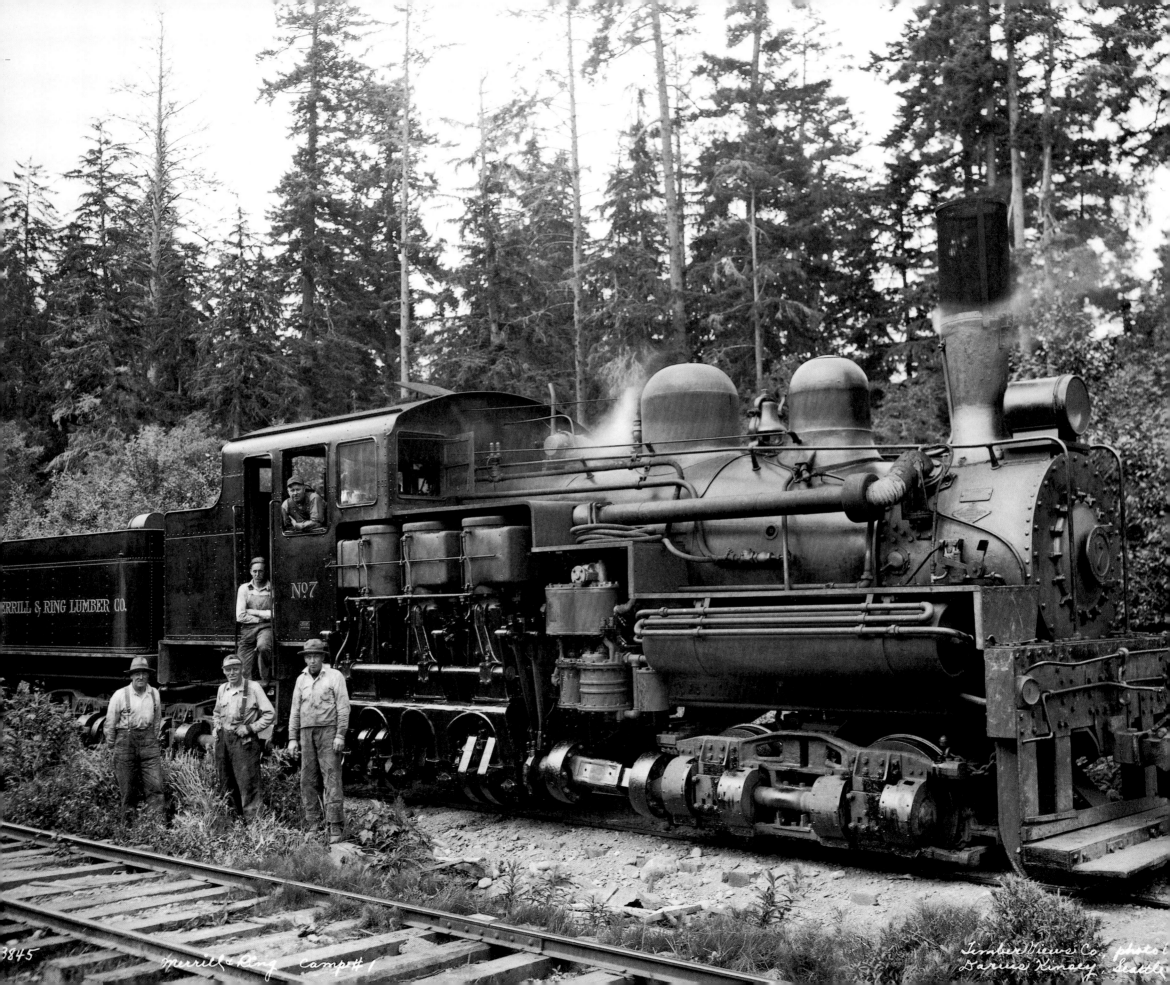

MERRILL & RING LUMBER CO.

N°7

MERRILL & RING LUMBER CO.

3845 Merrill & Ring Camp #1 Timber Views Co. photo
Darius Kinsey Seattle

Shay
Lima Locomotive Works, Inc.
#3261 September 1925
Ninety-ton

Merrill & Ring got their start in the woods around Duluth, Minnesota, in the 1890s. With the profits from their operations they began making large timber purchases in the West, from California to British Columbia. By 1908 they had opened camps in Canada and on the shores of Puget Sound near Mukilteo, south of Everett. In 1915 they moved to the Olympic Peninsula and at Pysht, west of Port Angeles, built what is considered the first permanent logging camp in northwest Washington.

After more than ten years of active logging, much of the timber adjacent to the Pysht camp had been removed. What remained could be better served by the railroad of the Crescent Logging Company, so a merger was effected in 1927 with each company retaining its own name, and another large purchase along the Pysht River brought extended life to the camp. Although the camp stood idle during the early Depression years of 1931 and 1932, work resumed in August of 1933 and continued for another ten years.

Shay number 7 was built by Lima in September of 1925 as construction #3261. For two years she served as a demonstrator for the builder before being sold to Merrill & Ring in July of 1927, at the time of the merger. A 90-ton superheated engine, she was the immediate predecessor to Lima's Pacific Coast Shay, which proved to be the last and the ultimate steam locomotive of Lima's Shay design.

With the end of the Merrill & Ring operations on the Olympic Peninsula, the number 7 was put up for sale in the spring of 1944 when steam locomotives were going out of favor. But steam still ruled the forests of British Columbia. In August of 1946 she found a new home with the Alberni Pacific Lumber Company, Ltd., at Port Alberni on Vancouver Island. In her final years she was taken over by MacMillan & Bloedel, Ltd., along with the Alberni Pacific properties, and given the new road number 1037.

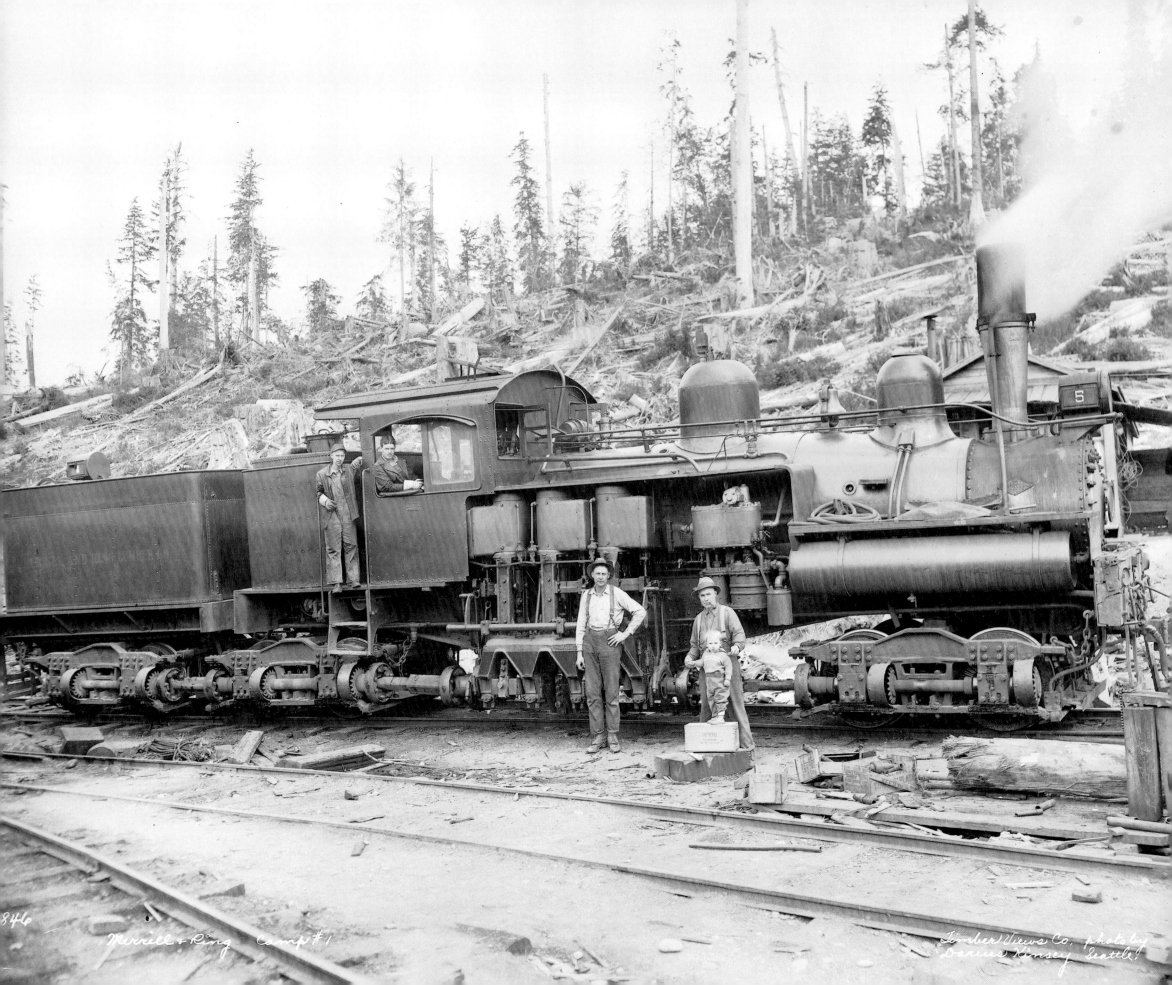

Shay
Lima Locomotive Works, Inc.
#3108 August 1920
Seventy-ton

Lima Locomotive Works construction #3108 was a 70-ton Shay built in August of 1920. Merrill & Ring bought her new. Operating as road number 5, she served the company until the operation at Pysht was cut out. She was picked up by the Columbia Construction Company in December of 1936 and put to work on the north jetty of the Columbia River, where that company had a contract. From there, in 1938 she went on to Consolidated Builders, Inc. for work on the construction of the Grand Coulee Dam.

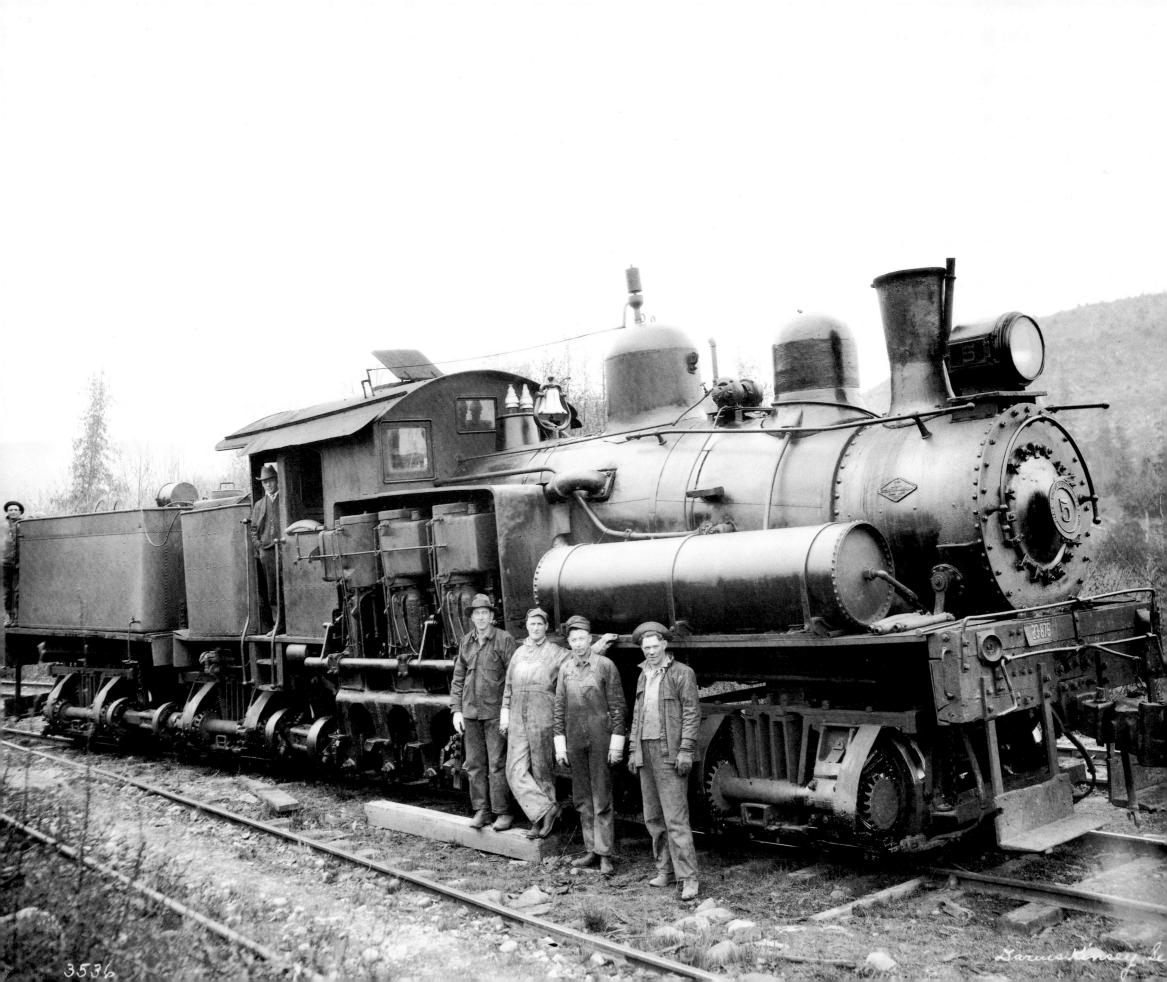

3536

Darius Kinsey

Shay
Lima Locomotive Works, Inc.
#2929 June 1917
Ninety-ton

Crescent Logging Company's number 5 was a 90-ton Shay, built by Lima in June of 1917 as construction #2929 for the Sewell Valley Railroad of the Meadow River Lumber Company of West Virginia. After a period of service in West Virginia, she was sold to the Irving-Hartley Logging Company and shipped west for use out of Port Angeles.

Joseph Irving and Roland D. Hartley represented families deeply involved in timber operations north of Seattle, and Irving-Hartley was formed in 1923 to log west of Port Angeles on lands acquired from the Milwaukee Land Company, which held title to Olympic Peninsula land grants of the Chicago, Milwaukee & St. Paul Railroad Company. This new opportunity in Clallam County had been opened up in the later years of World War I by the Spruce Production Division of the United States Signal Corps. In search of spruce for aviation products, the government in 1918 had constructed thirteen logging railroads that penetrated coastal regions from Coos Bay to the Strait of Juan de Fuca. The one that ran west from Port Angeles was acquired as a mainline by Irving-Hartley and was in fact an extension of the Milwaukee Railroad. Irving-Hartley then gained access to their first cuttings in Clallam County by re-laying rails on a grade that had been abandoned earlier by Puget Sound Mills & Timber Company, to whom many of the logs were later sold.

During 1927 Irving-Hartley purchased some five hundred million feet of timber along the Soleduck River, which resulted in the extension of the railroad almost to the shores of the Pacific. In this same period Roland Hartley was elected governor of the State of Washington, at which time he sold his interest in the company. The company was then reorganized and named the Crescent Logging Company, under which title it continued to operate into the mid-1940s.

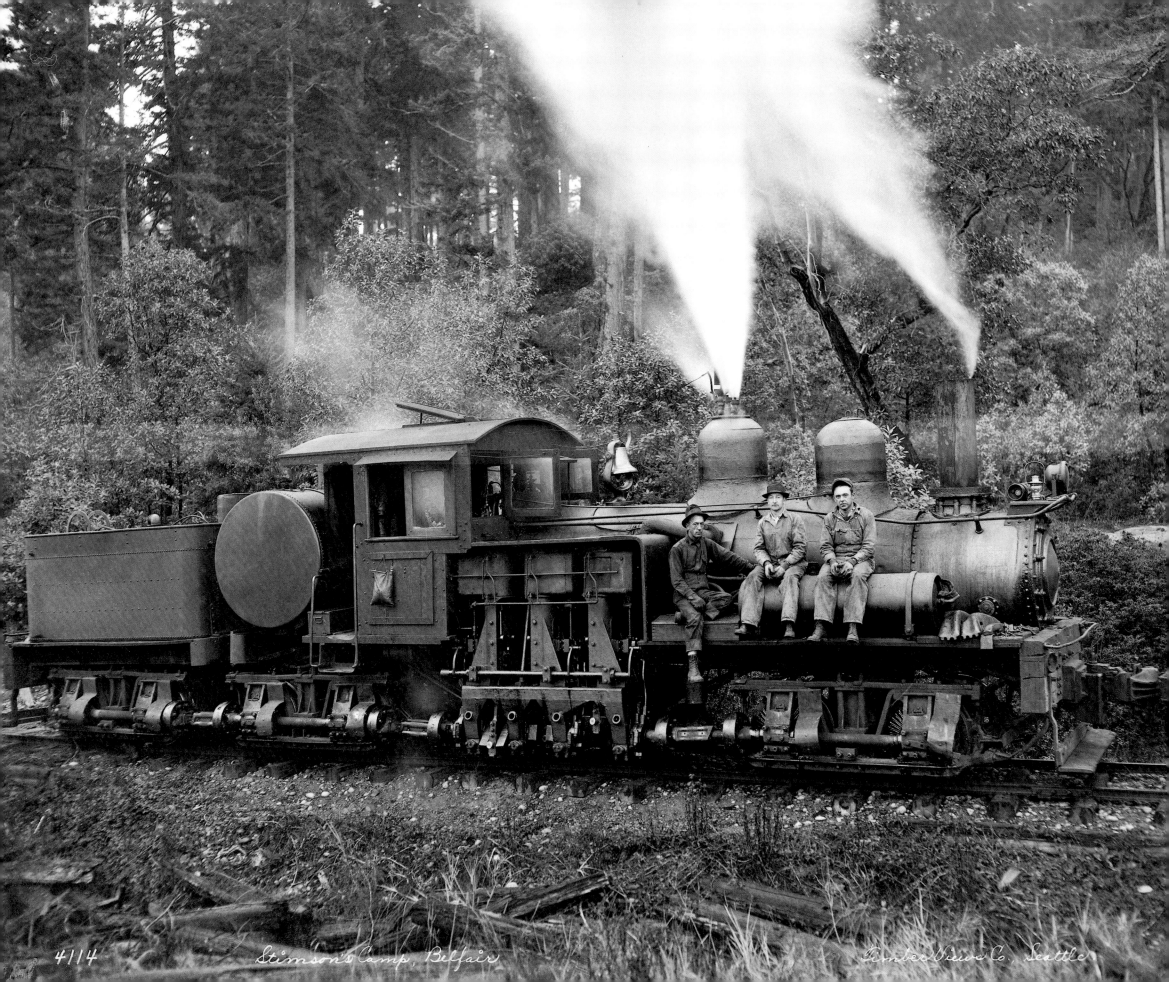

Stimson's Camp, Belfair

4114

Timber Views Co., Seattle

Shay
Lima Locomotive Works, Inc.
#2839 March 1916
Sixty-ton

The Stimson Timber Company was incorporated in August of 1913 by C. W. Stimson of Seattle, who had large timber holdings south of Bremerton. Since Stimson's holdings lay adjacent to those of Pope & Talbot, arrangements were made to share dumping and rafting facilities near Belfair, on Hood Canal. Utilizing a part of the Pope & Talbot railroad, Stimson was able to hold its own construction to just ten miles of trackage. Geared engines were the motive power because grades in the woods reached up to nine percent.

Stimson number 2 was built by Lima in the spring of 1916 as their construction #2839. Originally a wood burner, she was later converted to oil fuel, and the wood bunker was replaced with an unusual round oil tank. Together with Shay number 1, she served faithfully until the last of Stimson's timber was cut out about 1931.

In 1932 the entire operation was moved to Oregon and set up in Scoggins Valley, southwest of Forest Grove, where a large sawmill was constructed. Within a short time the locomotives were hauling logs to the new millpond. In spite of the Depression and the devastation caused by the big Tillamook fire of 1933, which swept through much of the timber, the company continued to thrive. After more than fifty years, the mill in Scoggins Valley produces lumber today and expects to operate into the future on trees grown since the fire, although the railroad was discontinued in the early 1950s.

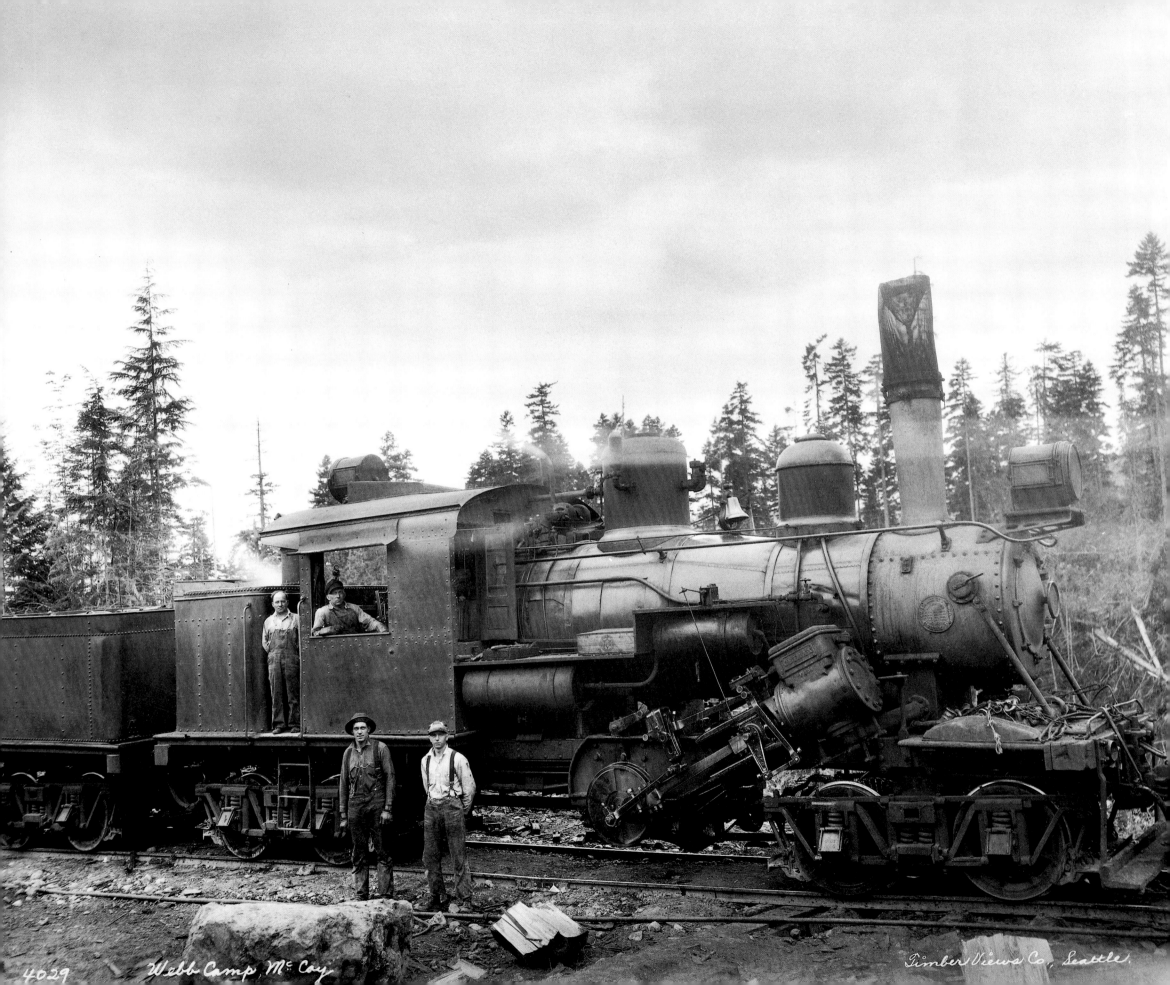

Climax
Climax Manufacturing Company
#1599 December 1920
Eighty-ton

Climax Manufacturing Company's construction #1599 was an 80-ton engine built in December of 1920 for the Webb Logging & Timber Company. The cylinders were mounted at a 45-degree angle, a hallmark of the Climax design.

From their log dump on Hood Canal, Webb operated a logging railroad along the Duckabush River, west into the Olympic Range. The company had purchased some two hundred twenty-seven million feet of timber in 1919, not long before acquiring the new locomotive, which was given road number 7. The Climax continued in service on the railroad into the late 1920s and was offered for sale in 1928. It is believed that Stimson later acquired this engine and renumbered her road number 3. She was scrapped in 1942.

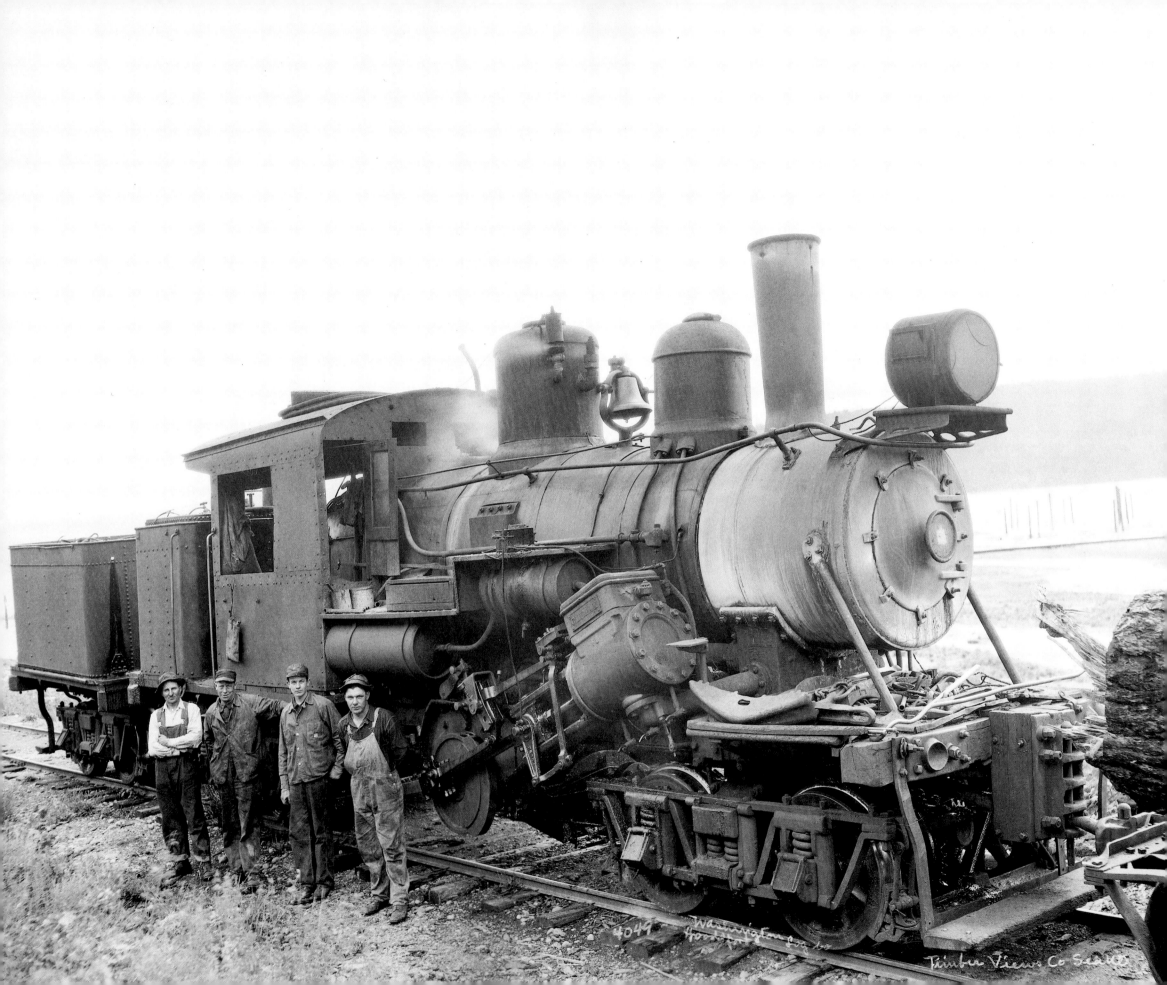

4049 Washington Logging Co

Timber Views Co Seattle

Climax
Climax Manufacturing Company
#1499 1919
Seventy-ton

This 70-ton Climax #1499 was built in 1919 for the Snow Creek Logging Company
who used her on their railroad near Sequim in Clallam County. In July of 1928 the
engine was sold to the Washington State Logging Company for their operations
near Shelton in Mason County. Generally known as the Washington Logging
Company, the operation had been incorporated in 1919 and did not expand beyond
its modest size in more than a decade. Logging there was finished in 1931 but
the ultimate disposition of the Climax is unknown.

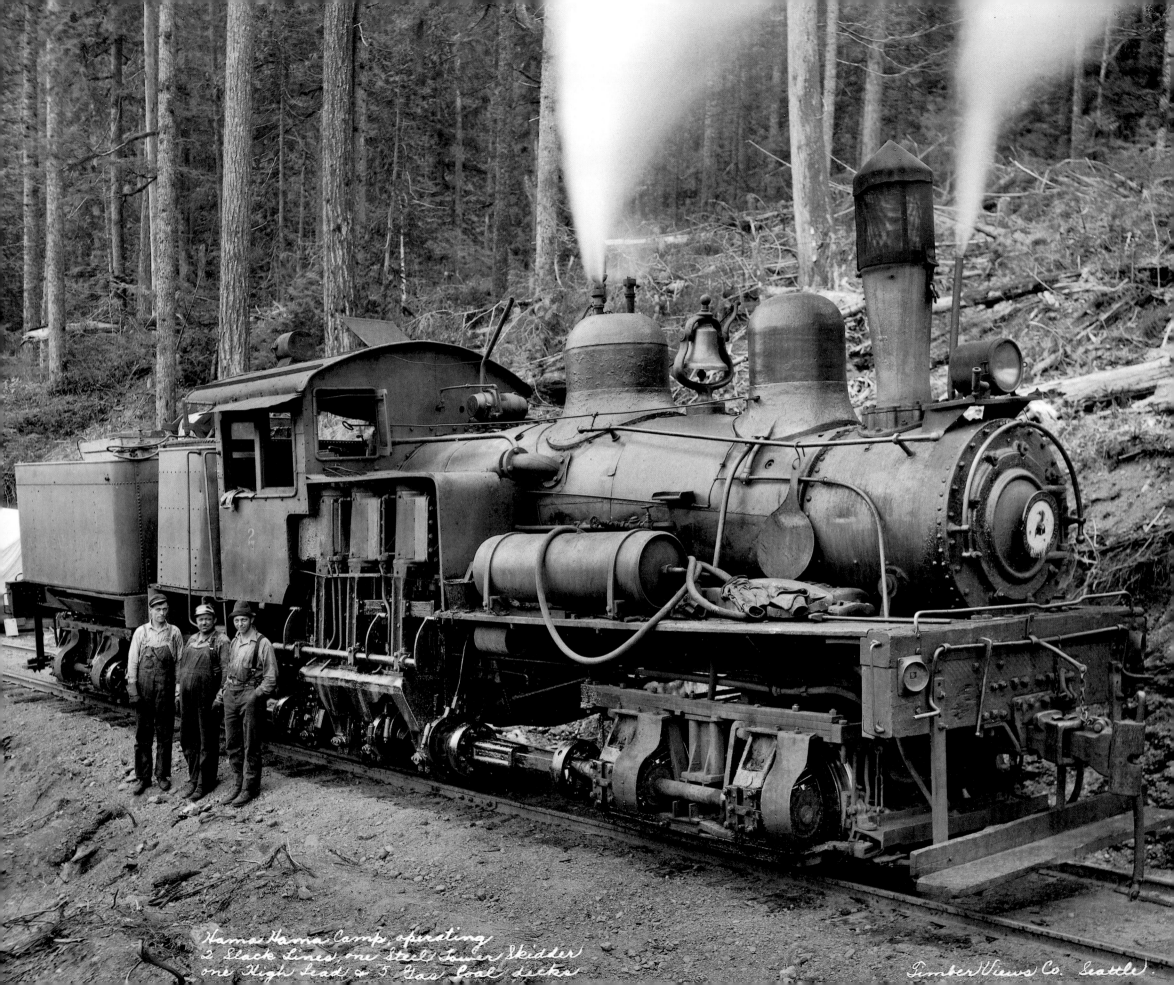

Hama Hama Camp, operating
2 Slack Lines, one Steel Tower Skidder
one High Lead & 5 Gas Coal Decks

TimberViews Co. Seattle

Shay
Lima Locomotive Works, Inc.
#2858 May 1916
Seventy-ton

Hama Hama Logging Company was incorporated in 1922 to log a tract of timber along the Hama Hama River, which flows east out of the Olympic Range into Hood Canal. Locomotive number 2, a 70-ton Shay built by Lima in May of 1916 as construction #2858, was originally sold to Rucker Brothers as their number 7 and worked out of Hazel—in the foothills of the Cascades east of Everett—for a few years.

 She was then sold to the Discovery Bay Logging Company, which operated northeast of Hood Canal, and retained her road number 7. When the engine was acquired by Hama Hama, who already had a number 7, she was renumbered by the simple expedient of turning the spot plate on the front of the smokebox upside down.

 Having finished up at Hama Hama with the end of the operations there in 1932 she was faced with the prospect of the scrapper's torch, but in October of 1938 was picked up by the Andron Logging Company for use at Mayfield, east of Chehalis. That operation ended in 1941 and she was finally dismantled in Seattle in April of 1945.

Backhead from the Willamette #21, built February 20, 1926. Photographed at Railroad Park, Dunsmuir, California.

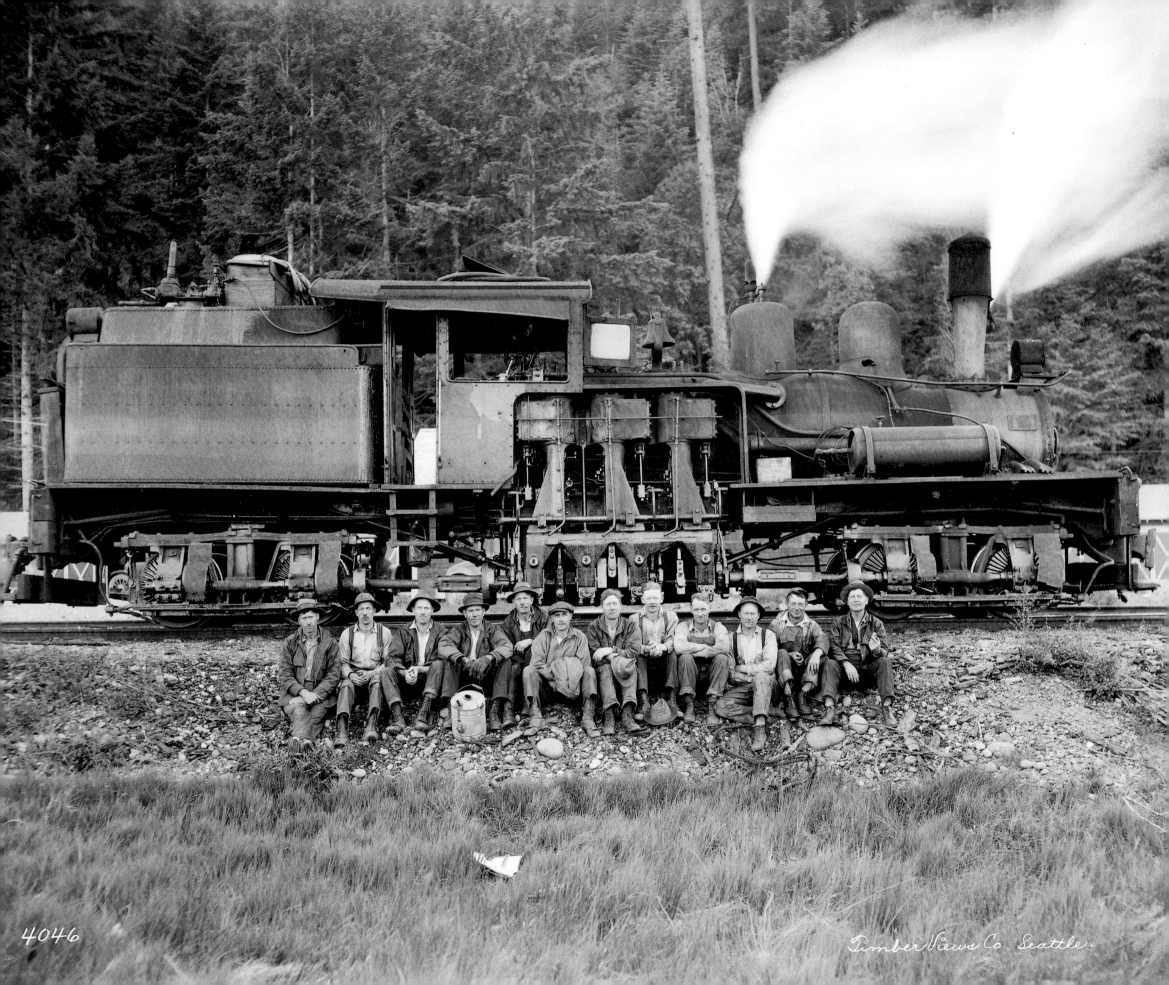

4046

Timber Views Co. Seattle.

Shay
Lima Locomotive Works, Inc.
#2581 August 1912
Fifty-ton

Hama Hama Logging Company's road number 1 was a Lima Shay of about 50 tons. The Shay design proved to be the most popular of the several types of geared engines which competed for the logger's favor, in part because of its superior climbing ability. The Shay was said to have been able to work up to a sixteen percent grade and is known to have worked up to fourteen percent. This capacity was essential for an operation like Hama Hama, where the railroad ascended sharply from the boom grounds at shoreline on Hood Canal to the timberlands in the Olympic Range.

Lima construction #2581 was built in August of 1912. She was first acquired by Nute & Packard, Inc. of Tolt, east of Seattle, where she was given road number 1. Later she was sold to the Discovery Bay Logging Company as their number 1, then to Hama Hama Logging Company at Eldon, on Hood Canal.

When Hama Hama cut out in 1932, the engine was picked up by Lloyd Crosby, an uncle of Bing Crosby, for his Crosby Logging Company at Walville, west of Chehalis. Bethlehem Steel Company bought her in the late 1930s, used her as a plant switcher, and finally cut her up in Seattle in 1940.

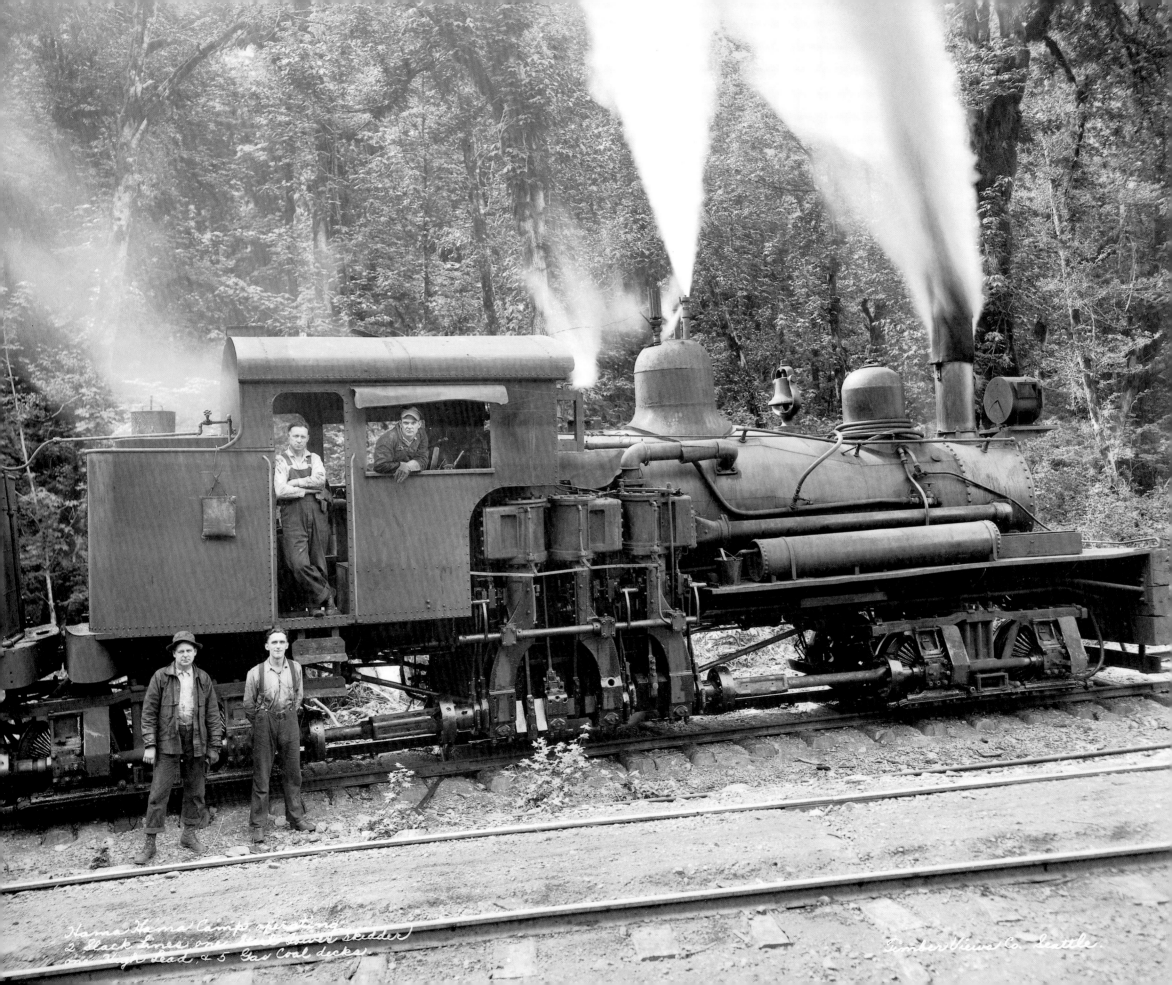

Hama Hama Camp operating
2 Slack Lines over head Towel skidder)
one High lead, & 5 Gas Coal decks.

Timber Views Co. Seattle.

Shay
Lima Locomotive Works, Inc.
#716 August 1902
Sixty-five-ton

Hama Hama Logging Company's locomotive number 5 was a 65-ton Shay built by Lima as construction #716 in August of 1902 during the era of Lima's greatest output. Purchased originally by McDougall & Jackson which operated at Orting, she was subsequently sold to Panther Lake Lumber Company for service at Three Lakes in Snohomish County.

In 1923, when Hama Hama needed another geared locomotive, there were a number of used engines on the market at favorable prices. They picked up this Shay and gave her road number 5. Although she was older than the company's other engines, the Shay design had been standardized for years and working on engines built as much as twenty years apart presented no problems for the master mechanics of the woods. She served the operation until Hama Hama cut out in 1932. Her ultimate disposition is unknown.

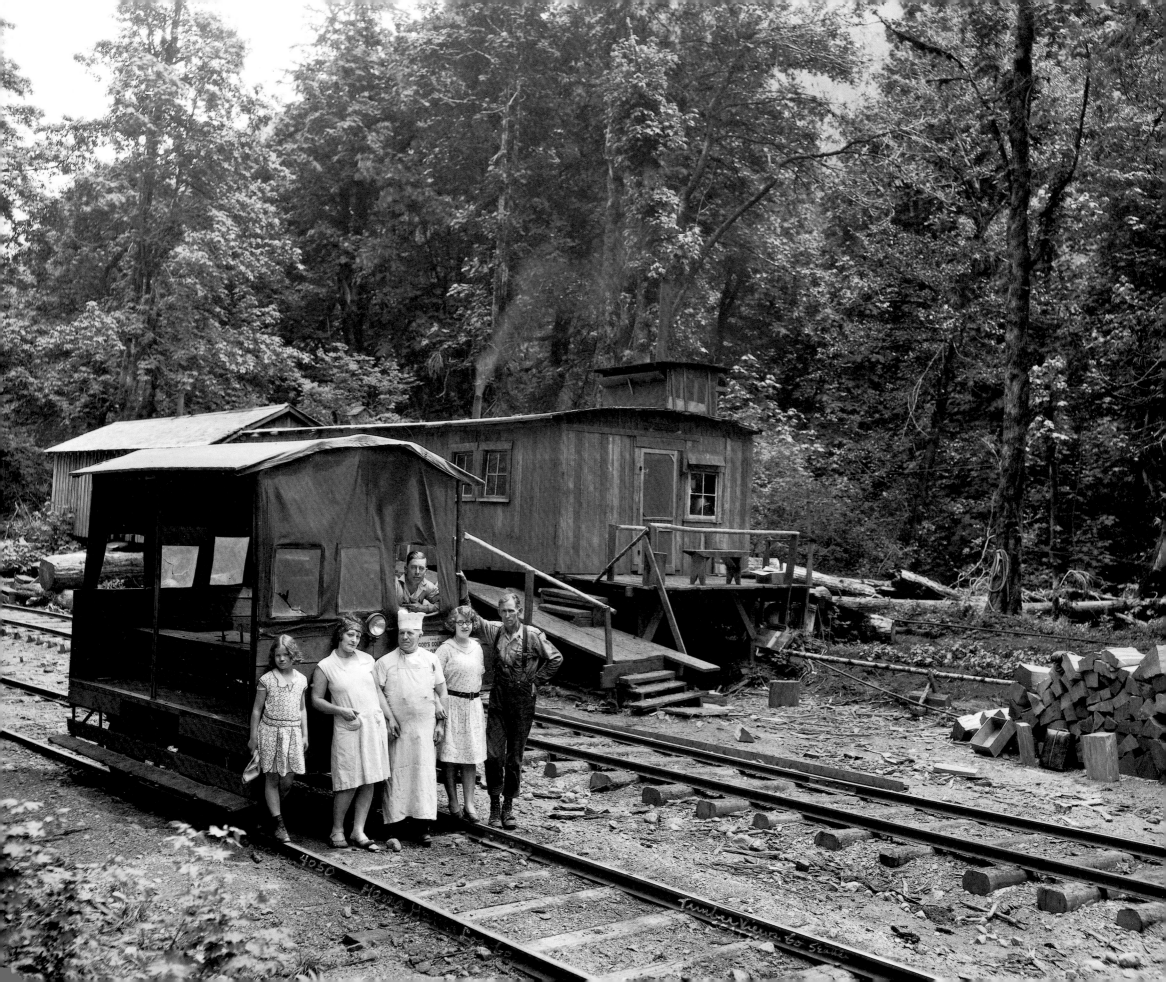

The little gasoline speeder was an invaluable tool for the logger. It was used to carry the mail, haul in supplies, handle the injured, carry the work crews, and serve the boss as his private car. When assigned this duty, the operator was known as the "speeder monkey." Here, the kitchen crew of Hama Hama's boom camp—at the mouth of the Hama Hama on Hood Canal—pose with their link to the main operation and its three hundred men, located in the upper reaches of the river valley.

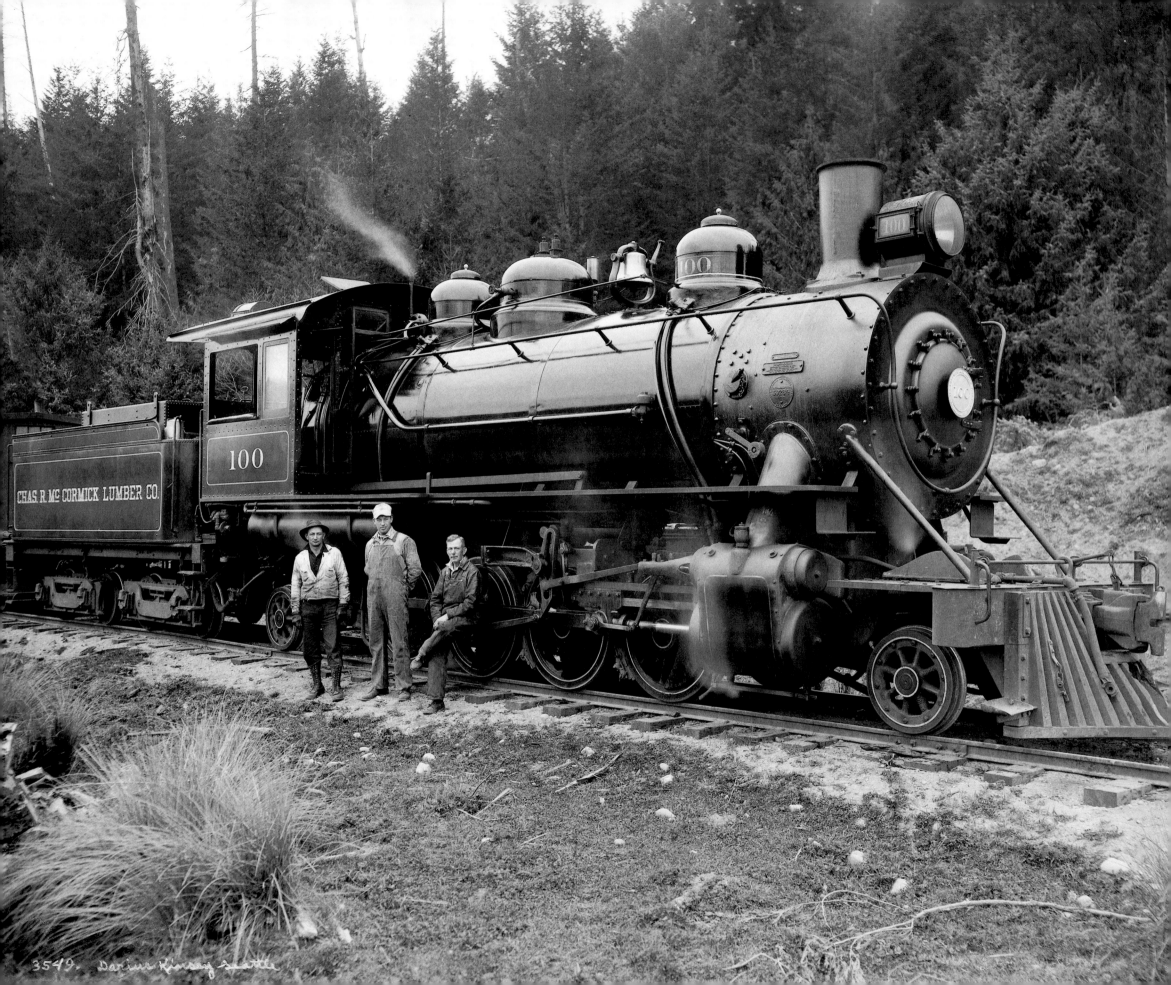

CHAS. R. McCORMICK LUMBER CO.

100

3549. Darius Kinsey Seattle

Mikado 2-8-2
The Baldwin Locomotive Works
#59284 June 1926
Seventy-two tons

Originating as a steamship line, Chas. R. McCormick got into the lumber business in 1908 with the purchase of a sawmill site at St. Helens, Oregon. In 1910 the company purchased the logging operation supplying the mill. More mills and logging operations were acquired in the years following. Finally, in 1924, all of the company's diverse interests were merged into a single company under the Charles R. McCormick Lumber Company title, making it one of the largest lumbering concerns on the Pacific Coast.

In August of 1925 the company acquired the Washington State holdings of Pope & Talbot for $20 million, which gave them an additional eighty thousand acres of timberland. Pope & Talbot executives retained their positions with McCormick. The Port Townsend Southern Railroad was then purchased by McCormick and under Paul Freydig, a prominent logging engineer, was renamed as the Discovery & Quilcene Railroad, running south from Discovery Junction to a Hood Canal dump known as Linger Longer. A logging camp (Camp Talbot) was then built at Crocker Lake, designed to serve a large new sawmill at Port Ludlow on Puget Sound.

Motive power for this extensive operation in the eastern region of the Olympic Peninsula was purchased new in 1926. The mainline locomotive was road number 100, a Baldwin Mikado bearing construction #59284. With 18 x 24-inch cylinders and 44-inch drivers, she was typical of the Baldwins that were proving so popular with loggers of the period.

As the timber was cut out, a new railroad was built south, this time directly from the mill at Port Ludlow, where a new camp (Camp Walker, named after Cyrus Walker, the head of Pope & Talbot) was established. The Baldwin continued to handle mainline chores. Then in 1938, the Chas. R. McCormick Lumber Company went out of business and the various interests were taken over by Pope & Talbot. Most of the remaining logging operations were contracted to small loggers who used trucks for transportation, and the railroads were soon phased out.

In 1942, the M. F. Brady Equipment Company of Portland, Oregon, resold the engine to the Santa Maria Valley Railroad at Santa Maria, California. Rebuilt and repainted, but retaining her road number 100, she began life anew, serving until retirement in 1955. She was stored at Santa Maria for a number of years, then sold in 1964 to the White Mountain Scenic Railroad at McNary, Arizona. Recently she began yet another life with the Wasatch Mountain Railway at Heber City, Utah, working for the Heber Creeper (Deer Creek Scenic Railroad) tourist line.

Casey Richards brakeman, Rodney Jones engineer
Buster Byers second brakeman, Les Smith fireman (not shown)

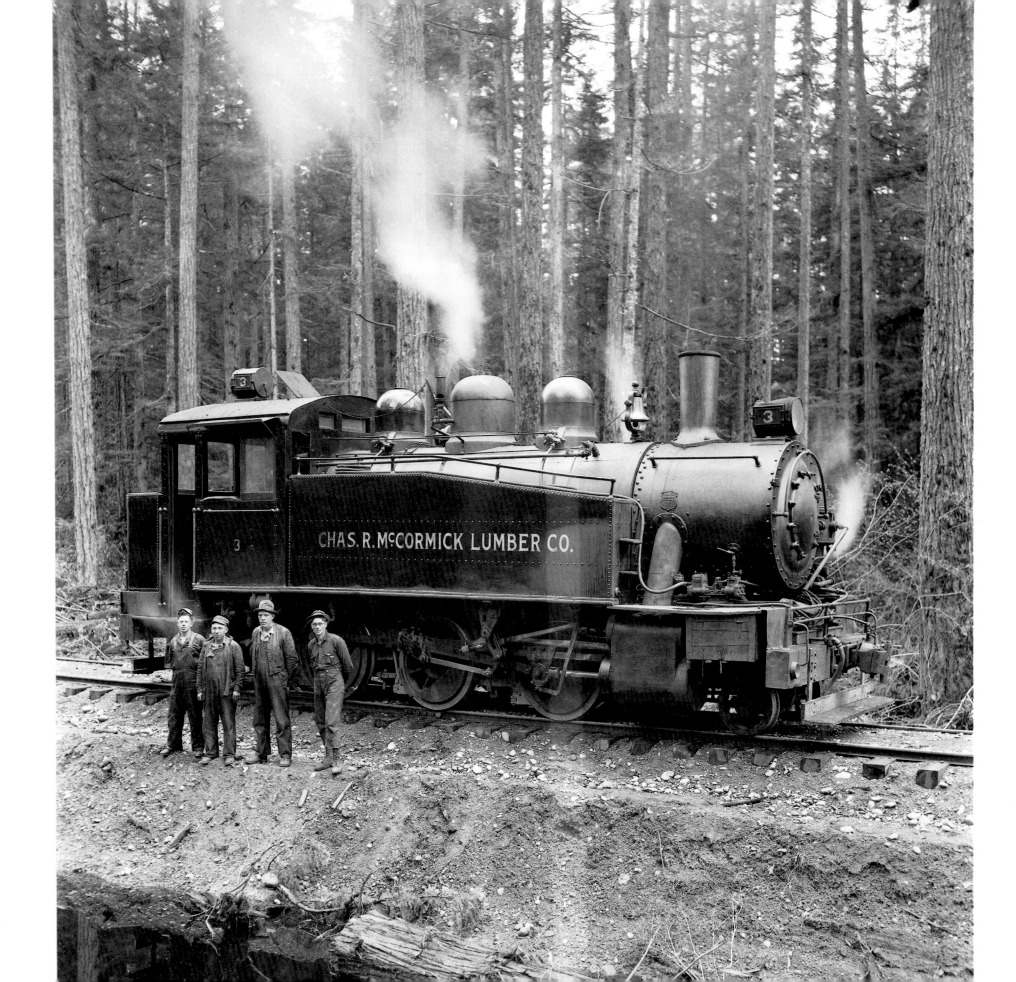

Side-tank 2-6-2
H. K. Porter Company
#6821 August 1923
Seventy tons

The timber on the eastern Olympic Peninsula adjacent to Puget Sound consisted primarily of red Douglas fir, a tree of small diameter but having a fine grain and firm texture. In the days of sailing vessels it was highly prized for masts and spars, and in later years found favor as a finishing wood.

In November of 1927 the West Fork Logging Company sold their logging railroad at Seabeck, on Hood Canal, together with some twenty-five million feet of standing timber, to the Chas. R. McCormick Lumber Company. Included in the deal was the Porter 2-6-2 tank engine, road number 3, built by H. K. Porter Company as construction #6821. (West Fork had purchased the 70-ton engine new to open the Seabeck operation in the spring of 1923.)

The Seabeck railroad led south to a tract of Pope & Talbot timber lying near the southern end of Hood Canal, where a logging railroad had been located for many years. The addition of the West Fork railroad allowed McCormick to combine the two operations and utilize the dump and rafting facilities at Seabeck, which were superior to the old dump near Belfair, at the toe of the Canal.

In 1938, when the properties reverted to Pope & Talbot, the railroads were phased out and the logging was turned over to contractors who logged with trucks.

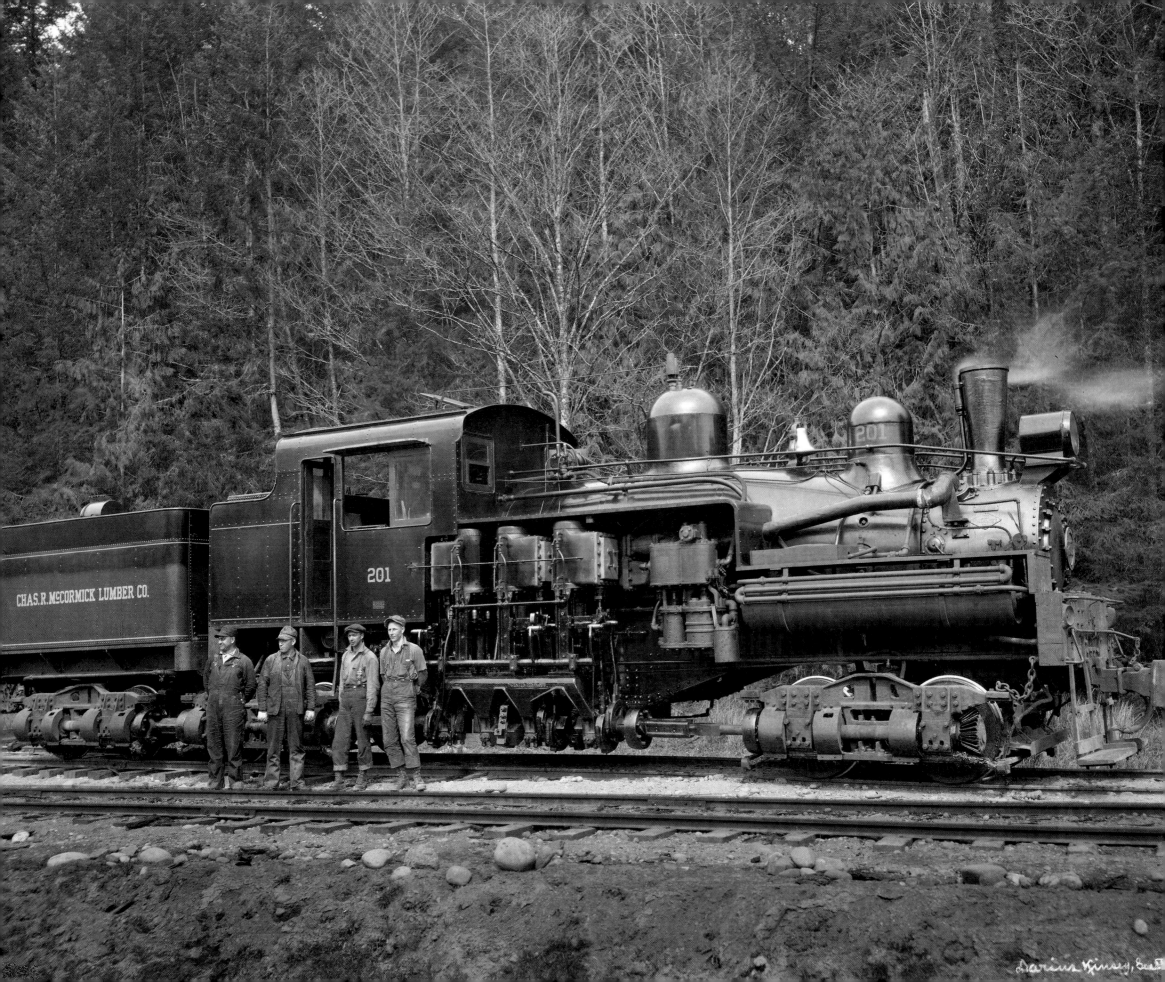

Shay
Lima Locomotive Works, Inc.
#3304 June 1926
Seventy-ton

Two new 70-ton Shays were acquired from Lima in June of 1926 to open the new Chas. R. McCormick operations at Camp Talbot, north of Quilcene. These locomotives, given road numbers 200 and 201, bore construction #3295 and #3304 and at the time represented the ultimate in geared engines. With cast steel trucks, superheaters and 12 x 15-inch cylinders, they were among the last of their kind. Eventually, number 201 was transferred to Camp Union at Seabeck.

 With the end of the logging railroads, both engines went on to further service. The 200 worked for Mason-Walsh-Atkinson-Kier and Consolidated Builders—both companies contractors on the construction of Grand Coulee Dam—and ended up at Headquarters, Idaho, for Weyerhaeuser's Potlatch Forests, Inc. The 201 was also acquired by a contractor, Columbia Construction Company, for use at Westport, and ended up in one of the company's rock quarries at Declezville, near Fontana in Southern California.

Urban "Pross" Rondeau fireman, Frank Jones engineer
Harold Tracy brakeman, Wilbur Hamann second brakeman

When I was seven years old, I first got interested in locomotives. We lived down by the Silver Falls Timber Company track and the roundhouse was about a quarter of a mile from our house. I got in the habit of going down there and spending my time, and the train crews seemed to take a liking to me. They let me hang around and they even let me ride in the engine cabs. So I was always down there when the afternoon trains came down from the woods. About five o'clock, they would slow down and I'd get on and ride with them, and it wasn't long before it was my job to blow the whistle while backing down to the pond. Then, after they got through dumping logs at night, they'd bring the empties back to the yard and cut them out and drop down to the fuel tank, take on fuel and water, and go into the roundhouse.

Well, after I had been around there for a couple of years — by then I was about ten years old — I was in the cab one evening and Mike Stewart says, "Come on, Sliffe, take her to the barn." And I couldn't believe it. But I got up into the engineer's seat and I knew what to do. I had watched him, and had watched Wren Matheney, the fireman, so of course I knew how to release the brakes and open the throttle. But Wren Matheney, he almost spoiled things for me that first time. After I had released the brakes he said, "Widen on her, Sliffe." So I pulled the throttle clear back and the wheels just spun. Mike gave me hell, but that never happened again, neither. So from then on, from the fuel tank to the water tank and up to the switch, then back about three hundred yards to the roundhouse — that was my job.

So then, Les Whitlock—he was the engineer of the number 104—found out what I was doing and he would let me ride up to Reynolds with them, about ten miles out of town. After they got through with their switching in the morning, they would take a drag of empties up there. So one time I was riding with them and it was pouring down rain, a dismal day. We got about three miles away from town and Les says, "Come over here, Sliffe." He got out of his seat and stuck me in there and he says, "You take her on the rest of the way." Well I was in the height of my glory.

Then, at the five-mile post we hit the grade—not very steep there, only about two and a half percent—and at the eight-mile post there was a siding. When we came in sight of it they saw that the roadmaster's speeder was in there. Old Les didn't say anything, but he went over to the fireman's side of the cab to where the road-master, Bert Meyers, couldn't see him. So we went steaming by with me up there, and Bert's mouth dropped open and he just stood there shaking his head.

We made it to Reynolds all right, but we learned later that Bert had gone into the master mechanic's office and said, "Hey, do you know that Sliffe boy who was running that engine, the number 104?" The master mechanic says, "Yeah, Les got sick and we needed an engineer and we didn't have time to look up another one." Bert left the office muttering to himself, "What's this world coming to?"

So that is the way I grew up on those engines.

Arlie Sliffe
Woodburn, Oregon

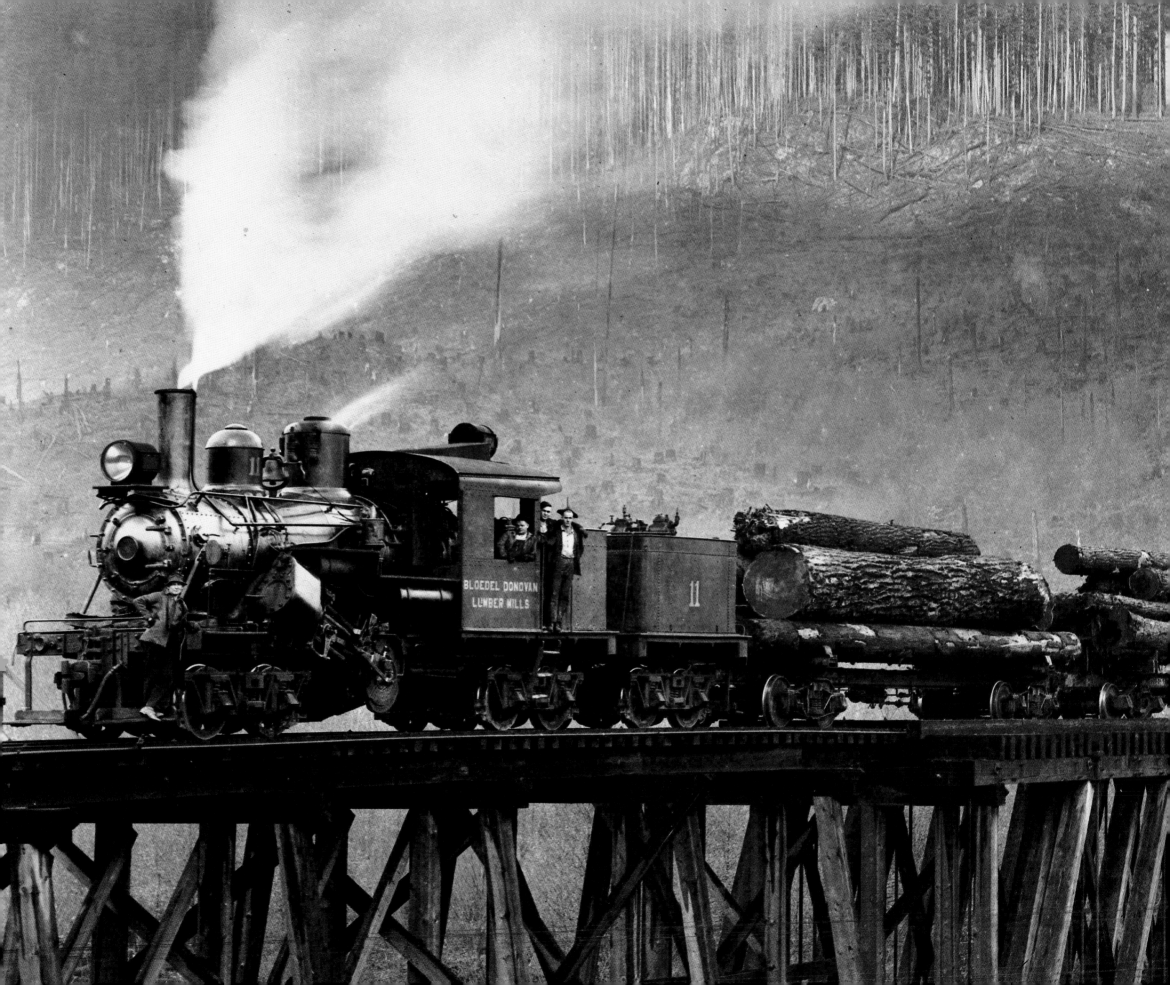

Climax
Climax Manufacturing Company
#1632 August 1923
Seventy-ton

In the spring of 1917, Bloedel Donovan Lumber Mills acquired control of the Skykomish Lumber Company, with a sawmill on the Skykomish River in King County, near the foot of Stevens Pass. To reach the timber stands on the north side of the river, in 1920 the company constructed a bridge at a cost of $60 thousand. The sawmill, built in 1900, burned in July of 1928 and was immediately rebuilt. Then in 1931 the plant was shut down, not to open for five years, by which time much of the logging was being contracted to truck loggers. Planks were laid on the bridge and trucks shared the right of way with trains until the mid-1940s, when the rail service was ended.

 Climax number 11 was a 70-ton locomotive built in 1923 as construction #1632. She was purchased for use at Skykomish, sharing duties with a second large Climax, and continued to serve the camps until the rails were removed.

*The Climax number 11 on
the Skykomish River*

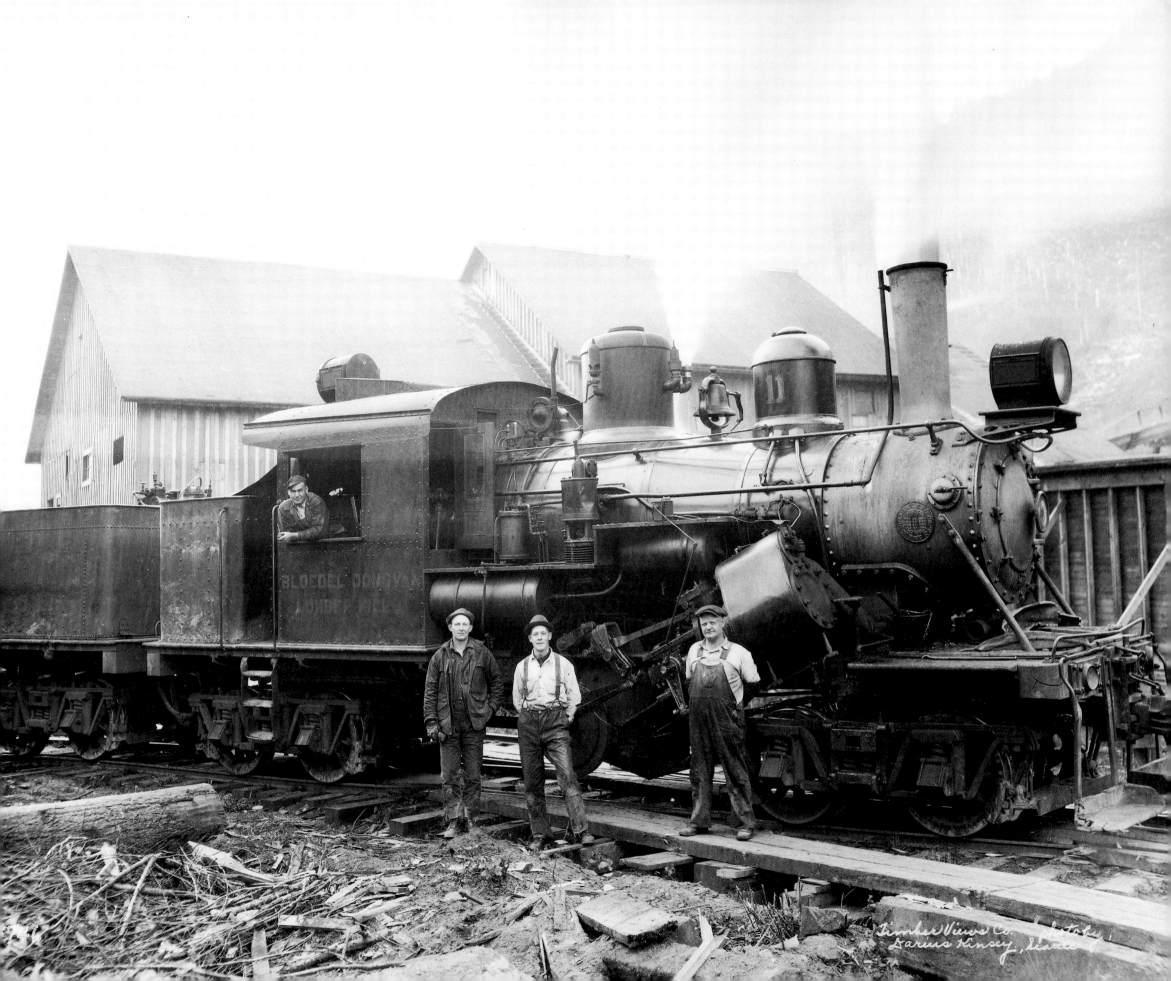

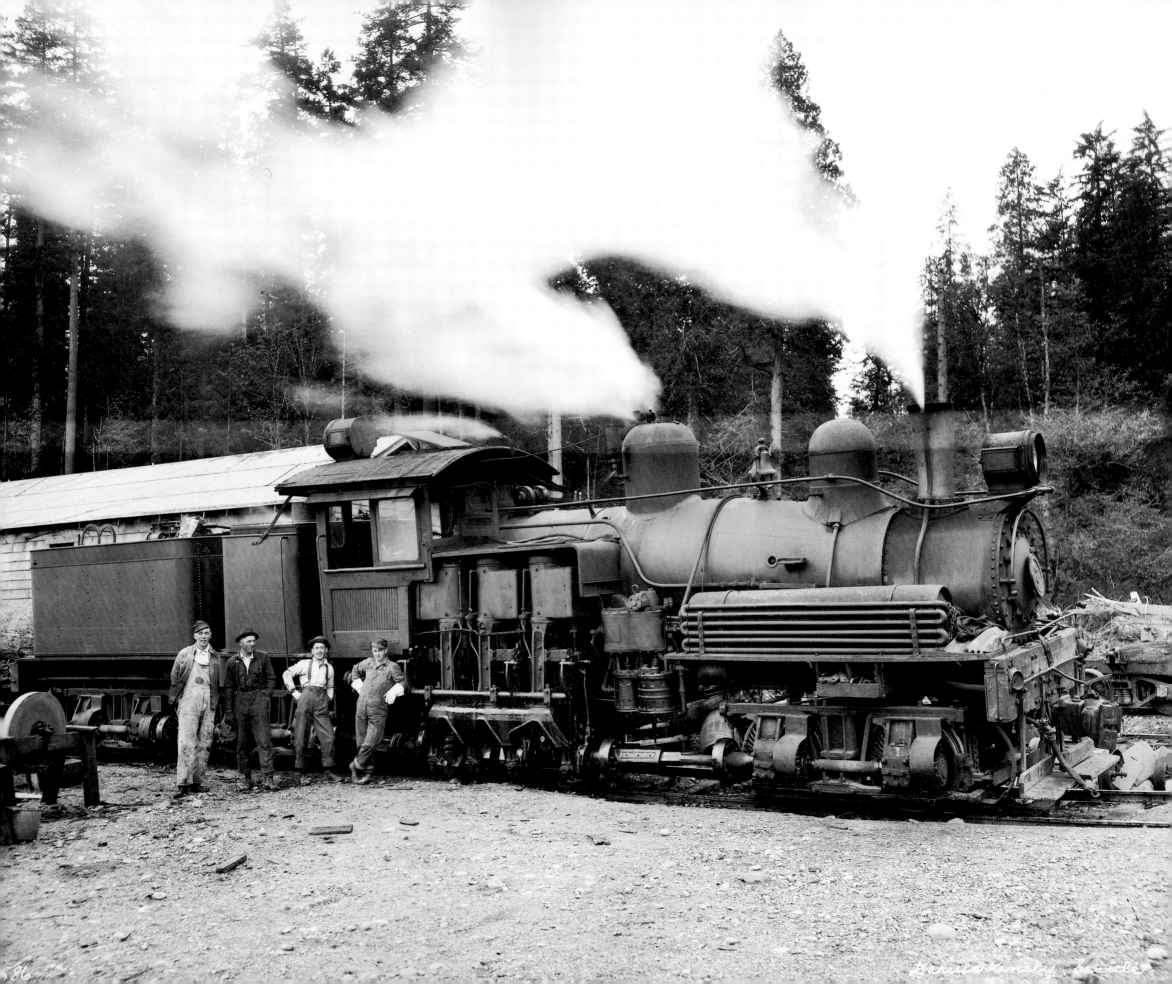

Shay
Lima Locomotive Works, Inc.
#2786 September 1914
Sixty-five-ton

The Goodyear Logging Company was incorporated by Charles A. Goodyear, a Wisconsin logger, in July of 1914 to log a tract of timber on the Strait of Juan de Fuca. The tract contained an estimated two billion feet of timber on thirteen thousand acres, requiring some seven miles of railroad. James Manary, an Oregon logger, was put in charge and a camp was established on Clallam Bay. At the time this was the most westerly large logging operation in the United States.

 The advent of World War I and the creation of the Spruce Production Division drastically altered plans for logging in the area. The Spruce Division Railroad #1 was built west from Port Angeles to Lake Pleasant, opening the entire region to development and increasing the value of adjacent timberlands. The railroad cut through about seventeen thousand acres of Goodyear lands and reached holdings recently acquired by Bloedel Donovan. All along the inland waters, however, logs were still rafted to sawmills, which meant the logging railroads had to drop down to tidewater by the most economical route. To gain this important access for their newly acquired holdings, Bloedel Donovan purchased the properties of Goodyear Logging Company in 1924.

 Locomotive number 3 was a 65-ton Shay built by Lima as construction #2786 in September of 1914. She was used in the construction of the first railroad and the opening of logging out of Clallam Bay, which continues to the present day. She passed to the control of Bloedel Donovan Lumber Mills in 1924, and then to Rayonier, Inc. in April of 1945, retaining her road number 3 until the end. She was scrapped about 1949.

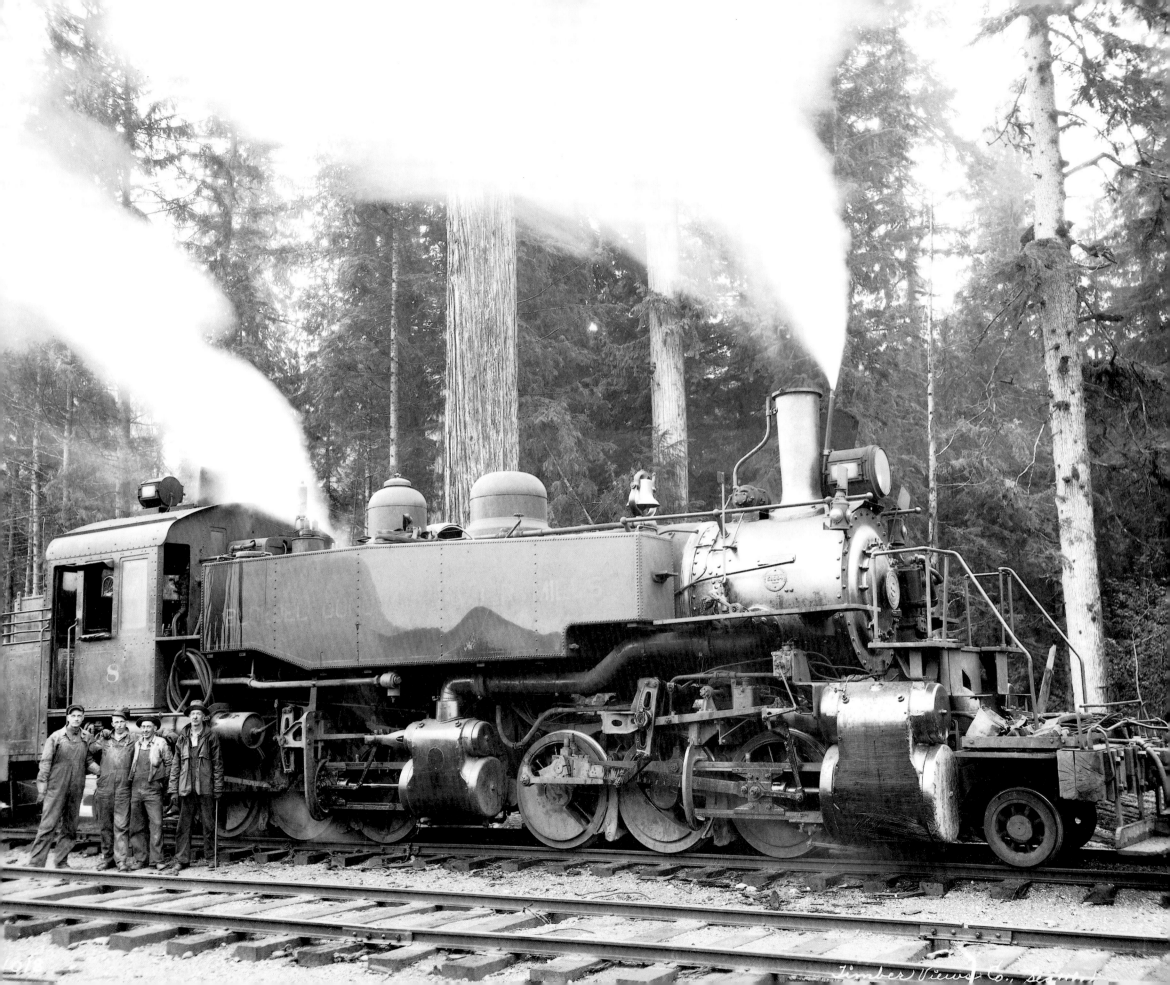

Mallet 2-6-6-2T
The Baldwin Locomotive Works
#58064 November 1924
One hundred ten tons

About 1898, Peter Larson of Helena, Montana, invested $500 thousand in a large tract of timber in Whatcom and Skagit counties. He established the Larson Lumber Company with sawmills in Bellingham, and the Lake Whatcom Logging Company to harvest the timber. When he died in 1907 he left a fortune of some $20 million to show for his efforts. With his death control of the company passed to his manager J. H. Bloedel, and J. J. Donovan—an engineer who had headed the Bellingham Bay & British Columbia Railroad for Larson.

In the spring of 1913 the various enterprises were merged as the Bloedel Donovan Lumber Mills, and the properties of Bellingham Bay Lumber Company were added, giving the new company two sawmills in Bellingham, twenty thousand acres of timberland, and thirty miles of railroad. In addition to the extensive operations in southwest Whatcom and northwest Skagit counties, the company also operated the Skykomish Lumber Company in King County, along the Skykomish River. By 1919, they were operating four different camps in northwest Washington and had begun purchasing new tracts of timber on the Olympic Peninsula.

With the purchase of the Goodyear properties in January of 1924, the Clallam camps were inaugurated, assuring the company of a future supply of logs. To handle the trains over what would become an extensive railroad system, the company purchased two 110-ton side-tank Mallet locomotives, numbered 8 and 9. While awaiting the construction of the new railroad on the Peninsula, the Mallets were broken in at camps out of Bellingham. One was at Alger in Skagit County and the other at Saxon in Whatcom County.

The Bloedel Donovan operation in Clallam County was eventually sold to Rayonier, Inc. in the spring of 1945. The number 8 continued to serve under the new ownership. She was, in fact, the last steam locomotive to be used on the railroad, acting as standby for the new diesels that were to see the end of the logging railroad. In 1965, the number 8—Baldwin construction #58064, turned out in November of 1924—became the property of Peter Replinger and Byron Cole, and was shipped to Shelton where she remains in storage.

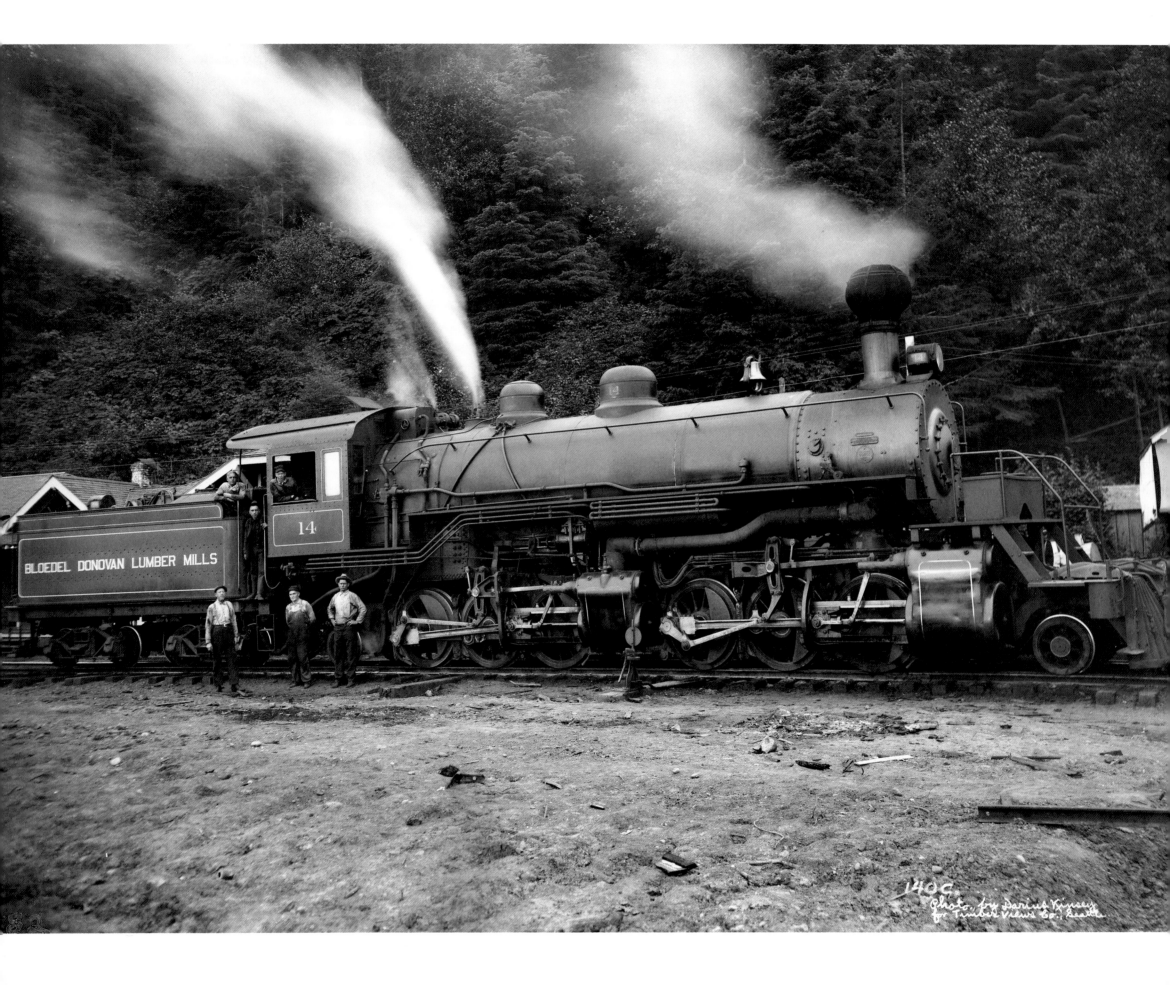

Mallet 2-6-6-2
The Baldwin Locomotive Works
#60256 November 1927
One hundred thirty-seven tons

Articulated locomotives of this type were among the largest to be used in logging. Coming in near the end of the logging railroad era, when the mainlines were long and loads heavy, they proved ideal for the larger operations. Most were compound Mallets, after the design originated by Anatole Mallet. Steam used in the rear set of cylinders was reused in the forward set which, due to the expansion of the steam, were necessarily larger to produce the same amount of power. By using the steam twice, there was a saving of fuel and water with no loss of power. The system was most effective at slow speeds and on heavy pulls, such as on the mainline railroads of the larger companies.

 The number 14 was the first of the heavy Mallets to be built with the 51-inch drivers loggers came to prefer for mainline service. She was purchased from Baldwin in November of 1927 as construction #60256 and went to work on the Bloedel Donovan line out of Sekiu on Clallam Bay, bringing trains down from the interior to tidewater.

 After almost twenty years of steady work out of Sekiu, she passed to Rayonier, Inc. in 1945. Rayonier later transferred her to their operation out of Grays Harbor at Hoquiam. There she joined two of the larger Mallets that had followed her from Baldwin, the famous "Sierra" 38 and the 120, both former Weyerhaeuser engines. Together they closed out the era of steam on the logging railroads of the West. They might have served even longer in the Rayonier stable, where steam was dropped with reluctance, had not the ravages of age made their demise inevitable. The Bloedel Donovan number 14 was scrapped at Crane Creek in the 1960s.

Above: Bob Loheed fireman, Vern Dibb engineer (in window)
Ground: Bill Staples, Red Orr, Rollo Parsons

Oh boy, she sure shines, don't she? I ran that for three years and fired it for five. The picture was taken down at Sekiu and Vern Dibb is running her there. Vern started running her when Ed Woods died, and I fired for Vern. Then Vern had a heart attack and I went running.

Vern told me about when she first came. They brought her over the Port Angeles & Western, and down into Sekiu. They had the tender off of her and they look pretty narrow, you know, pretty big engine if you look at the back of them when there is no tender. Ed Hawley was around then, and he just shook his head. "It's too goddamned big, Vern, it's too goddamned big."

She was a mainline engine—a lower-end engine, we called it. The geared engines and small Mallets would bring the loads in and put 'em on side track, and we'd gather 'em up and take the loads to Sekiu and dump them. From Sappho to Sekiu, about twenty miles. They double-shifted her—a night crew and a day crew. They worked her twenty-four hours a day. They had to get those empties back to the woods, you see. That hill was a three percent grade and she'd come back with thirty-five empties and then would be all night dumping those logs. She was the mainstay. Whenever she had to go to the shop, they had a hell of a time keeping up with those empties.

She went out on the same barge the diesels came in on. They took her to Seattle, and she went around to Aberdeen and worked several more years on the lower end, in Grays Harbor operations. And then they scrapped her. I would have loved to have the bell off of her. I rang that bell many times when I fired her. I'd just tap it whenever we moved the engine so that anything that was behind us would get the hell out of the way and not get run over. The thing about the number 14 running was it was just like a horse in harness. Everything working, everything had its thing to do. God that's a beautiful engine.

Rex Everett
Burlington

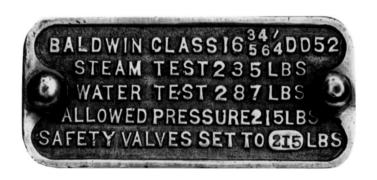

Boiler plate from
the Bloedel Donovan number 14
Courtesy Buster Corrigan

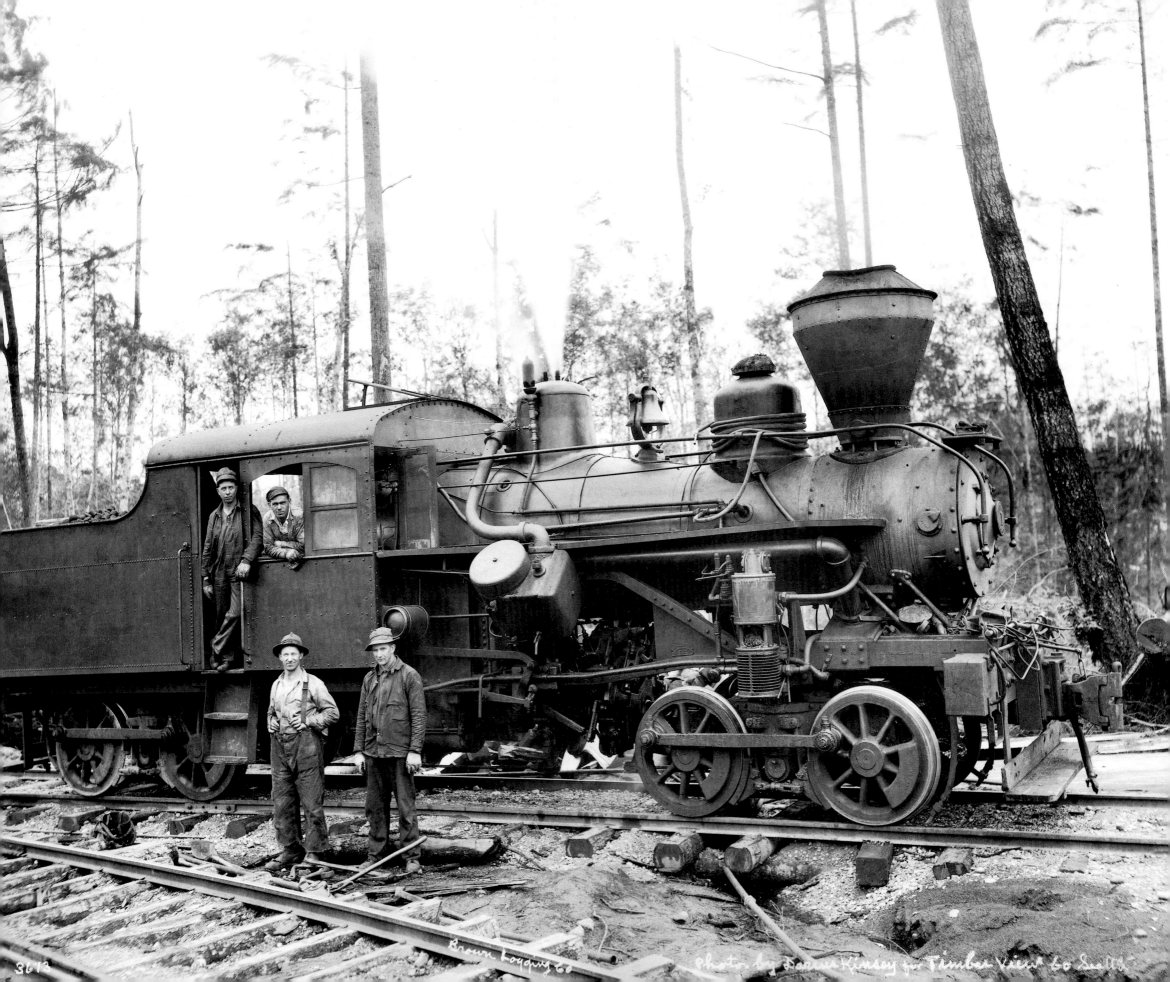

Brown Logging Co. Photo. by Darius Kinsey for Timber View Co. Seattle

Heisler
Heisler Locomotive Works
#1436 1920
#1470 November 1922
Forty-seven-ton

B. & B. Logging Company was a small concern formed by William and Jesse Brown in 1922 to log an area near Redmond, east of Seattle. They purchased a 47-ton Heisler in November of 1922 to service the operation's six miles of track. When they bought it, the engine bore construction #1470, but it had been built originally as construction #1436 for the Bee Tree Lumber Company of Virginia, which used a 42-inch gauge track. The locomotive was later returned to Heisler in Erie, Pennsylvania, where it was rebuilt and regauged and then sold to the Browns. When the tract at Redmond was cut out in 1927, the engine was sold to E. J. Sherman Lumber Company which was building an extension to their logging railroad near Mountaindale, Oregon, a few miles west of Portland.

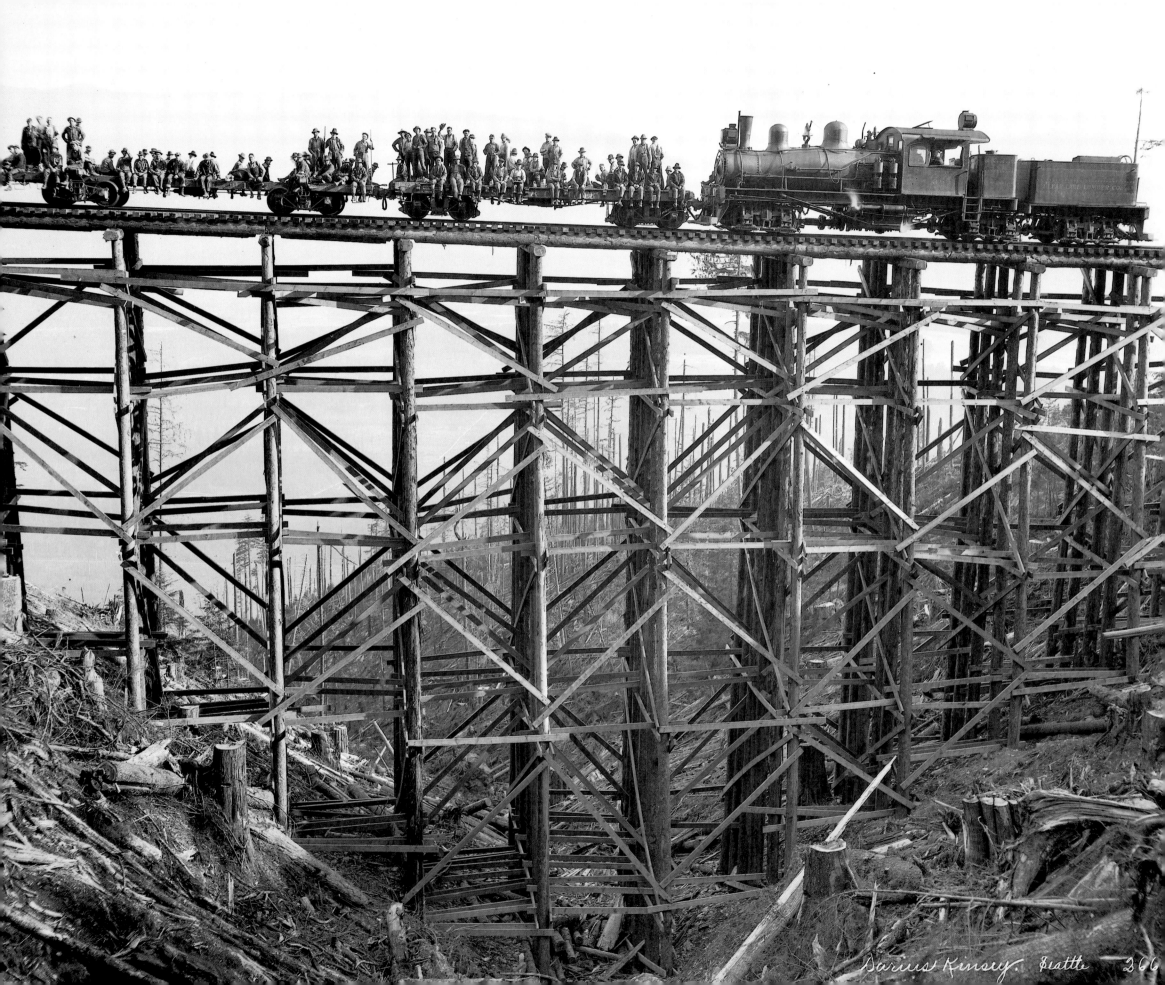

Darius Kinsey. Seattle. 366

Shay
Lima Locomotive Works, Inc.
#2643 July 1913
Eighty-ton

About 1900, two Minneapolis lumbermen joined forces to harvest timber from their Washington State holdings near Clear Lake, just south of Sedro Woolley. As the Bratnober-Waite Lumber Company they built a sawmill on Clear Lake and contracted with a local logging concern to cut and deliver logs. In November of 1902 the sawmill burned and the property changed hands. Clear Lake Lumber Company emerged in January of 1903. Another sawmill was erected and log production increased under the new owners.

In the spring of 1913 the company doubled its holdings by merging its interests with those of B. R. Lewis. Lewis owned timber under the Mount Baker Timber Company title and processed it through the Skagit Logging Company. Lewis also had under construction the common carrier Puget Sound & Cascade Railroad. Each of these enterprises came under the ownership of the Clear Lake Lumber Company, Lewis himself taking charge of the logging and rail operations.

The timber holdings lay south of the Skagit River and the rails of the Puget Sound & Cascade Railroad were laid eastward along the south bank to serve numerous logging spurs. This created a unique situation since Clear Lake's railroad paralleled the Puget Sound & Baker River Railroad—which ran along the north bank of the Skagit serving the logging operations of Lyman Timber Company, Hamilton Logging Company, and Dempsey Lumber Company. Between the two, also on the north bank, lay the rails of the Great Northern, seemingly spurned by the loggers.

For transporting loads of logs, Clear Lake Lumber Company favored connected logging trucks, or skeleton cars, over the disconnected trucks of an earlier era. Disconnected trucks—two independent sets of wheels—were attached directly to the logs they carried and required manual adjustment of the brakes on each truck with an iron tool known as a "brake hickey." Skeleton cars, built with a central beam connecting the trucks, could be equipped with air brakes and the engineer could control the entire brake system from the cab.

In the days before accident commissions and insurance companies put a stop to the more dangerous practices in the woods, crews were often expected to ride the cars to and from the job. Here the crew cars are handled by Clear Lake's 3-spot, an 80-ton Lima Shay built as construction #2643 for the Skagit Logging Company in July of 1913, and originally assigned road number 5 by Skagit. She was renumbered with the merger, and retained that number for the Puget Sound Pulp & Timber Company, who succeeded Clear Lake.

Climax
Climax Manufacturing Company
#872 July 1907
Fifty-two-ton

Clear Lake number 4, a 52-ton Climax, was built in July of 1907 for Clear Lake Lumber Company as construction #872. In his caption on the 1908 glass plate, Kinsey claimed that the train carried 43,462 feet of logs, all from a single tree that measured twelve feet in diameter at the butt. The engine was sold, probably in the early 1920s, to the West Fork Logging Company at Tacoma.

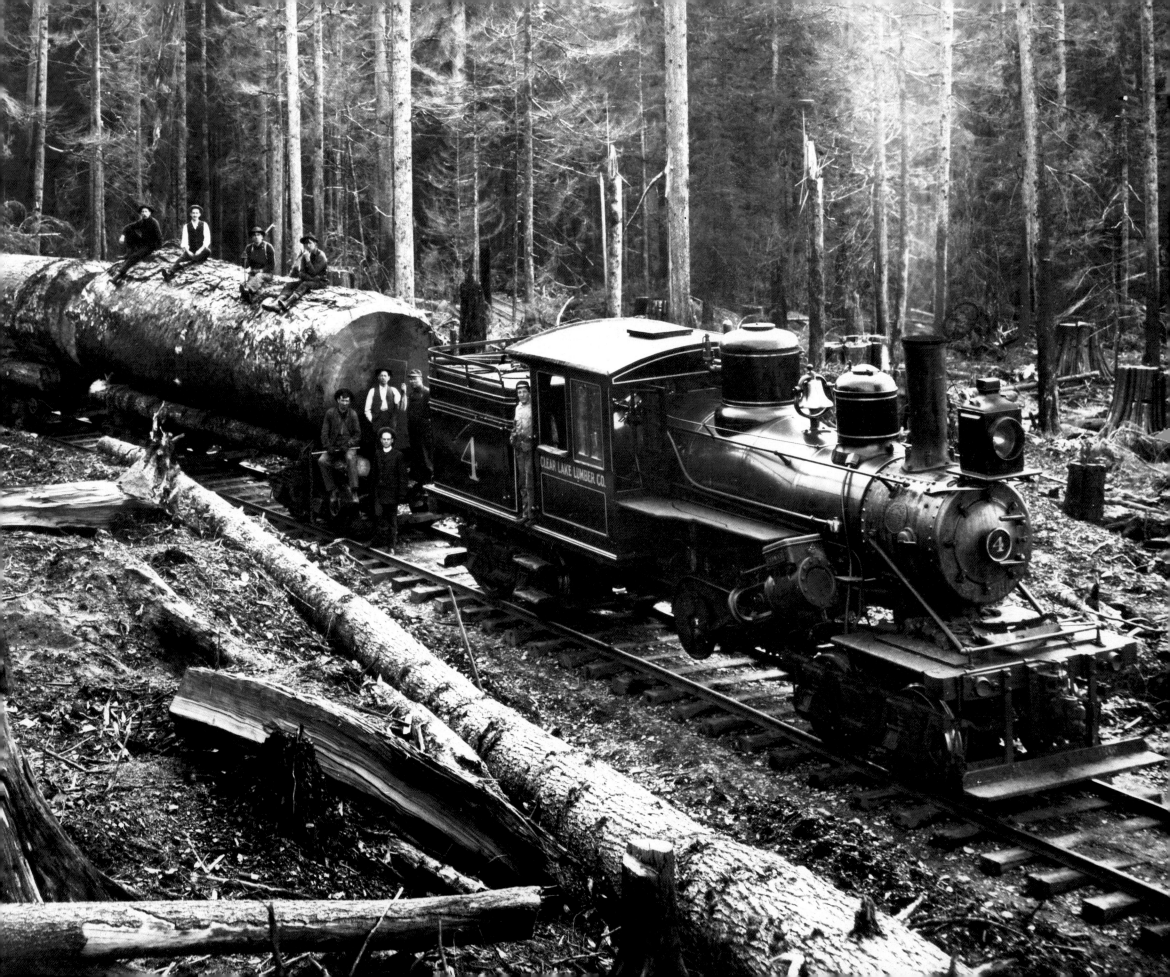

Shay
Lima Locomotive Works, Inc.
#2653 July 1913
Seventy-ton

The Monroe Logging Company was formed in July of 1921 by E. M. Stephens and B. F. Bird, of the Stephens-Bird Lumber & Logging Company at Monroe, but Joseph Irving headed the new company. A tract of something over forty-four hundred acres of timberland was acquired from the Northern Pacific Railroad located north of Monroe in the vicinity of Lake Roesiger. In the spring of 1926 the company acquired another six thousand acres and sixteen miles of railroad with the purchase of the Waite Mill & Timber Company's operation out of Granite Falls.

 Monroe's number 3, a 70-ton Shay, was built by Lima in July of 1913 as their construction #2653, and sold to the Sultan Railway & Timber Company who gave her road number 3. Joseph Irving, also the head of Sultan, transferred this locomotive to Monroe for the opening of their camp at Machias. After twenty-six years of service she was scrapped in 1939, a few years before the company cut out.

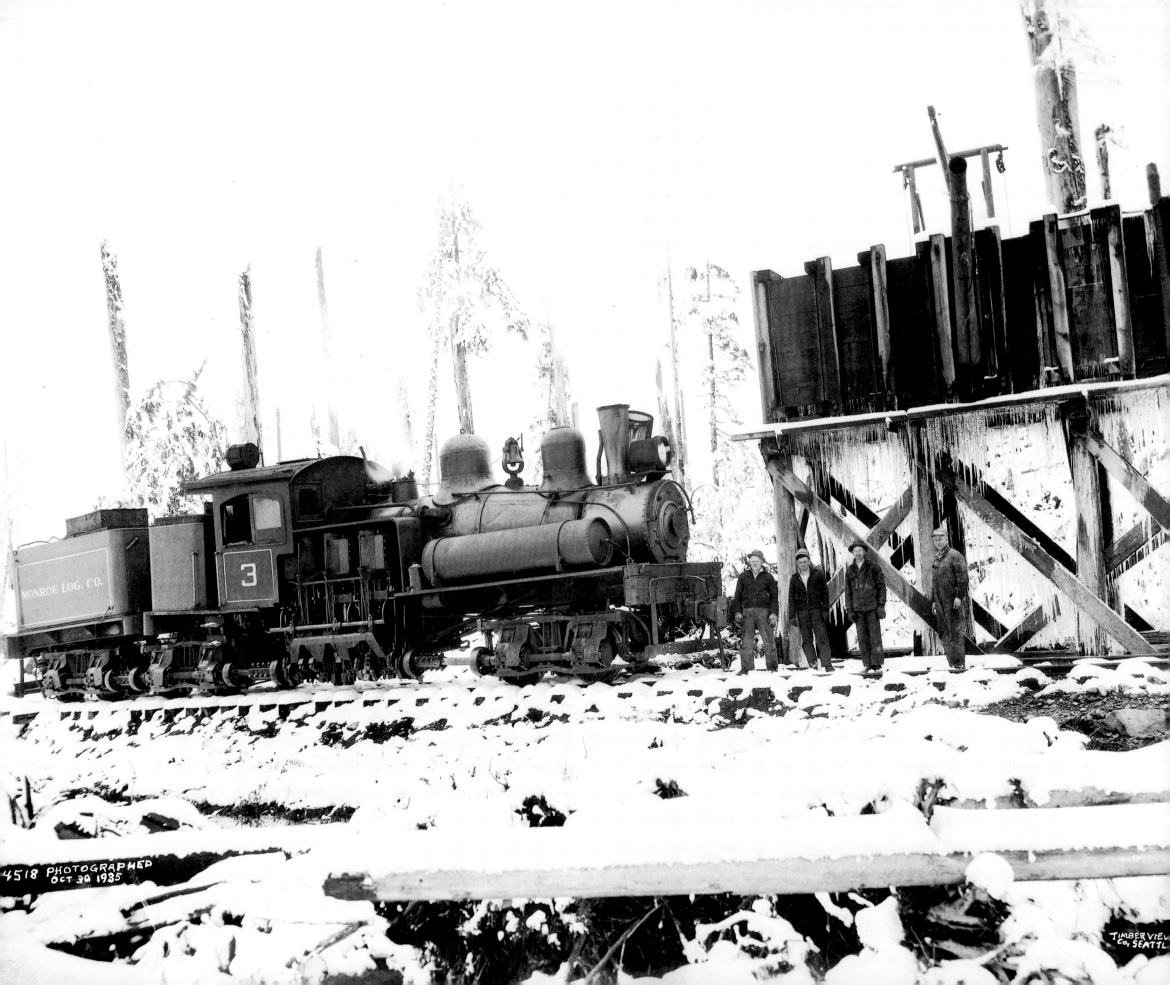

MONROE LOG. CO.

3

4518 PHOTOGRAPHED
OCT 30 1935

TIMBER VIEW
CO. SEATTL

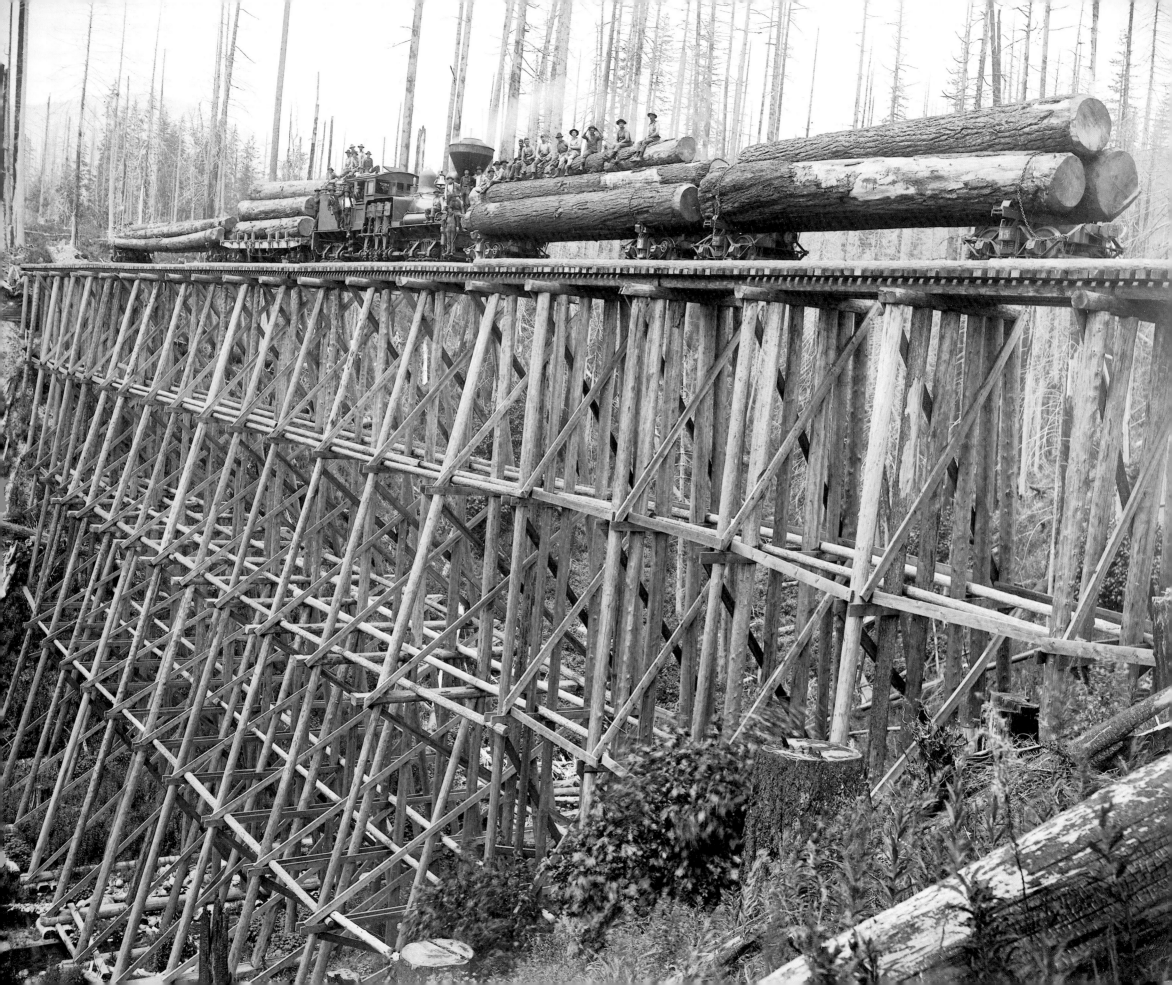

Shay
Lima Locomotive Works, Inc.
Sixty-ton

In the summer of 1916 the Hamilton Logging Company, which had been logging for a decade on the north side of the Skagit River near Hamilton, began construction of the Lyman Pass railroad as an extension of the Puget Sound & Baker River Railroad. The new line ran north through Lyman Pass to the Nooksack River and construction required a bridge over Red Cabin Creek. The structure was designed by Sam Stamm, a logging engineer, who fabricated the bents on the ground and then raised them into an upright position.

This rather unorthodox train, hauled by a Lima Shay, has ventured onto the newly finished trestle, possibly as a test of the structure since the track is not yet connected to the far bank. The locomotive is a 60-ton two-trucker built about 1912. The small turret just ahead of the cab on which the whistle is mounted is unusual on a two-truck machine. This locomotive may have been the Hamilton Logging Company's 2-spot. Positive identification is not feasible, since no known confirming photograph has yet come to light.

Well, I ran speeder, fired locy, second-braked for awhile and I worked in the shops for awhile. That was when I was working at the roundhouse drying sand. They had a big stove, kind of a cone-shaped thing, and you'd build a fire in it and dump wet sand in the top, and the sand would sift down and dry. And then you had to shovel it through a screen so there weren't any rocks in it. Then on the locomotives we had to fill the sand dome, and the sand box on the rear of the engine—so they would have sand to spray on the rails for traction when it was slippery. If you slid the wheels on the track you would create a flat spot on the wheels, which resulted in a thumping noise and vibration as you traveled along.

But about second-braking. Mostly, when you were switching cars you had to stay where you could see the locomotive so you could signal to the engineer, and you had to be able to see the head brakeman at the same time because he was out on the end of the train of cars making a coupling or throwing a switch. Sometimes you had to climb up on moving loads or scramble up on a stump to see. You had to signal to the engineer so he would know how fast to come and when to stop. Standard hand signals. When you wanted him to come towards you, you would rotate your hand this way. When you wanted him to go the other direction you rotated your hand backwards. And then sometimes both hands if you were a long ways off. We could almost talk to the engineer, especially if we had worked together a lot.

And then when we came downhill from camp, we'd come down with up to forty loads to Hamilton, where we made up the train to Similk Bay. We used one of the

larger Shays on this run. It was a grade all the way. Well, with your air brakes, when you draw air off of the cars it sets the brake. You don't increase the pressure on the cars—you draw air off to set the brake. And if you come down a long hill, if you draw too much air off, when you go back to pump up your train line the train would run away because you wouldn't have any brakes. So they had retainers on the line—a little valve—and you had to set them up at the top of the hill, and then when you got back on the level you'd have to knock them down again so the engine could pull the train, because they held a certain amount of the brakes on the cars at all times.

So when you set the retainers up, usually the train was standing still and you'd just go back and turn each valve. The valves were underneath the car so you had to step over the rail to set them up. And then, when you got to the bottom of the hill you moved along with the car and you'd step over the rail—underneath the car, more or less—and take the valves down, and then you'd trot back up to the next car that came by, and so forth. It was dangerous, in a way, because nobody could see you. If the train was on a curve you were just there all by yourself, and the only way they could tell if something happened to you is that they wouldn't be able to pull the train pretty quick because there would be nobody there knocking the retainers down.

<div align="right">

Bill Pulver
Bellingham

</div>

Shay
Lima Locomotive Works, Inc.
#708 June 1902
Forty-ton

English Lumber Company's 1-spot heads a train of big logs in southern Skagit County in 1908. Such large logs were difficult to hold on the trucks because they could easily roll over the usual blocking, so poles were laid alongside to secure them.

The trestle, built up of cribbed logs, was common in the earlier era before the pile driver became an integral part of the logger's equipment. Logs were notched so that they could be held in place without the use of spikes, and they could be easily salvaged when the track was removed.

The 1-spot was built by Lima in June of 1902 as construction #708 and was rated at 40 tons. She worked for English until April of 1920 when they sold her to the Goodro Logging Company who moved her to their operations near Shelton.

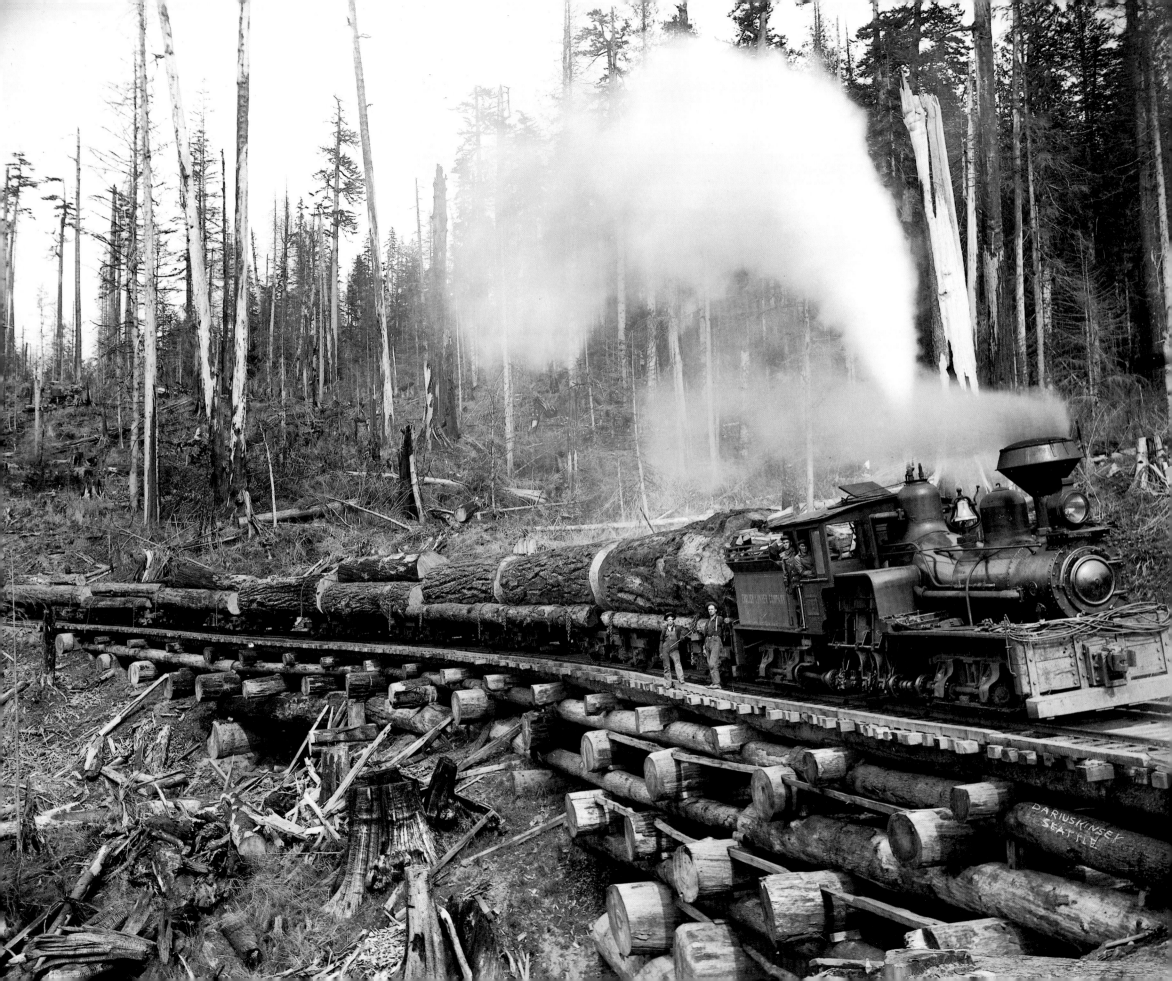

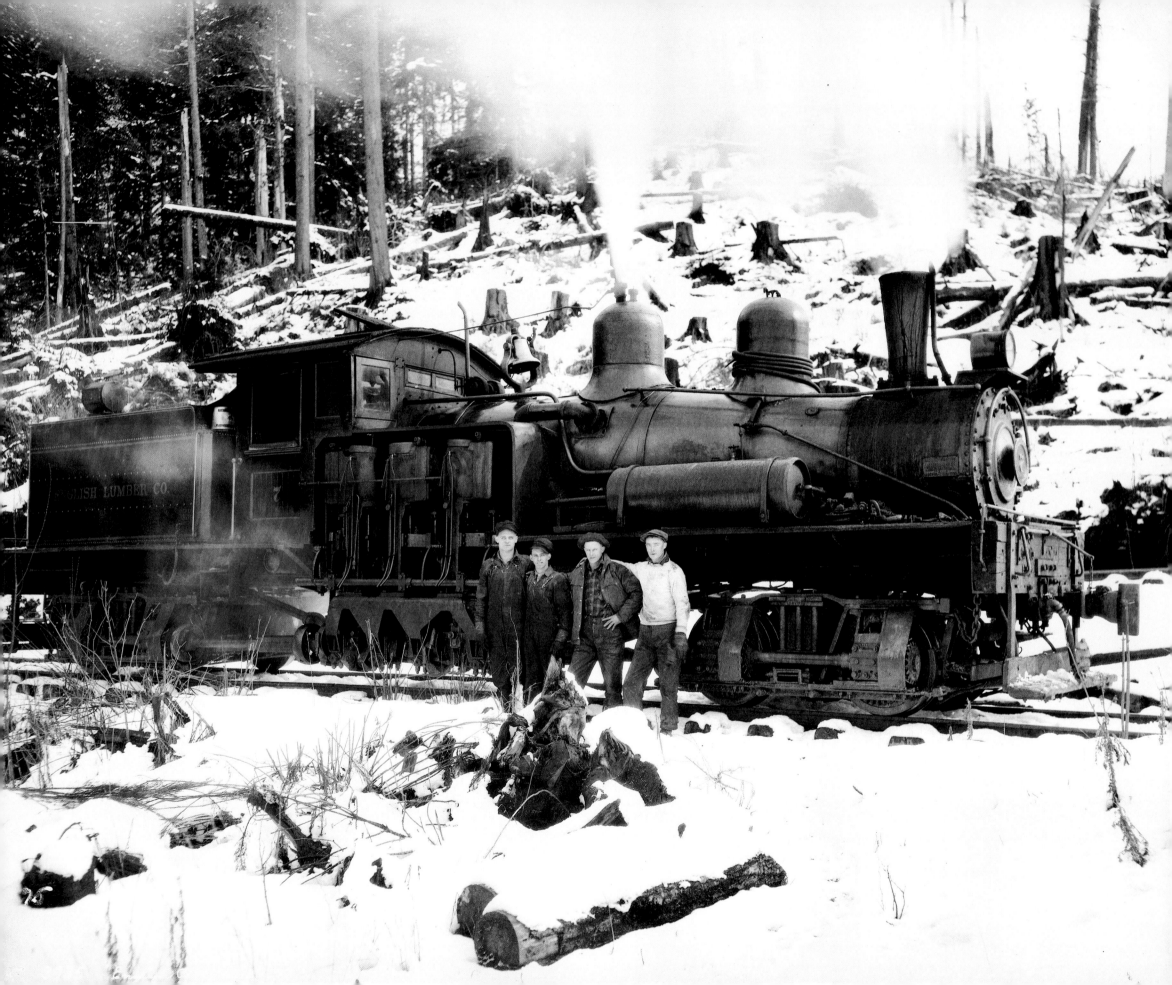

Shay
Lima Locomotive Works, Inc.
#2630 December 1912
Sixty-ton

The English Lumber Company number 7 was a 60-ton two-truck Shay purchased new from Lima late in 1912. Turned out as construction #2630, she was built as a coal burner but English later converted her to oil. Loggers generally preferred two-truck engines which concentrated the weight of the locomotive on the two trucks and avoided maintenance of an extra truck. But sixty tons was about the limit for the lighter rail of the logging railroads, and as engine weight increased the addition of a third truck was required to spread the weight over a greater area and reduce track upkeep. The third truck also added tractive force, although in the lighter three-truck designs there was no added pulling power since the weight per truck was reduced. The number 7 continued to serve the company until she was scrapped in February of 1944.

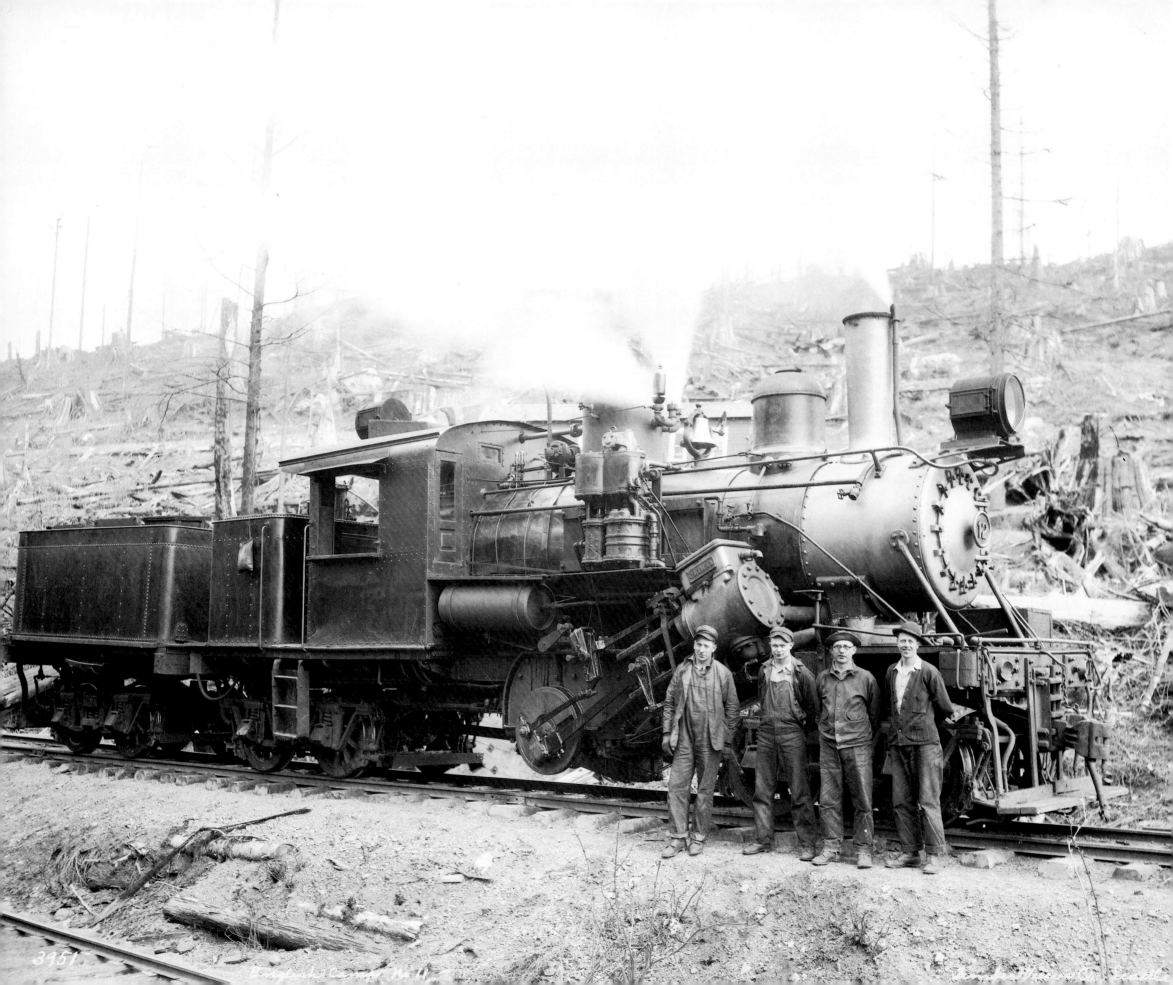

3951

Climax
Climax Manufacturing Company
#1581 May 1920
Ninety-ton

Edward G. English was born in Maine in 1850, not long after his parents arrived from Ireland. He migrated west to Skagit County where, in the 1880s, he became interested in the logging business. Early in 1907 he joined with the Dempsey Lumber Company of Tacoma in the building of the Puget Sound & Baker River Railroad to reach timberlands lying north of the Skagit River, for the Lyman Timber Company in which he held an interest. Further south, under the English Lumber Company title, he logged out of Conway and worked east into the Lake Cavanaugh area. Ultimately, the English Lumber Company operated up to sixty miles of railroad in the drainage east of Pilchuck and north of the lake. "Uncle Ed" died in 1930 at the age of 79. The various interests he helped develop continued for many years.

Locomotive number 12, built by Climax in May of 1920 as construction #1581, was rated at 90 tons. As such, she was the largest standard version of this machine offered to loggers, although one of 100 tons was sold to a British Columbia company. She was originally purchased by Parker-Bell Lumber Company at Pilchuck, who gave her road number 5. Early in 1922 English bought out Parker-Bell, acquiring timberlands and railroad equipment in southern Skagit County. English renumbered the big Climax road number 12. She was still in service when the operation ended in the mid-1940s.

Art Barringer engineer, Lewis Strangland fireman
McGuthrie brakeman

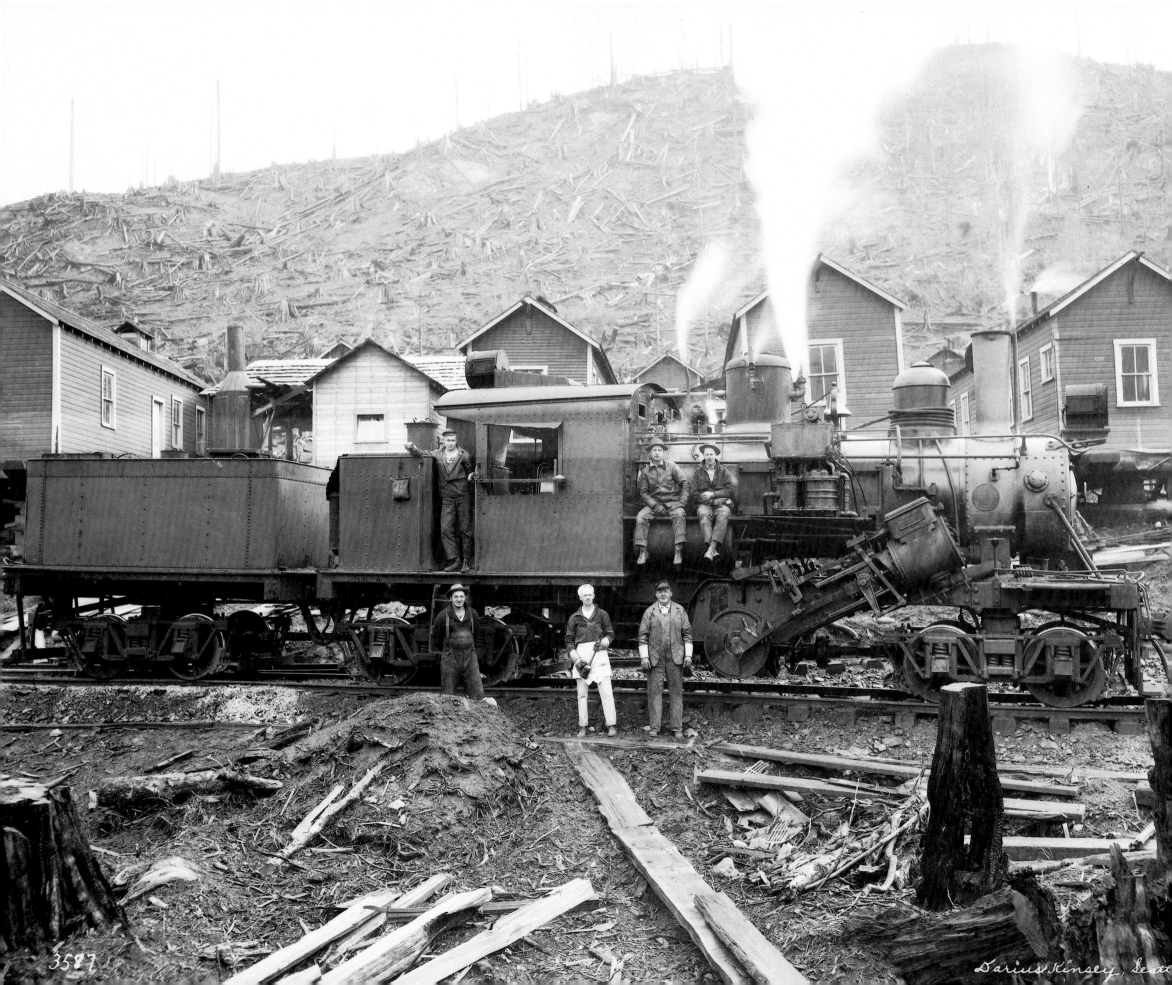

3587 Darius Kinsey, Seat

On hills, where they had air brakes on the cars—you didn't need it on other places—you could set up the air to six or seven pounds and you could pump them up, and you weren't going to run away because there wasn't that grade there. But when you ran on a six or seven percent grade you'd use what they called retainers. And when you set up the brake you would slow down, and when you had slowed down enough, then you could pump them up and these retainers wouldn't let the air exhaust out for a minute or so. So it would hold the brakes and the brake would gradually release, and by the time they released your air would be up to ninety pounds on the train line again. Then, if it picked up a little bit of speed, you had to set the brakes up again. And that's the way you came down a hill.

Well, if you didn't make your application in time you could run away, and many of them did run away. Or some of them would lose too much air—if they drew it down to sixty—and then they'd pump it up and maybe they didn't wait. If they hadn't slowed up enough maybe they would only get it back up to eighty pounds, but it would show ninety pounds on the gauge. They'd make another application and they'd probably get it to slow down again, but would end up with sixty or sixty-five pounds. And then they'd start pumping it up again too soon or make an application too soon, and by that time they would keep losing air and it would run away. You had to keep the air up pretty close to ninety pounds. You have to be a little experienced on that.

Buster Corrigan
Hoquiam

English number 12
in Camp 11

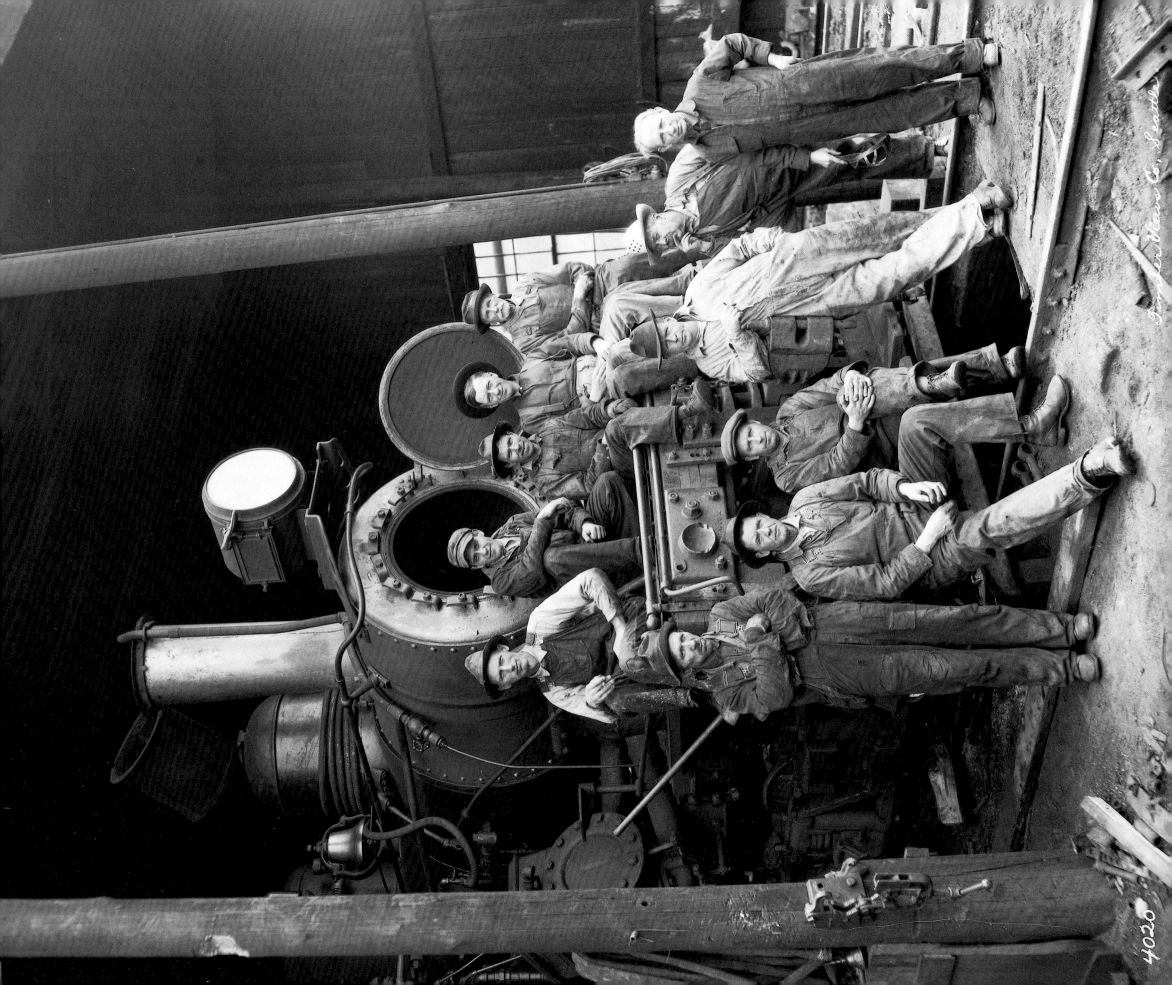

That's at the old shop, at headquarters. It was just up out of Conway, towards McMurray. It was up on the hill but everything is gone now. They had a great big old shake roundhouse and shop and car shop, and the whole business.

That old guy there was the superintendent's brother, Patrick O'Hearn [second from right, top row]. The story was that he sent away for a mail-order bride one time. He had shoes about that long, with big bunion things on them, and he had an awful look to him. So he took her to a show when they first met, and she excused herself to go to the powder room and never did come back.

So that's the shop crew, but I didn't know many of them. They are either washing boiler or something, because the front end is open.

Rex Everett
Burlington

Darius Kinsey's finest group portrait may well have been this bunch of railroad men posing with the number 12 — a masterpiece on film by an extraordinary photographer at the peak of his creative intuition.

DB and RP

English number 12
near Conway, ca. 1930

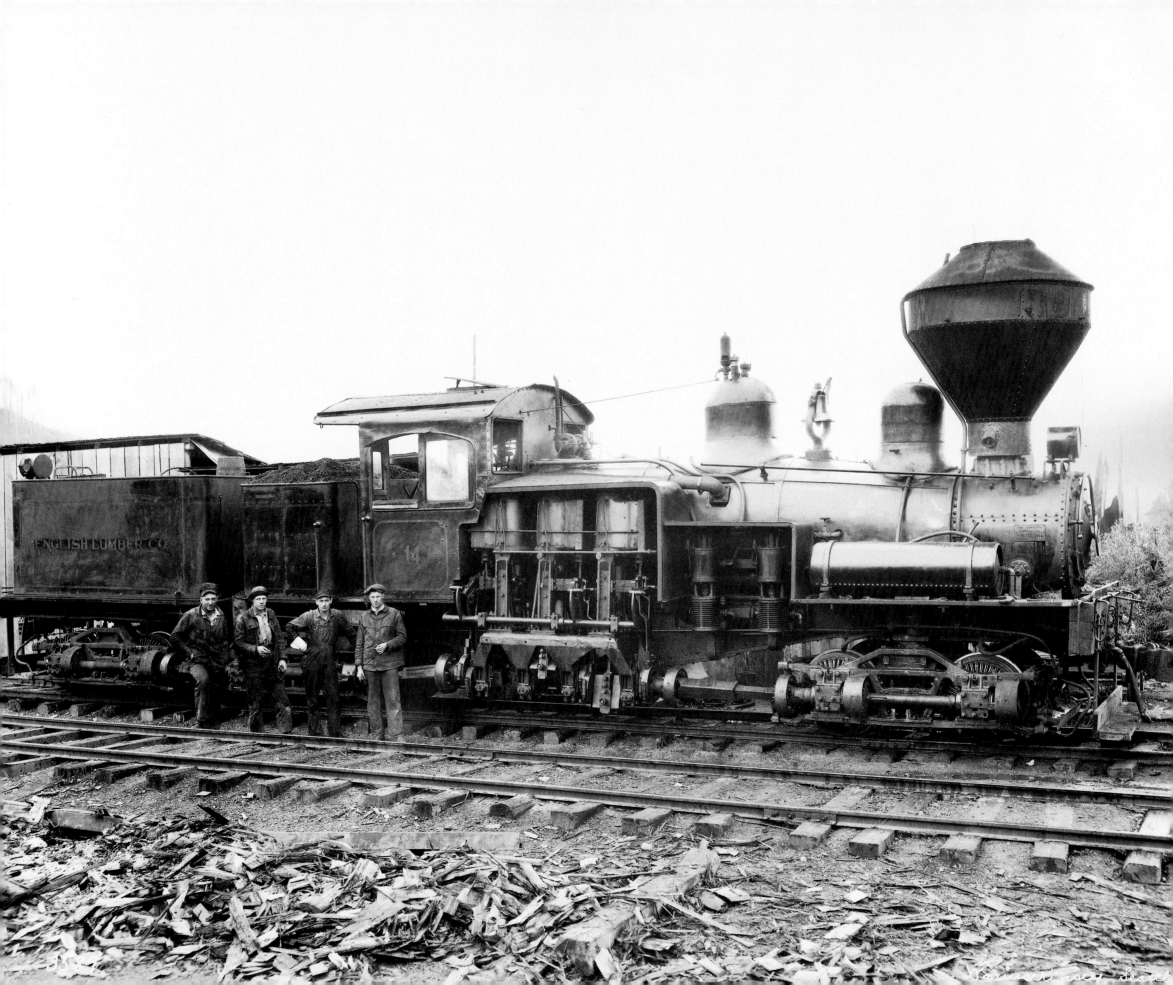

Shay
Lima Locomotive Works, Inc.
#2704 February 1914
Seventy-ton

Lima construction #2704 was something of a nomad. The 70-ton Shay was built in February of 1914 for the Pine Belt Lumber Company of Fort Towson, Oklahoma, who gave her road number 7. After serving Pine Belt for several years, she was sold to the Henderson Land & Lumber Company of Fox, Alabama. With the end of that company, she moved on to Alabama's Birmingham Rail & Locomotive Company. She was rather a late-comer to the English Lumber Company, purchased at a time when the market for steam locomotives was fast diminishing. English renumbered her 14 and equipped her with the Radley & Hunter stack, which the company preferred.

 Built as a coal burner, as with the wood burning locomotives she was prone to spray hot coals generously over the right of way, creating a considerable fire hazard in the summer. A variety of stacks incorporating spark arresters was available to loggers, and since they tended to impede the drafting of the locomotive, stacks were often removed in the winter when the fire danger was low.

 In June of 1945, English passed this Shay along to the Puget Sound Pulp & Timber Company.

Art Barringer engineer, Jack Kanope fireman,
"Gig" Sandy brakeman (far right)

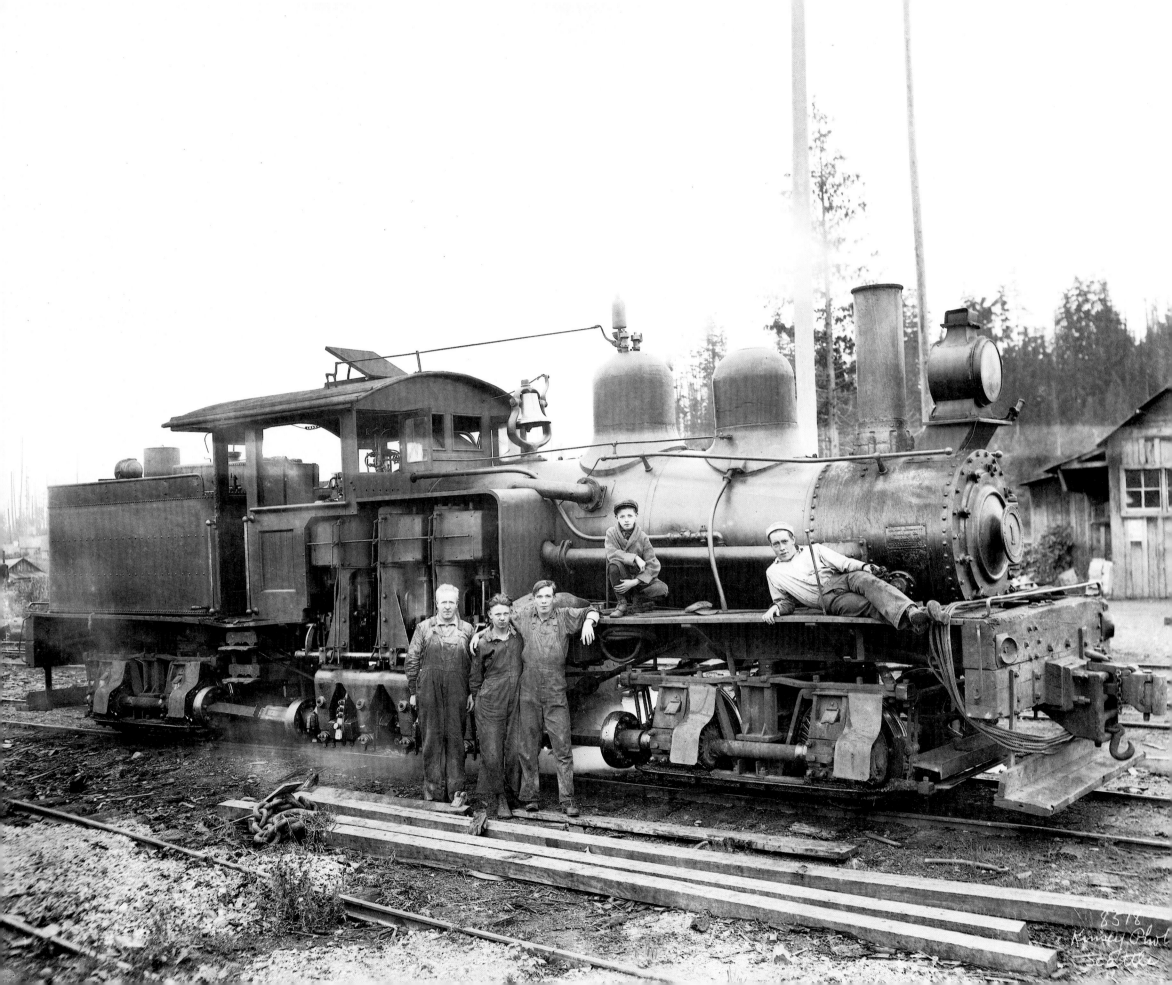

Shay
Lima Locomotive Works, Inc.
#2265 January 1910
Fifty-ton

The Florence Logging Company, a subsidiary of the Port Blakely Mill Company, was formed in 1910 to log Port Blakely's Snohomish County timber tracts. Florence's original site was a four-mile spur off the railroad of the English Lumber Company, and the trains were hauled to the dump by the Skagit Valley Railroad. To handle the loads on the spur, Florence acquired Lima Shay #2265, assigning her road number 1.

 As the various tracts belonging to the mill were logged out, Florence's locations changed. In 1917 logging was carried on near Silvana, on the coast north of Everett, and in 1921 Florence was operating a camp near Monroe, with a second at Maltby. Then in 1923 the Siler Logging Company built a new line through the area, making use of some of the Florence grades and taking over the Shay.

I used to always get a kick out of the locomotives. When they brought the logs down off the mountain, they put a locomotive in front and one in back, you know. And the engineer used to let me ride in the cab and I can just hear the racket when they put air in the cars. Boy, it would make a racket. I sure got a kick out of that.

Darius Kinsey, Jr.

Darius Kinsey, Jr. kneeling
on the running board, ca. 1919

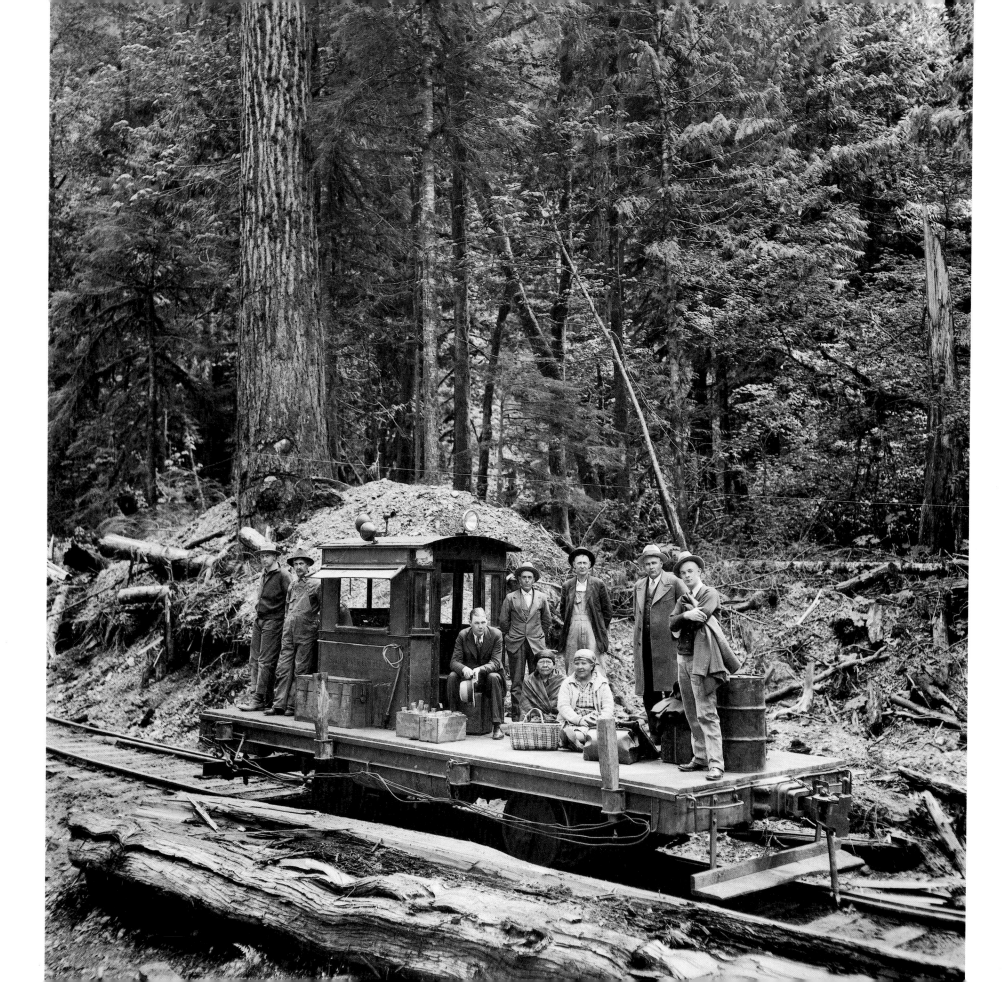

This Sauk River Lumber Company M.A.C. speeder was a popular design with loggers. It was the product of the Motor Appliance Corporation, a subsidiary of the Skagit Steel & Iron Works of Sedro Woolley. Variations of the M.A.C. speeder could be found on most logging railroads in the 1920s and 1930s.

Here, transportation is provided for VIPs visiting the logging operations, and the two Skagit Indian women who were probably going into the woods to pick berries.

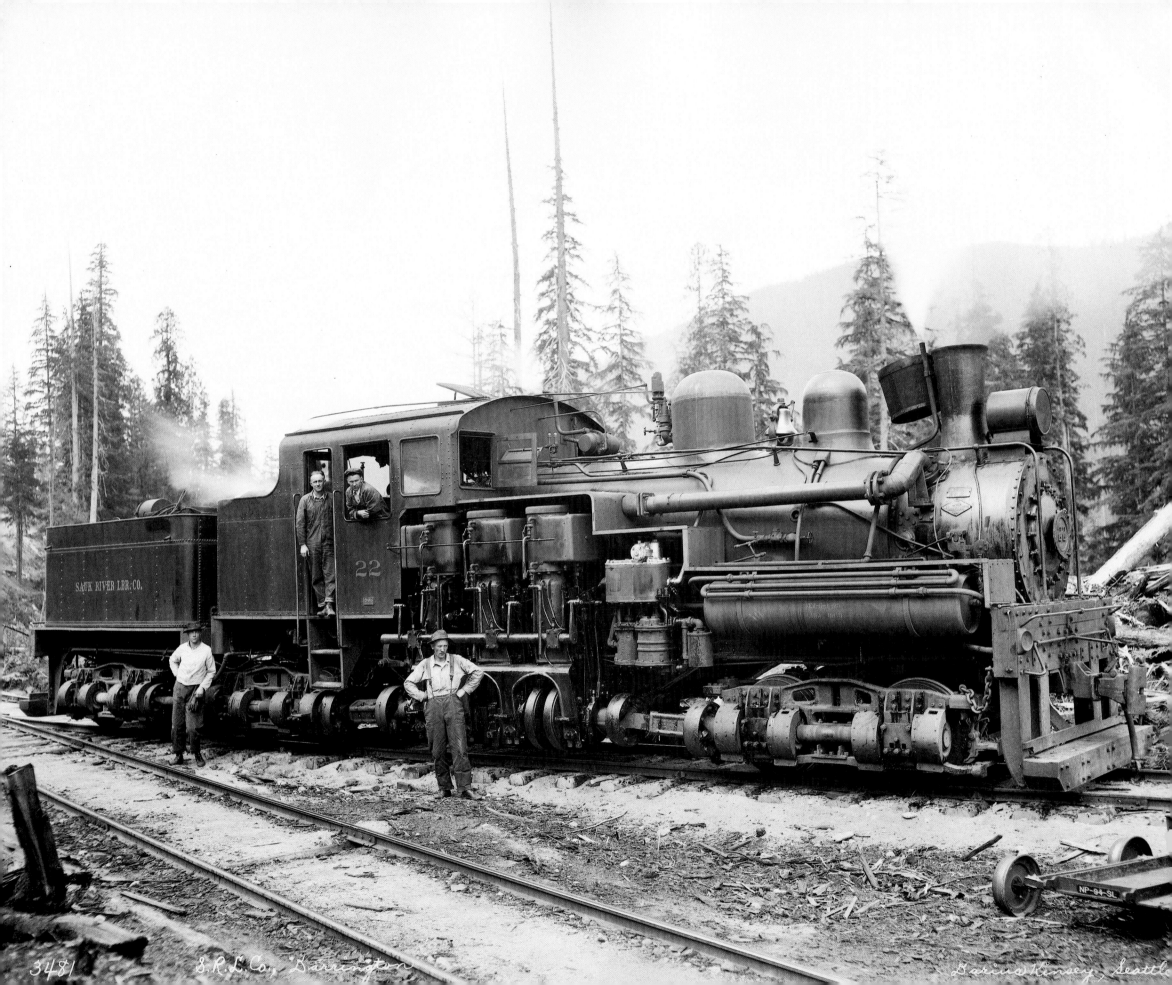

SAUK RIVER LBR. CO.

22

3481 S.R.L.Co., Darrington Darius Kinsey, Seattle

Shay
Lima Locomotive Works, Inc.
#3282 June 1925
Ninety-ton

The Sauk River Lumber Company was incorporated in April of 1922 to log four hundred million feet of timber acquired from the United States Lumber Company, in the Sauk River Valley in eastern Skagit County. Another two hundred thirty-five million feet were acquired from the Forest Service in July, by which time ten miles of railroad had been laid into the tract. Altogether the company held rights to one hundred seventy-five thousand acres of timberland for which they paid $2 per thousand feet for the fir and $2.75 per thousand for the cedar. It was the early 1950s before the last of the timber had been harvested.

Locomotive number 22 was a 90-ton Shay, Lima #3282, bought new in mid-1925. This machine was the immediate predecessor of Lima's final Shay, the Pacific Coast model. Sauk River's number 22 was later sold to the Victoria Lumber & Manufacturing Company at Chemainus on Vancouver Island, where it was given road number 12. Eventually it ended its service at Chemainus as road number 1012 for MacMillan & Bloedel.

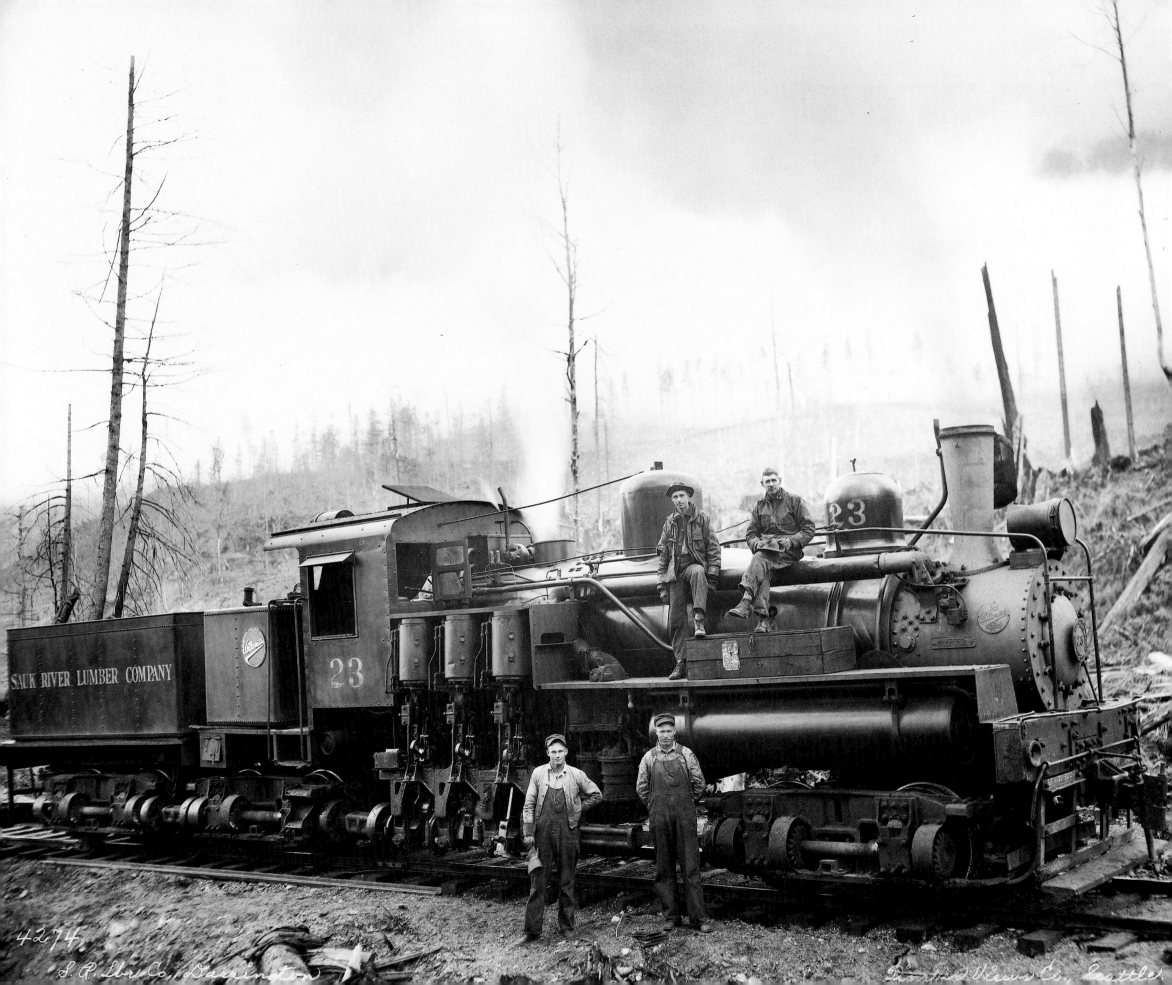

SAUK RIVER LUMBER COMPANY

23

23

4274,

Willamette geared engine (Shay type)
Willamette Iron & Steel Works
#22 March 1926
Seventy-ton

The Sauk River Lumber Company road number 23 was a 70-ton Willamette geared engine delivered new on March 30, 1926. It was the twenty-second locomotive built by the Willamette Iron & Steel Works at Portland, Oregon, and incorporated the most advanced technology of the locomotive art to that time.

The steam locomotive was a comparatively simple machine to maintain — the camp blacksmith with the help of the engine crews could handle much of the repair and maintenance in the woods. But major work, such as replacing the boiler, straightening bent frames and casting replacement parts had to be done by commercial shops. In some cases the shops of the largest railroads provided this service, but a few concerns specialized in heavy repairs for the locomotives of the logging industry. One such company was the Willamette Iron & Steel Works which had built boilers and engines for steamships and had produced an extensive line of steam donkeys. When loggers turned to them for major work on locomotives, the experience they gained in rebuilding Shays revealed weak spots in the design and they devised a number of improvements. With the end of their shipbuilding business after World War I, they decided to build a Shay-type locomotive of their own design.

continued p. 101

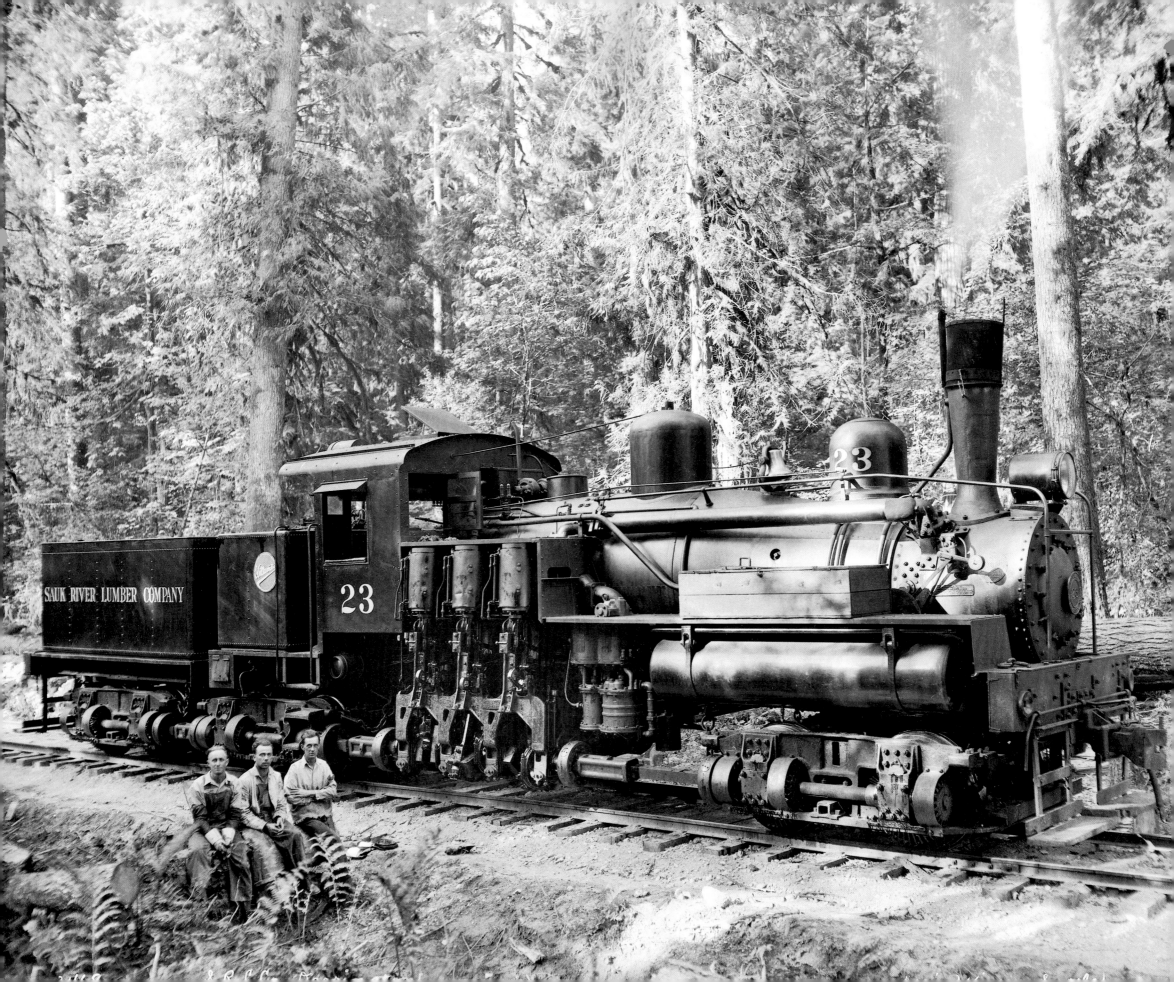

Willamette's ideal machine incorporated all the latest developments and was a standard type that could be serviced with one line of parts. Their locomotive had heavier cast steel trucks and deep girder frames in addition to more efficient Walschaerts valve gear. Many of the areas that required frequent servicing were made more accessible.

Not long after the introduction of their new locomotive, Willamette added two improvements already used by the builders of rod engines. The first was the superheater, which increased the power derived from steam through greater expansion. Previously, steam had been piped to the engines directly from the steam dome atop the boiler, where it was concentrated above the water level. This steam had a high water content and at times water might be drawn out with the steam. Known as *saturated* engines, these locomotives were more commonly called "slobberstacks" by their crews. But the superheater carried the steam forward to the smokebox where it was superheated before being piped back to the cylinders. This procedure created very dry steam which had greater expansion and reduced the water consumption of the system. The second improvement was the introduction of highly efficient piston valves that required less maintenance. The combination of superheated steam and piston valves brought the steam locomotive to its greatest potential.

Willamette Iron & Steel Works built only thirty-three engines, but their impact on the industry was profound. Competition from these fine locomotives forced Lima to design and produce their Pacific Coast model with similar improvements in an effort to recapture the market.

Mikado 2-8-2
The Baldwin Locomotive Works
#37539 March 1913
Eighty-seven tons

Simple articulated 2-6-6-2T
The Baldwin Locomotive Works
#60811 May 1929
One hundred thirty-one tons

Shay
Lima Locomotive Works, Inc.
#3090 August 1920
Eighty-ton

Mallet 2-6-6-2
The Baldwin Locomotive Works
#61904 May 1936
One hundred forty-six tons

South of Tacoma, Vail was the headquarters camp and shop for Weyerhaeuser Timber Company's Thurston County logging operation, first known as the Skookumchuck operation. It began in 1928 with a twenty-seven-mile mainline running north from the Vail area to South Bay near Olympia. Numerous spurs south of Vail fed logs from southern Thurston County and northern Lewis County onto the mainline to be hauled to the log dump at South Bay. From there the logs were towed by raft up the Sound to the Weyerhaeuser mill at Everett. The Vail operation started with equipment moved in from Weyerhaeuser's subsidiary, Cherry Valley Logging Company, which had just logged out, as well as some equipment from subsidiary Clark County Timber Company.

This 1938 lineup of the Weyerhaeuser engines (see pp. 104–105) presents a good cross section of locomotives used by the larger logging operations of the time. The Mallets and the geared engines worked on the spurs, or feeder lines, while the road engines, which were less powerful but much faster, handled the mainline trip to the log dump.

Heading the seven locomotives in the lineup is road number 103, an 87-ton Baldwin Mikado rod engine turned out for Weyerhaeuser's Twin Falls Logging Company in March of 1913. Numbered 101 by Twin Falls, she retained that number when Clark County Timber Company succeeded the Twin Falls operation at Vancouver, Washington. Weyerhaeuser renumbered her 103 when they brought her north for the mainline haul to South Bay. In 1943 she was sold to the Red River Lumber Company of Westwood, California, and shortly after that to Fruit Growers Supply Company, where she served for another decade before being scrapped in 1956.

The next locomotive in line is road number 111 which Weyerhaeuser acquired new from Baldwin in May of 1929 to operate on the spur lines south of Vail. It didn't require a tender because it had a fuel bunker directly behind the cab and split tanks around the boiler; the side tanks carried water and also provided additional weight for traction. This 131-ton locomotive was in effect two engines in one. It had two identically-sized cylinders and two sets of engines that were articulated, or jointed, that enabled the locomotive to negotiate the sharp curves on the spur lines. It was thus known as a *simple* locomotive, piping full steam pressure to both sets of engines. Later sold to Canadian Forest Products at Englewood on Vancouver Island, it continued to operate well into the 1950s.

Next is Weyerhaeuser's three-truck Shay, road number 2, which came from Cherry Valley Logging Company, also to work the spurs south of Vail. This slow but

Mallet 2-6-6-2T
The Baldwin Locomotive Works
#60561 August 1928
One hundred eleven tons

Mikado 2-8-2
The Baldwin Locomotive Works
#39787 May 1913
Eighty-seven tons

Shay 3-PC-13
Lima Locomotive Works, Inc.
#3316 February 1928
Ninety-ton

powerful locomotive, built by Lima in August of 1920, weighed 80 tons and was transferred to subsidiary White River Lumber Company at Enumclaw before being scrapped in 1943.

The largest locomotive at Vail was road number 120, a 146-ton Mallet purchased new for the operation from Baldwin in May of 1936. Also an articulated locomotive, but unlike the 111, the 120 carried a separate tender for oil and water and was a *compound* locomotive. She used her steam twice: to power a smaller set of high-pressure cylinders, then reused through a set of larger low-pressure cylinders. The end result was a locomotive more efficient than the simple 111, but slower. Weyerhaeuser's 120 worked primarily as the night train from Vail to Camp 2, but by the mid-1940s she was working on the Chehalis Western Railway, the line that ran from Camp McDonald, west of Chehalis, to the dump at South Bay. She was transferred to Weyerhaeuser's operation at Longview and later sold to Rayonier, Inc. out of Grays Harbor. She served at Hoquiam until the early 1960s when she was bumped by the diesels.

The fifth locomotive in line and the only one still in existence is Weyerhaeuser's road number 110, a tank Mallet similar in size and configuration to the 111. Purchased new for the Vail operation in August of 1928, she was rated at 111 tons. When Weyerhaeuser dieselized Vail in the late 1940s, the 110 was sold to Rayonier, Inc. where she was also bumped by diesels. She finally wound up at Heber City, Utah, with the Heber Creeper operation, where she is presently stored in a partially disassembled condition.

Vail's road number 101, pretty much identical to the 103, is next. Turned out by Baldwin in May of 1913, she originally served Weyerhaeuser's subsidiary Cherry Valley Logging Company near Stillwater. At Vail she was rotated with her counter-part as the road engine to the log dump.

The last locomotive is road number 5, a Pacific Coast Shay purchased new for the Vail operation in 1928. Weyerhaeuser later sold her to British Columbia Forest Products on Vancouver Island where she operated until 1959, when she was scrapped.

Weyerhaeuser still operates the railroad from Vail to the South Bay log dump, but diesels now handle all the log hauling chores and the spur lines have been converted to truck roads. Although the living quarters at Vail are gone, the same shop buildings and engine house remain, now providing maintenance limited to logging equipment and trucks.

Peter J. Replinger
Shelton, Washington

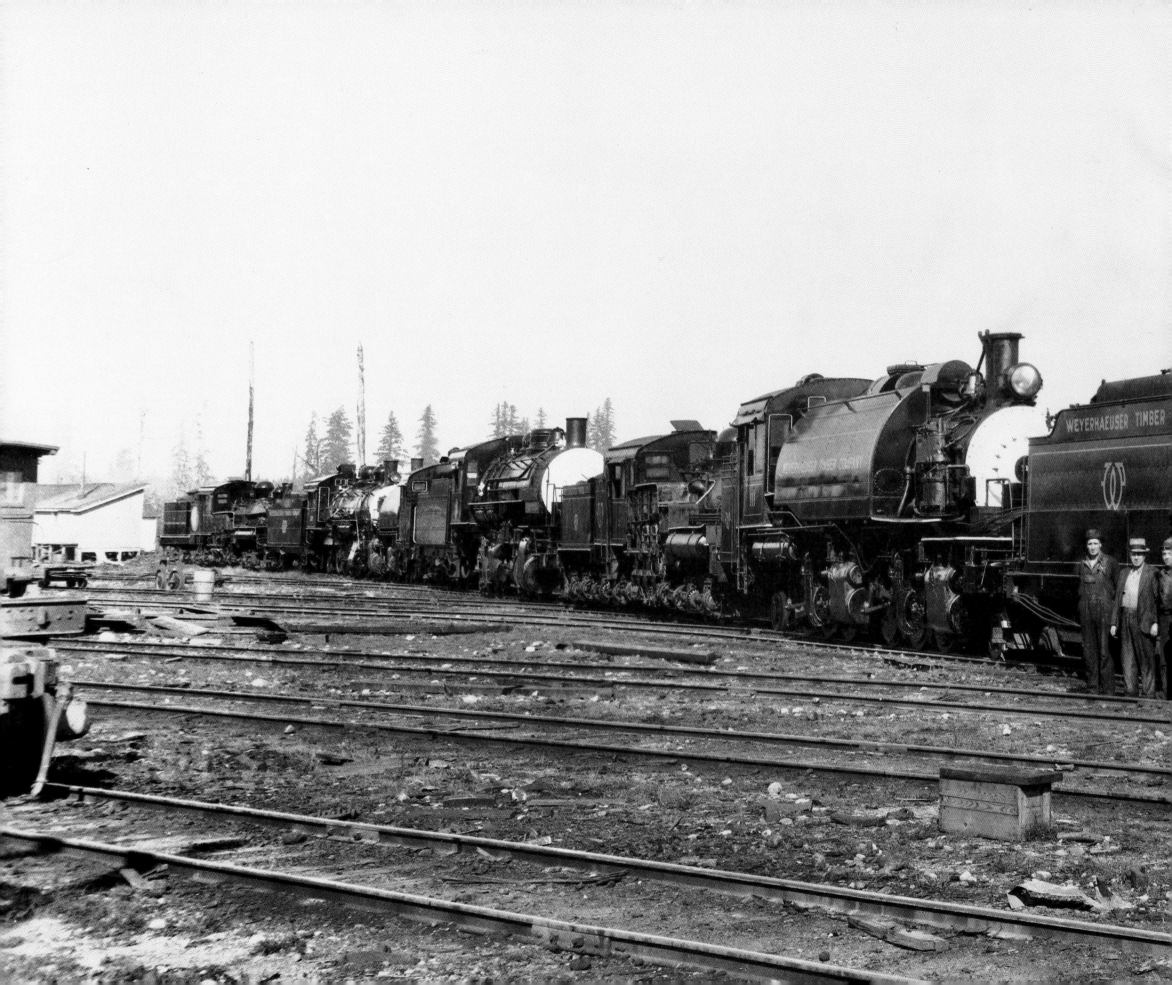

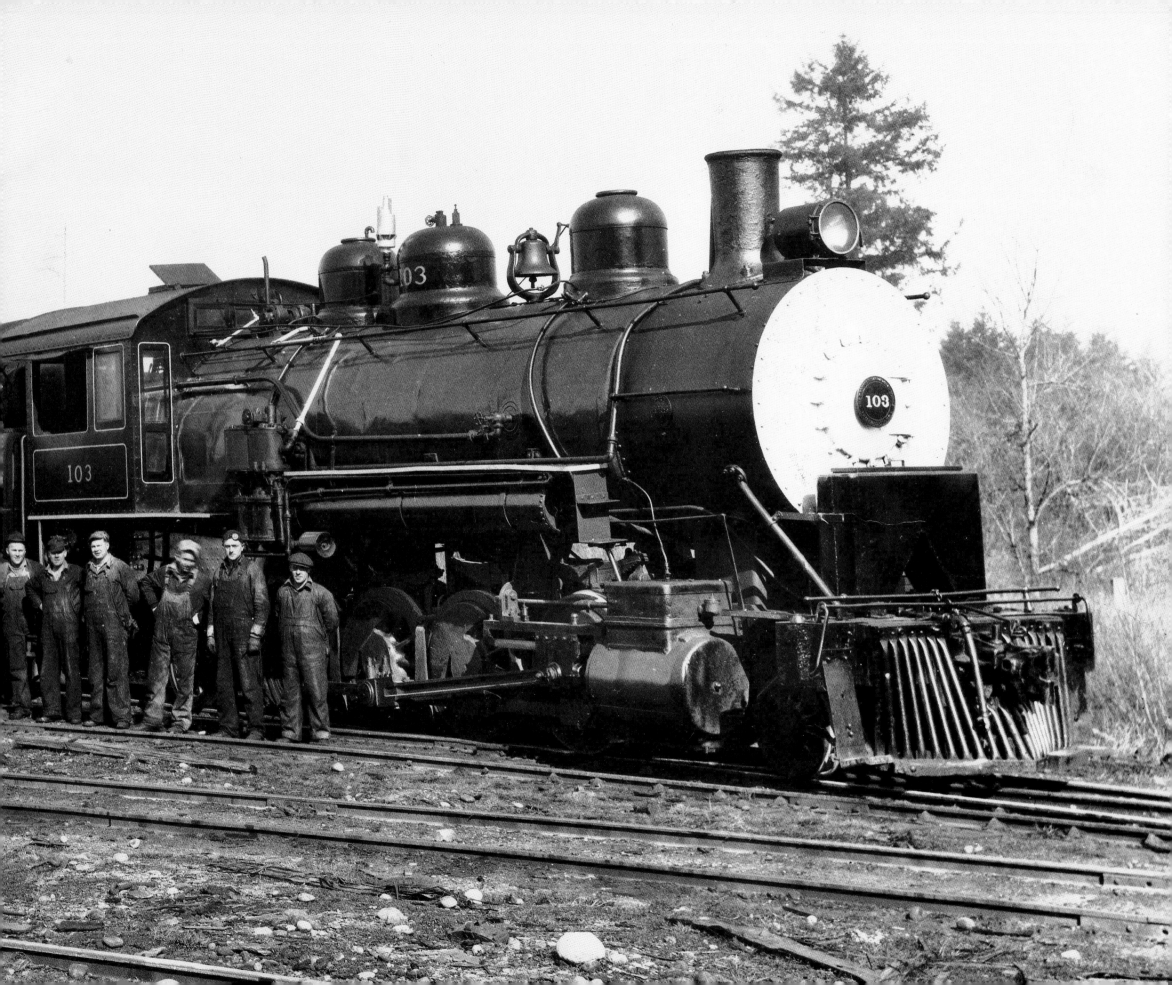

Mikado 2-8-2
The Baldwin Locomotive Works
#57705 March 1924
Seventy-six tons

The Siler Logging Company was one of several Weyerhaeuser Timber Company subsidiaries. It was incorporated in September of 1923 to log a tract of ten thousand acres of timber in the vicinity of Duval, east of Seattle in King County. Some twenty-two miles of railroad was laid, running north to a dump site on the Snohomish River near Cathcart. With the end of Siler's operations in the summer of 1936, the equipment was transferred to the big Weyerhaeuser camp at Vail.

 The 3-spot was a Baldwin Mike turned out in 1924 as construction #57705. She heads a train of thirty-two loaded log cars on a one percent adverse grade. A helper engine is cut in at the rear. With her transfer to Vail, she was renumbered 102.

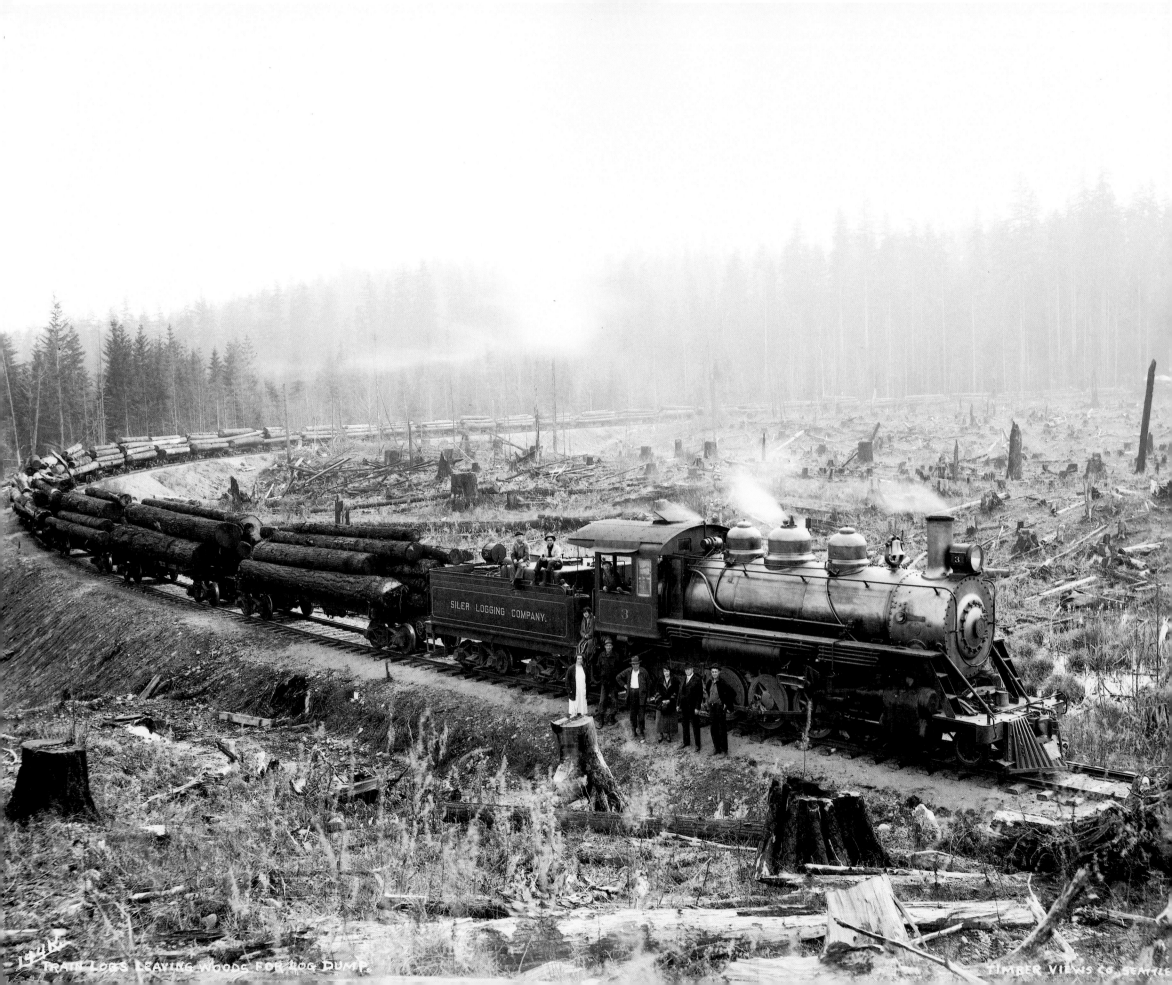

SILER LOGGING COMPANY.

TRAIN LOGS LEAVING WOODS FOR LOG DUMP.

TIMBER VIEWS CO. SEATTLE

Mikado 2-8-2
The Baldwin Locomotive Works
#39787 May 1913
Eighty-seven tons

The Cherry Valley Timber Company was a Weyerhaeuser subsidiary operating east of Seattle near Stillwater. Incorporated as the Cherry Valley Logging Company in September of 1920, the title was changed to Cherry Valley Timber Company in 1912. In August of 1916 it was changed back to the original name.

In its heyday the company used six locomotives on some forty-five miles of track. The railroad was chartered as the Cherry Valley Railway. With the end of logging at Stillwater in the late 1920s, the Cherry Valley equipment was sent south to Weyerhaeuser's new headquarters camp at Vail.

Locomotive 101 was a 2-8-2 Mikado built by Baldwin in 1913 as construction #39787. With 48-inch drivers and 20½ x 28-inch cylinders, she was among the larger Mikes so popular with loggers for mainline use. She retained her road number at Vail, becoming the second 101 there.

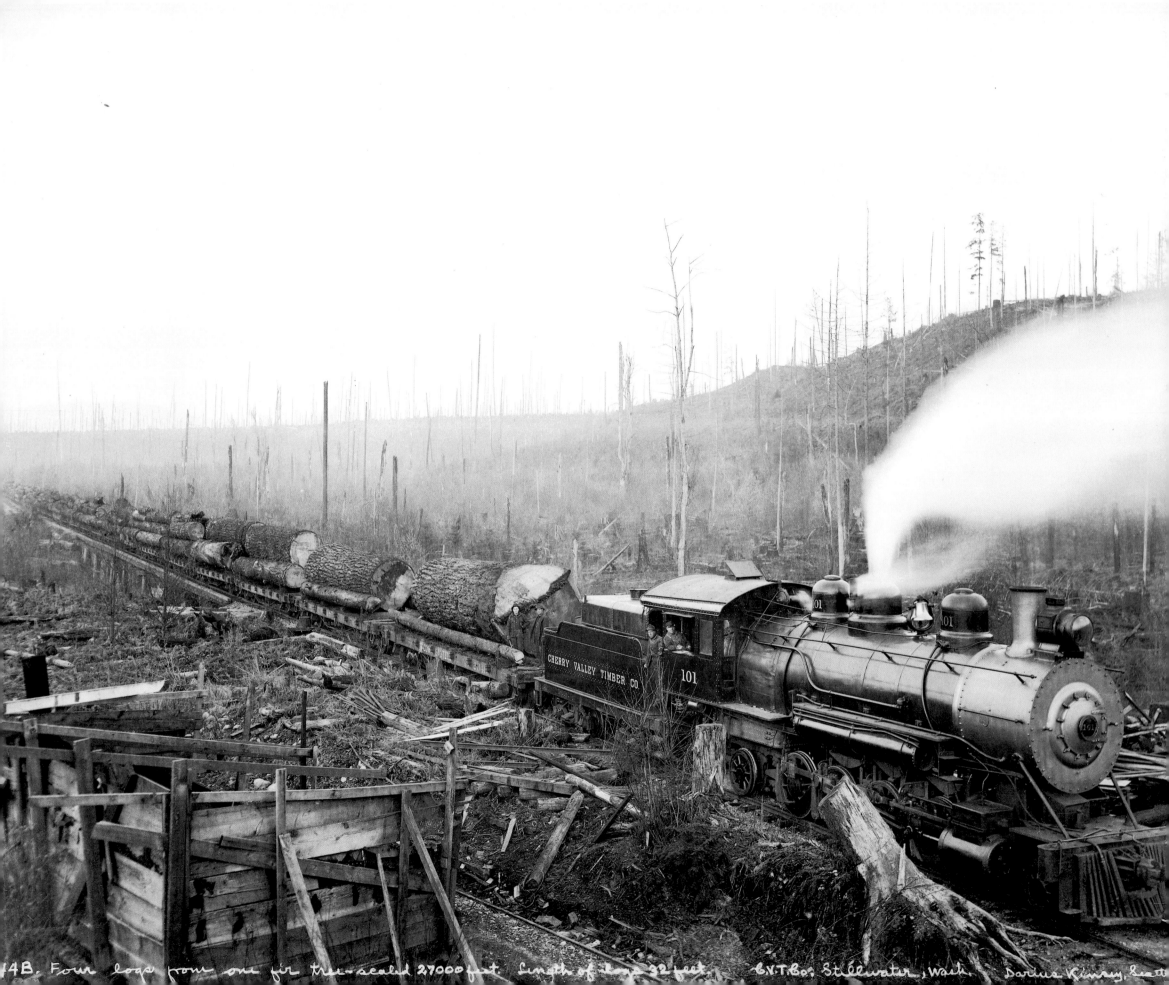

14B. Four logs from one fir tree—scaled 27000 feet. Length of logs 32 feet. C.V.T.Co. Stillwater, Wash. Darius Kinsey Seattle

One day Dave Skagen and I were riding with Buster Corrigan, and we noted how experienced he was as far as ease of operation. Us younger fellows really had to think to do the things he was doing, really had to concentrate. But he was just sitting there talking, in a very relaxed mood, with his legs crossed. Most engineers who ran steam locomotives would wear gloves, but Buster didn't. He had a rag there and kept wiping his hands off. Real clean type, you know. So he'd be sitting there talking and he'd set a little air on the train, and then kick off the air, and be talking to us like there's nothing to it, see. But at the same time, that train was going at the same speed, the same perfect speed down this grade with him sitting there talking to us. Like I say, it takes an old hand because he didn't even have to think to do it.

So we came to this downgrade—it seemed like a pretty steep grade—where we had to stop and take on water. The downgrades on a logging railroad are set so they're favorable to the loads, so less grade going up but steeper going down. You

have to spot the tank and line it up within inches or you'll miss the water filler. If you overrun the thing, you can't back up. But anyway, he just pulled down to a perfect stop just like he did it every day, which I guess he did.

Another time when Dave and I were riding with Buster, we were climbing this grade. The crew must have thought we were nuts because we were standing on top of the water tender with our heads right over the top of the cab, the smoke flying in our faces, so we could hear the exhaust. We asked old Buster "Hey, what does this thing sound like if you put it in simple?" That's where you put the live steam into the low-pressure cylinder. If you were starting a real heavy train you'd use it, or if you got in a pinch where you're barely moving, or almost hung up on a hill, for example. So Buster turned on the simpling valve so we could hear it. Boy, did that thing ever come alive. The exhaust got louder and you could really feel the power of the thing. He didn't need it at the time because the grade wasn't quite that steep. He just did it to show us.

Pete Replinger
Shelton

Everyone out there was a character. I don't know why it was, but you found more diversified personalities in a logging outfit, I think, than anywhere else.

We had one guy come up and work the railroad for a couple of weeks when the brakeman was off. This guy had been a brakeman down there in California. He looked like a chipmunk with a chaw on each side — about half a can on each side — and I thought, "Oh God," because the brakeman he replaced was a snoose-chewer with a shotgun spatter. And this new guy was going to be the same way, I thought. Well, we had the windows open only about two or three inches because it was December and it was cold, and damned if he couldn't spit right through there without hitting either side of the window. I got the biggest kick out of that guy.

Finally, one day he says, "Well, I'm leaving." I said, "What happened?" "Oh," he says, "I'm getting to like the grub too much. The hotcakes are getting too round." It was time for him to leave, and I never have seen him since.

Jim Gertz
Port Angeles

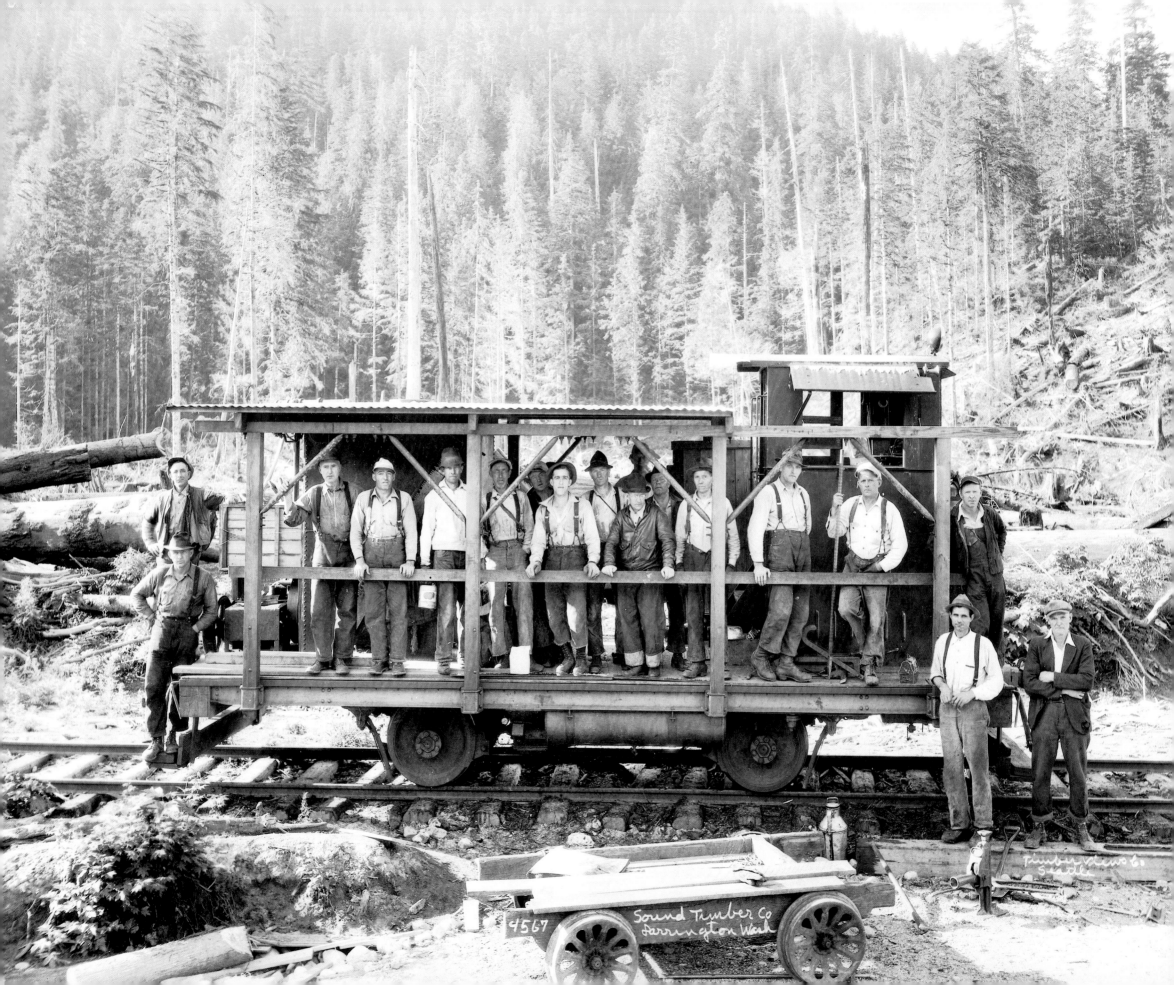

4567 Sound Timber Co
 Darrington Wash

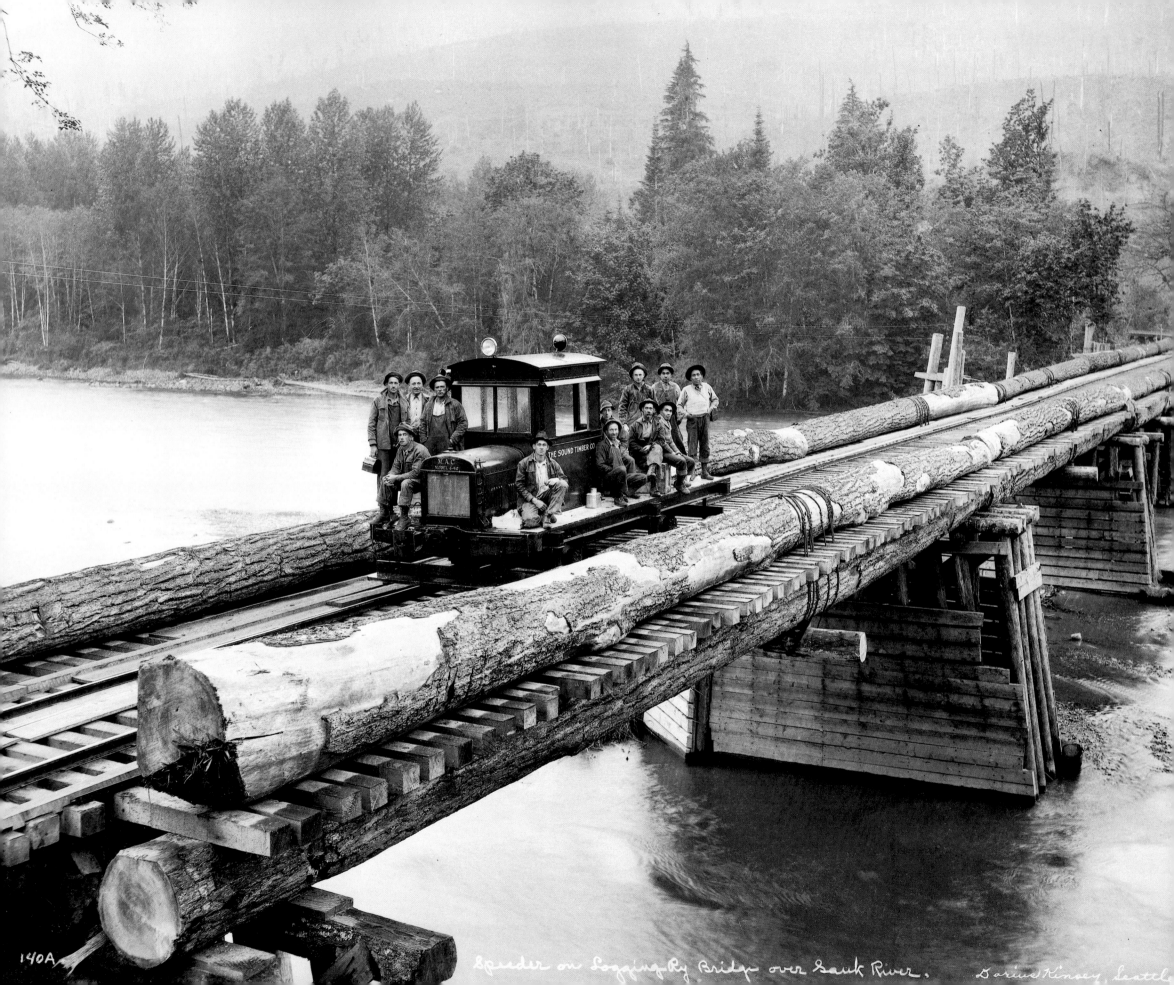

140A. Speeder on Logging Ry Bridge over Sauk River. Darius Kinsey, Seattle

This bridge across the Sauk River, built by the Sound Timber Company, is a fine example of the logger's ingenuity. To provide a substantial structure at a minimum expense, piles have been driven to form the piers and logs have been used above and below the ties to form the spans.

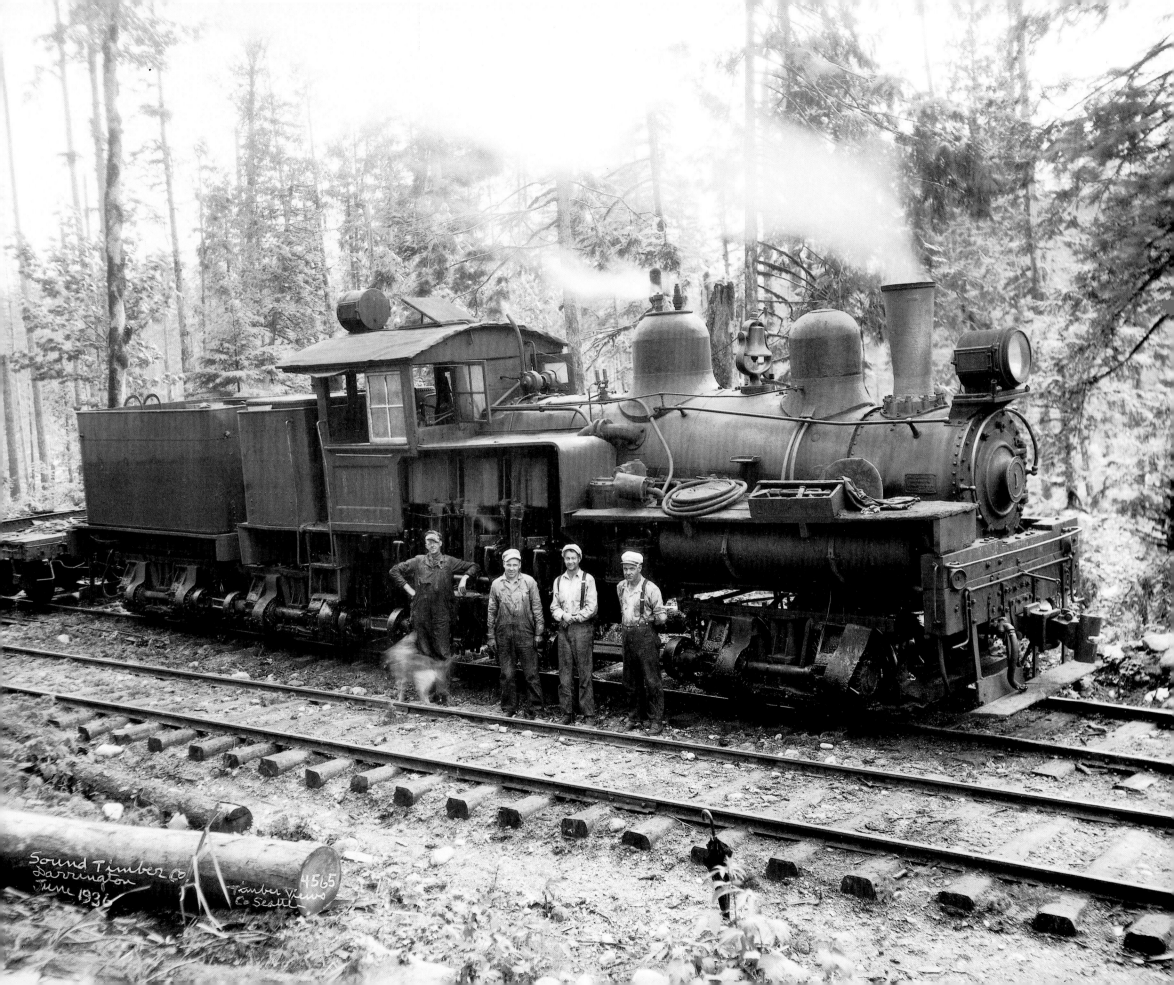

Sound Timber Co.
Darrington
June 1936

4565

Timber Views
Co Seattle

Shay
Lima Locomotive Works, Inc.
#2868 September 1916
Seventy-ton

The Sound Timber Company was organized in late 1899 to manage a tract of timber along the upper Skagit and Sauk rivers. Purchased by the Weyerhaeuser group, this tract was the syndicate's first investment in West Coast timberlands. Logging did not begin until about 1916 when a railroad was built into the holdings. By 1921 the railroad extended ten miles into the timber and was served by a pair of Shays. Logging continued there for two decades, until the Washington Veneer Company acquired the property in 1944.

Locomotive number 1 was construction #2868 from the plant at Lima, built in September of 1916. The 70-ton engine opened the first service on the railroad. She worked there until Sound Timber sold out, and was passed along to the veneer company with the rest of the properties.

Darius Kinsey's "photographic" umbrella
is standing in right foreground

electric light plant; 1 Lidgerwood skidder; manager and superintendent, Fred MacFarlane; master mechanic, Victor Freyd; 12 miles s. g. track; 56 lb. rail; 2 geared locomotives; 75 sets connected trucks; 2 flat cars; 3 tank cars; 2 speeders; maximum grade, 8 per cent; locomotive fuel, oil; 1 steam shovel.

Archer & Rawls Timber Co., 212 Marion St., Seattle; 1 side; daily output, 25 M; 2 donkey engines; 1 high lead; 2 motor trucks; 12 men; manager, Samuel Archer. (Successors to Trout Lake Timber Co.)

*****B. & B. Logging Co., Inc.**, Redmond; camp postoffice, same; 1 side; daily output, 50 M; 2 donkey engines; 1 high lead; 1 logging tractor; machine shop; air compressor; 35 men; manager, Wm. Brown; superintendent, A. N. Brown; master mechanic, F. E. Evans; 6 miles s. g. track; 56 lb. rail; 1 geared locomotive; locomotive fuel, coal; air on equipment; maximum grade, 9 per cent; 10 skeleton and 6 flat cars; output handled by Northern Pacific railroad.

Baker & Cramp, Puget.

Baker Lumber Co., Robe; camp postoffice, same; 1 side; daily output, 12 M; log with horses; commissary; 12 men; manager, E. G. Baker; superintendent, M. H. Baker; purchasing agent, E. G. Baker; master mechanic, B. H. Buchanan; output handled by Hartford & Eastern, branch of Northern Pacific.

Baring Mill Co., Miley Bldg., Everett; camp postoffice, Baring; 1 side; daily output, 30 M; 4 donkey engines; 1 motor truck; electric light plant; 40 men; manager, D. H. Carpenter; superintendent, W. R. Scripture; master mechanic, J. B. Matthews; output handled by Great Northern railroad.

Barker, S. W. 1602 Hoge Building, Seattle; opening new camp on Hoods Canal, to operate in 1927.

Barnes (H. C.) Lumber Co., Colville; camp postoffice, Twin Lakes; Spruce Lake; daily output, 20 M; blacksmith shop; 10 men in woods; 10 men in mill; manager, H. C. Barnes; superintendent, at mills, R. M. Dunham.

Barr (Robert) Logging Co., Kalama.

Bearse Mill Co., J. L., Sultan; camp postoffice, same; daily output, 10 M.

*****Beaver Creek Lumber Co.**, Rochester; camp postoffice, same; 1 side; daily output, 35 M; 1 donkey engine; 1 high lead; commissary; electric light plant; 20 men; manager and superintendent, A. W. Stegman; 3½ miles s. g. track; 20 to 40 lb. rail; 1 direct locomotive; locomotive fuel, wood; maximum grade, 2 per cent; 2 logging trucks.

*****Betchard, Frank**, P. O. Box 27, Roy; postoffice, same; 2 sides; daily output, 40 M; 50 men; 2 donkey engines; route supplies via Roy; camp telephone, via same; manager and purchasing agent, Frank Betchard; superintendent, Fred Hicks; 8 miles s. g. track; 35-40 lb. rail; 1 geared locomotive; 3 flat

cars; 1 speeder; maximum grade, 3 per cent; maximum curvature, 4 degrees; locomotive fuel, wood.

*****Big Fir Logging Co.**, Darrington; camp address, same; 1 side; 1 geared locomotive; 3 donkey engines; 2 miles spur line connecting with Sauk River Timber Co. mainline.

*****Bloedel Donovan Lumber Mills**, Bellingham; camp postoffices: Beaver, Box 2, Bellingham (Saxon Camp); South Bellingham (Alger Camp); Sekiu; Skykomish; 11 sides; daily output, 1100 M; 800 men; 26 donkey engines; machine shop; commissary; electric light plant; 1 Lidgerwood skidder; manager, J. J. Donovan; superintendent, J. N. Donovan; purchasing agent, C. W. Mason; master mechanic, L. Baldwin; 95 miles s. g. track; 60-70 lb. rail; 2 rod locomotives; 10 geared locomotives; 6 sets disconnected trucks; 250 sets connected trucks; 20 flat cars; 2 moving cars; 20 tank cars; 8 speeders; maximum grade, 6 per cent; maximum curvature, 24 degrees; locomotive fuel, oil; shovels: 3 gas, 1 steam; 1 locomotive crane.

Blue, Chas., Box 687, Tenino; daily output, 8 M; 5 men; 4 horses; route supplies via Tenino.

Bocek Bros. Logging Co., Box 1057, Aberdeen; 1 side; daily output, 40 M; 25 men; 4 donkey engines; commissary; electric light plant; route supplies via truck; camp telephone via Montesano; manager and purchasing agent, Paul Bocek; superintendent and master mechanic, George Bocek.

*****Brew Logging Co.**, Puyallup; camp P. O., Kerriston; daily output, 75 M; 1 side; 60 men; 5 donkey engines; machine shop; commissary; manager and purchasing agent, T. H. Brew; superintendent, R. Smith; 4 miles s. g. track; 56 lb. rail; 1 geared locomotive; 1 speeder; maximum grade, 6 per cent; locomotive fuel, coal; trucks and flat cars supplied by Northern Pacific.

Broomfield Lumber Co., South Prairie.

*****Broughton Lumber Co.**, 503 Railway Exchange Bldg., Portland; camp postoffice, Willard; daily output, 60 M; 1 side; 25 men; 1 donkey engine; commissary; electric light plant; route supplies via Cooks; camp telephone via Hood; manager, superintendent and purchasing agent, D. M. Stevenson; 3 miles s. g. track; 40-50 lb. rail; 1 geared locomotive; 6 sets disconnected trucks; 1 speeder; maximum grade, 7 per cent; locomotive fuel, wood.

Buck Lumber Co., Everett; camp postoffice, Granite Falls; daily output, 10 M; horses used in logging to mill.

*****Buckley Logging Co.**, 605 American Bank Bldg., Seattle; camp postoffice, Buckley; 2 sides; daily output, 200 M; 150 Men; 10 donkey engines; machine shop; commissary; electric light plant; air compressor; route supplies via Buckley; camp telephone via Buckley; manager, Craig L. Spencer; superintendent B. B. Peterson; purchasing agent, E. G. Peterson; master mechanic, Ras. Robertson; 25 miles s. g. track; 56 lb. rail; 2 geared locomotives; 27 flat cars; 1 tank car; 4 speed-

1 moving car; 2 speeders; maximum grade, 10 per cent; locomotive fuel, wood; 1 steam shovel.

***Elbe Lumber & Shingle Co.**, 806 Tacoma Bldg., Tacoma; camp postoffice, Elbe; daily output, 80 M; 1 side; 52 men; 5 donkey engines; commissary; electric light plant; route supplies via Tilton (prepay); camp telephone via Mineral, No. 2913; manager, John Patten; 4½ miles s. g. track; 56-60 lb. rail; 1 geared locomotive; 1 moving car; 2 speeders; maximum grade, 4 per cent; maximum curvature, 24 degrees; locomotive fuel, coal; shovels: 1 steam; trucks and flat cars supplied by the C. M. & St. P. railroad.

Elkhorn Mill Co., Bluecreek; camp postoffice, same; 1 side; daily output, 30 M; 3 motor trucks; machine shop; electric light plant; 25 men; manager, superintendent and purchasing agent, J. R. Humphrey; master mechanic, S. A. Humphrey.

***Emery & Nelson, Inc.**, Napavine; 2 sides; daily output, 60 M; 120 men; 6 donkey engines; machine shop; electric light plant; 1 motor truck; route supplies via Napavine; manager and purchasing agent, W. W. Emery; superintendent, H. B. Dickinson; master mechanic, E. Hegstrom; 12 miles s. g. track; 40 lb. rail; 2 geared locomotives; 40 sets disconnected trucks; 2 flat cars; 3 speeders; maximum grade, 3 per cent; locomotive fuel, wood.

***England Lumber Co., J. H.**, Winlock; camp postoffice, same; daily output, 25 M; 1 side; 6 men; 1 donkey; 1 motor truck; route supplies via Winlock; manager and purchasing agent, J. H. England; superintendent and master mechanic, George England; 5 miles s. g. track; 40 lb. rail; 1 geared locomotive; 1 set disconnected trucks; maximum grade, 1½ per cent; locomotive fuel, gasoline.

***English Lumber Co.**, Ballard Station, Seattle; camp postoffice, R. F. D. No. 5, Mount Vernon; daily output, 300 M; 6 sides; 500 men; 18 donkey engines; machine shop; commissary; electric light plant; air compressors; route supplies via freight to Fir and Mount Vernon; camp telephone via Mount Vernon; manager, E. G. English; superintendent and purchasing agent, Jas. O'Hearne; master mechanic, Louis Statelin; 60 miles s. g. track; 56-60-68 lb. rail; 1 rod locomotive; 6 geared locomotives; 20 sets disconnected trucks; 300 sets connected trucks; 9 flat cars; 3 moving cars; 4 tank cars; 5 speeders; maximum grade, 6 per cent; maximum curvature, 20 degrees; locomotive fuel, oil and coal; shovels: 2 steam.

***Erickson-Fuhrman Co.**, Rockport; camp address, same; 1 side; daily output 70 M; 40 men; 3 donkey engines; commissary; electric light plant; 1 logging tractor; 1 motor truck; route supplies via Rockport; camp telephone via U. S. Ranger Station, Marblemount; manager, Frank Fuhrman; superintendent, A. H. Erickson; 1¼ miles s. g. track; 56 lb. rail; 1 rod locomotive; 1 moving car; 2 tank cars; 1 speeder; maximum grade 3 per cent; locomotive fuel, oil.

***Etna Logging Co.**, 727 Gasco Bldg., Portland, Ore.; camp postoffice, Hall; 1 side; daily output, 70 M; 25 men; 4 donkey engines; machine shop; commissary; electric light plant; route supplies via Woodland, Wash.; camp telephone via same; manager and president, W. W. McCredie; superintendent, Sam Adams; purchasing agent, J. R. Harvey; 8 miles s. g. track; 45 lb. rail; 1 geared locomotive; 6 sets disconnected trucks; 4 sets connected trucks; 2 flat cars; 1 speeder; maximum grade, 5½ per cent; locomotive fuel, wood.

***Feazle Logging Co.**, 634 Chamber of Commerce Bldg., Portland; camp postoffice, Skamokawa; daily output, 120 M; 2 sides; 100 men; 9 donkey engines; machine shop; commissary; 1 motor truck; route supplies via Skamowaka; camp telephone, via same; manager, and purchasing agent, W. P. Stevens; superintendent, Paul Rooney; master mechanic, Chas. Elchmn; 7 miles s. g. track; 40 lb. rail; 1 geared locomotive; 11 sets disconnected trucks; 1 flat car; 1 speeder; maximum grade, 7 per cent; locomotive fuel, wood.

***Fir Tree Lumber Co.**, Tacoma; camp postoffice, route No. 5, Olympia; 1 side; daily output, 45 M; 4 donkey engines; 2 high leads; commissary; 35 men; 5 miles s. g. track; 40-55 lb. rail; 1 geared locomotive; 1 direct locomotive; locomotive fuel, oil and wood; 10 sets logging trucks; 5 flat cars; 1 locomotive crane.

Flaherty-Daly Logging Co., 220 W. Seventh St., Port Angeles; camp postoffice, same; 1 side; daily output, 40 M; 3 donkey engines; commissary; route supplies via Port Angeles; superintendent, J. W. Flaherty; purchasing agent, D. G. Daly.

***Fobes Timber Co.**, Nagrom; camp postoffice, sabe; 2 sides; daily output, 80 M; 5 donkey engines; 1 high lead; commissary; machine shop; 80 men; manager, I. C. Clark; purchasing agents, I. C. Clark and H. L. Rex; master mechanic, Al Burns; 3 miles s. g. track; 40 lb. rail; 2 geared locomotives; locomotive fuel, coal; air on equipment; output handled by Northern Pacific railroad.

***Foster Newbegin Lumber Co.**, Frederickson; camp postoffice, same; daily output, 80 to 100 M; 2 sides; 70 men; 5 donkey engines; machine shop; commissary; electric light plant; air compressors; route supplies via C. M. & St. P. Ry.; camp telephone via Frederickson; manager, C. D. Howe; 8 miles s. g. track; 60 lb. rail; 1 geared locomotive; 24 sets connected trucks; 8 flat cars; 1 moving car; 2 tank cars; 1 speeder; maximum grade, 6 per cent; maximum curvature, 30 degrees; locomotive fuel, oil; 1 locomotive crane.

***Fredrickson Logging & Timber Co.**, Skamokawa; camp postoffice, same; 2 sides; daily output, 150 M; 75 men; 8 donkey engines; machine shop; commissary; electric light plant; 1 set big wheels; route supplies via boat to Skamokawa; camp telephone via same; manager and purchasing agent, E. P. Fredrickson; master mechanic, Frank Johnson; 5½ miles s. g. track; 35-40-56 lb. rail; 2 geared locomotives; 8 sets dis-

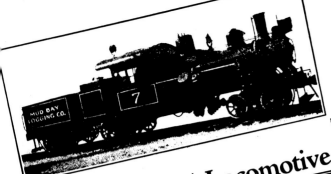
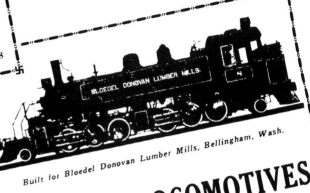

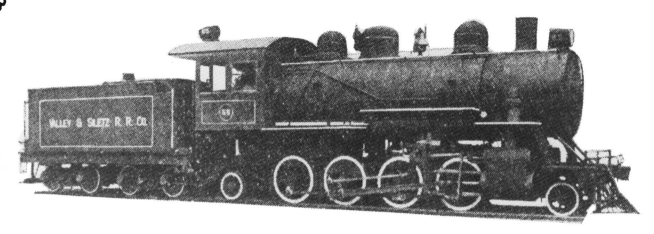

Built by master craftsmen

PORTER craftsmen build for permanence. Into every Porter Locomotive part goes the careful and thorough workmanship of the highest type of American craftsmen, many of whom have the accumulated skill of a lifetime in Porter service. ¶ That's why Porter Locomotives give the lasting, long-lived service for which they are world-renowned.

H. K. PORTER COMPANY
PITTSBURGH, PENNSYLVANIA

West Coast Distributors

Northwestern Representatives:
Loggers and Contractors Machinery Company
70 Fourth Street, Portland, Oregon

California Representative:
N. D. Phelps
Sheldon Bldg., San Francisco

Vancouver Machinery Depot, Ltd.
1155 Sixth Avenue, West
Vancouver, B. C.

sary; electric light plant; air compressor; route supplies express or freight to Hoquiam; parcel post to Aberdeen; camp telephone via Hoquiam; manager, W. E. Boeing; superintendent, F. J. Fitzgerald; purchasing agent, F. A. Wick; master mechanic, Frank Crown; 16 miles s. g. track; 60 lb. rail; 3 geared locomotives; 80 sets connected trucks; 1 moving car; 3 tank cars; 3 speeders; maximum grade, 5 per cent; locomotive fuel, oil; shovels: 1 gas, 1 steam; 1 locomotive crane.

*Gruber-Docherty Lumber Co., Yelm; camp postoffice, same; 1 side; daily output, 40 M; 20 men; 1 donkey engine; commissary; route supplies via Great Northern; camp telephone via Yelm; manager and purchasing agent, B. J. Docherty; 2 miles s. g. track; 40 lb. rail; 1 geared locomotive; 5 sets disconnected trucks; 1 speeder; locomotive fuel, wood; trucks and flat cars supplied by Northern Pacific.

*Hama Hama Logging Co., camp postoffice, P. O. Box 387, Bremerton; daily output, 250 M; 3 sides; 250 men; 8 donkey engines; machine shop; commissary; electric light plant; 1 Lidgerwood skidder; 1 Washington slack line skidder; 1 logging tractor; 1 motor truck; 2 horses; route supplies via Steamer Aloha, Coleman Dock, Seattle; camp telephone via Hoodsport; manager, H. W. White; superintendent, A. J. Gray; purchasing agent, J. M. Ryan; master mechanic, C. T. Johnson; 15 miles s. g. track; 56-60 lb. rail; 3 geared locomotives; 64 sets connected trucks; 1 flat car; 1 moving car; 2 tank cars; 3 speeders; maximum grade, 5 per cent; maximum curvature, 25 degrees; locomotive fuel, oil; 3 steam shovels; logging inline: length, 3700 feet; maximum grade, 37 per cent; special equipment, 2 gas donkeys.

Hamilton & Rosenstiel, White Salmon; camp postoffice, Trout Lake; daily output, 4 M; 3 men; electric light plant; 1 motor truck; 2 horses; route supplies via White Salmon; camp telephone via same; manager and purchasing agent, Hamilton & Rosenstiel; master mechanic, Mr. Rosenstiel.

*Hammerschmith & Sons, L., Yelm; daily output, 30 M; 1 side; 18 men; 1 donkey engine; route supplies via C. M. & St. P., Arkley Spur; camp telephone via Yelm; manager and purchasing agent, F. Hammerschmith; 5 miles s. g. track; 40-45 lb. rail; 1 geared locomotive; 2 flat cars; 1 tank car; maximum grade, 16 per cent; locomotive fuel, wood.

*Hammond Lumber Co., 812 Gasco Bldg., Portland; camp postoffice, Kelso; daily output, 200 M; 2 sides; 130 men; 5 donkey engines; machine shop; commissary; electric light plant; air compressor; 1 Lidgerwood skidder; 1 horse; route supplies via steamer Greyhound; camp telephone via Kelso; manager, Geo. B. McLeod; superintendent and purchasing agent, A. R. Baker; master mechanic, Herbert Berg; 12 miles s. g. track; 60 lb. rail; 3 geared locomotives; 54 sets disconnected trucks; 2 flat cars; 2 moving cars; 3 tank cars; 2 speeders; maximum grade, 5 per cent; maximum curvature, 22 degrees; locomotive fuel, oil; shovels: 1 gas, 1 steam.

Harper Lumber Co., Northport; camp postoffice, Kane Siding; daily output, 35 M; manager, E. J. Harper.

Harris & Sons, C. A., Ardenvoir; daily output, 35 M; 35 men; commissary; electric light plant; 1 logging tractor; 3 motor trucks; 14 horses; route supplies via Entiat; camp telephone via same; manager, Arden Harris; superintendent, J. Zwight.

*Harstad Lumber Co., South Prairie; camp postoffice, same; 1 side; daily output, 50 M; 35 men; 3 donkey engines; electric light plant; air compressor; camp telephone via South Prairie; manager, Theo. Harstad; 5 miles s. g. track; 40-56 lb. rail; 1 geared locomotive; 5 sets connected trucks; 4 flat cars; 1 moving car; 1 tank car; 1 speeder; maximum grade, 7 per cent; locomotive fuel, oil; trucks and flat cars supplied by Northern Pacific.

*Hawthorne, W. R., P. O. Box 427, Bremerton; camp postoffice, same; 1 side; daily output, 43 M; 4 donkey engines; 2 high leads; commissary; machine shop; air compressor; 38 men; manager, W. R. Hawthorne; superintendent, P. G. Bergman; purchasing agent, W. R. Hawthorne; master mechanic, S. Hansen; 5 miles 36-inch track; 35 lb. rail; 1 geared locomotive; locomotive fuel, wood; maximum grade, 3½ per cent; 14 sets logging trucks.

Heath Lumber & Shingle Co., Granite Falls; 1 side; 10 men; 1 donkey engine.

*Hedlund Lumber & Manufacturing Co., Spokane; camp postoffice, Marcus (will be changed to Kettle Falls in spring of 1927); 100 men; manager, D. C. Hedlund; superintendent, H. Henrickson; purchasing agent, D. A. Hedlund; (constructing) 25 miles s. g. track; 68 lb rail; 1 geared locomotive; 1 tank car; 1 speeder; maximum grade, 2 per cent; maximum curvature, 15 degrees; locomotive fuel, oil; shovels; 1 Diesel.

Hemlock Lumber Co., Hoquiam; camp postoffice, Copalis Crossing; 1 side; daily output, 25 M; 1 donkey engine; 1 high lead; 1 motor truck; electric light plant; 25 men in mill and woods; manager, Z. A. Toye; superintendent, M. E. Bloom.

Hicks Lumber Co., Underwood; camp postoffice, same; daily output, 30 M; 1 side; 22 men; commissary; 1 motor truck; 10 horses; route supplies via Underwood; camp telephone via Underwood; manager, W. S. Fogaby.

*High Point Mill Co., High Point; daily output, 60 M; 1 side; 45 men; 8 donkey engines; machine shop; commissary; 1 motor truck; route supplies via Issaquah; camp telephone via Fall City; manager, Emil Lovegren; superintendent, W. D. Lovegren; 3 miles s. g. track; 40 lb. rail; 1 geared locomotive; 4 sets connected trucks; 1 speeder; maximum grade, 7 per cent; maximum curvature, 40 degrees; locomotive fuel, wood; logging incline: length, 9500 feet; maximum grade, 35 per cent; special equipment; 3 pole road tram cars.

Hilo Lumber Co., Robe; camp postoffice, same; daily output, 25 M; 1 side; 14 men; 2 donkey engines; electric light plant; 1

Carey; purchasing agent and master mechanic, Ivan E. Mc-Cormick; 8 miles s. g. track; 56 lb. rail; 1 rod locomotive; 2 geared locomotives; 10 sets disconnected trucks; 30 sets connected trucks; 6 flat cars; 1 moving car; 1 speeder; maximum grade, 6 per cent; locomotive fuel, oil and coal.

*McCormick Lumber Co., Chas. R., 960 Stuart Bldg., Seattle; camp postoffice, Camp Talbot, Star Route No. 2, Port Townsend; daily output, 480 M; 3 sides; 300·men; machine shop; commissary; electric light plant; 3 Lidgerwood skidders; 1 motor truck; route supplies via Discovery Junction, via C. M. & St. P.; camp telephone via Leland; manager, P. E. Freydig; superintendent, J. E. Wiley; purchasing agent, S. L. Harper; master mechanic, A. Tufts; 25 miles s. g. track; 60 lb. rail; 1 rod locomotive; 2 geared locomotives; 80 sets disconnected trucks; 7 flat cars; 7 tank cars; 2 speeders; maximum grade, 6 per cent; maximum curvature, 30 degrees; locomotive fuel, oil; shovels: 1 gas, 1 steam, 1 Diesel. (See listings below for Camp Gamble and Castle Rock.)

*McCormick Lumber Co., Chas. R., 960 Stuart Bldg., Seattle; camp postoffice, same; daily output, 260 M; 3 sides; 200 men; 3 donkey engines; machine shop; commissary; electric light plant; 3 duplex loaders; route supplies via boat from Seattle to Camp Gamble; manager, Paul E. Freydig; superintendent, Herman E. Engel; purchasing agent, E. C. McReavy; master mechanic, Al Foulds; 15 miles s. g. track; 60 lb. rail; 2 geared locomotives; 50 sets skeleton trucks; 4 flat cars; 2 moving cars; 2 tank cars; 1 speeder; maximum grade, 6 per cent; maximum curvature, 18 degrees; locomotive fuel, coal.

*McCormick Lumber Co., Chas. R., Castle Rock; camp address, same; 1 side; 1 high lead (loader, yard and swing); daily capacity, 100 M; 5 miles s. g. track; 1 direct locomotive; 10 sets trucks; superintendent, Oliver Byerly.

*McGoldrick Lumber Co., Spokane; camp postoffice, same; daily output, 300 M; 300 men; 3 donkey engines; machine shop; commissary; electric light plant; 9 motor trucks; 100 horses; route supplies via Spokane; camp telephone via same; manager, J. P. McGoldrick; superintendent, R. C. Lammers; purchasing agent, O. B. Covey; master mechanic, A. C. Thoms; 21 miles s. g. track; 60 lb. rail; 1 rod locomotive; 1 geared locomotive; 2 sets disconnected trucks; 2 flat cars; 1 speeder; maximum grade, 1½ per cent; maximum curvature, 12 degrees; locomotive fuel, coal; trucks and flat cars supplied by N. P., G. N., O.-W. R. & N., S. I.

*McKenna Lumber Co., McKenna; camp postoffice, same; daily output, 150 M; 3 sides; 135 men; 12 donkey engines; machine shop; commissary; route supplies via N. P., G. N.; camp telephone via McKenna or Yelm; manager and purchasing agent, W. W. Goodwin; superintendent, C. A. Shields; master mechanic, C. C. Hull; 14 miles s. g. track; 56 lb. rail; 2 rod locomotives; 1 geared locomotive; 43 flat cars; 3 tank cars; 2 speeders; maximum grade, 4½ per cent; maximum curvature, 18 degrees; locomotive fuel, wood.

* Indicates Logging Railroad

*McMillin Lumber Co., McMillin; camp postoffice, Orting; daily output, 40 M; 1 side; 30 men; 3 donkey engines; machine shop; commissary; electric light plant; air compressors; route supplies via Orting; camp telephone via Orting; manager, W. R. Svensson; superintendent, Albert Nelson; 2 miles s. g. track; 45-50 lb. rail; 1 geared locomotive; maximum grade, 6 per cent; maximum curvature, 18 degrees; locomotive fuel, coal; trucks and flat cars supplied by Northern Pacific.

Meiklejohn & Brown Company, 1423 L. C. Smith Bldg., Seattle; camp postoffice, R. R. No. 2, Renton; 1 side; daily output, 40 M; 3 donkey engines; 3 motor trucks; 2 logging tractors; 30 men; managers, R. D. Brown and E. H. Meiklejohn; purchasing agent, R. D. Brown; output handled by Pacific Coast railroad.

*Merrill & Ring Lumber Co., 920 White Bldg., Seattle; camp postoffice, Pysht; daily output, 300 M; 5 sides; 350 men; 9 donkey engines; machine shop; commissary; electric light plant; air compressor; 1 Clyde skidder; route supplies via Puget Sound Navigation Co.; camp telephone via U. S. Weather Bureau telephone; manager and purchasing agent, W. J. Chisholm; superintendent, J. R. Benjamin; 15 miles s. g. track; 60 lb. rail; 4 geared locomotives; 100 sets connected trucks; 5 flat cars; 3 moving cars; 5 tank cars; 1 speeder; maximum grade, 6 per cent; maximum curvature, 20 degrees; locomotive fuel, oil; shovels: 1 gas, 3 steam; 1 locomotive crane.

*Mid-Columbia Lumber Co., Carson; camp postoffice, same; daily output, 60 M; 1 side; 35 men; 6 donkey engines; machine shop; commissary; electric light plant; 2 motor trucks; 2 horses; route supplies via S. P. & S.; camp telephone via Stevenson; manager and purchasing agent, J. C. Price; superintendent and master mechanic, S. F. DuBois; 2 miles s. g. track; 50 lb. rail; 2 rod locomotives; 1 geared locomotive; 20 sets disconnected trucks; 2 flat cars; 1 tank car; 2 speeders; maximum grade, 5 per cent; locomotive fuel, wood.

*Miller Logging Co., Sultan; camp postoffice, same; 3 sides; daily output, 300 M; 240 men; 9 donkey engines; commissary; electric light plant; air compressor; route supplies via Sultan; camp telephone, same; superintendent, Ken. G. Fraser; 13 miles s. g. track; 56-60-72 lb. rail; 3 geared locomotives; 1 moving car; 2 tank cars; 2 speeders; maximum grade, 6 per cent; maximum curvature, 28 degrees; locomotive fuel, oil; shovels: 1 gas; trucks and flat cars supplied by G. N. Ry.; special equipment; 2 Roger CD, 1 Western SD cars.

Miller Mill & Flume Co., Carson; camp postoffice, same; daily output, 15 M; 1 side; 10 men; 1 donkey engine; commissary; 1 logging tractor; 3 motor trucks; route supplies via S. P. & S., Carson; manager, superintendent and purchasing agent, C. H. Miller; master mechanic, M. G. Miller.

*Mineral Lake Logging Co., 822 Tacoma Bldg., Tacoma; camp postoffice, Ashford; 2 sides; daily output, 200 M; 120 men;

* Indicates Logging Railroad

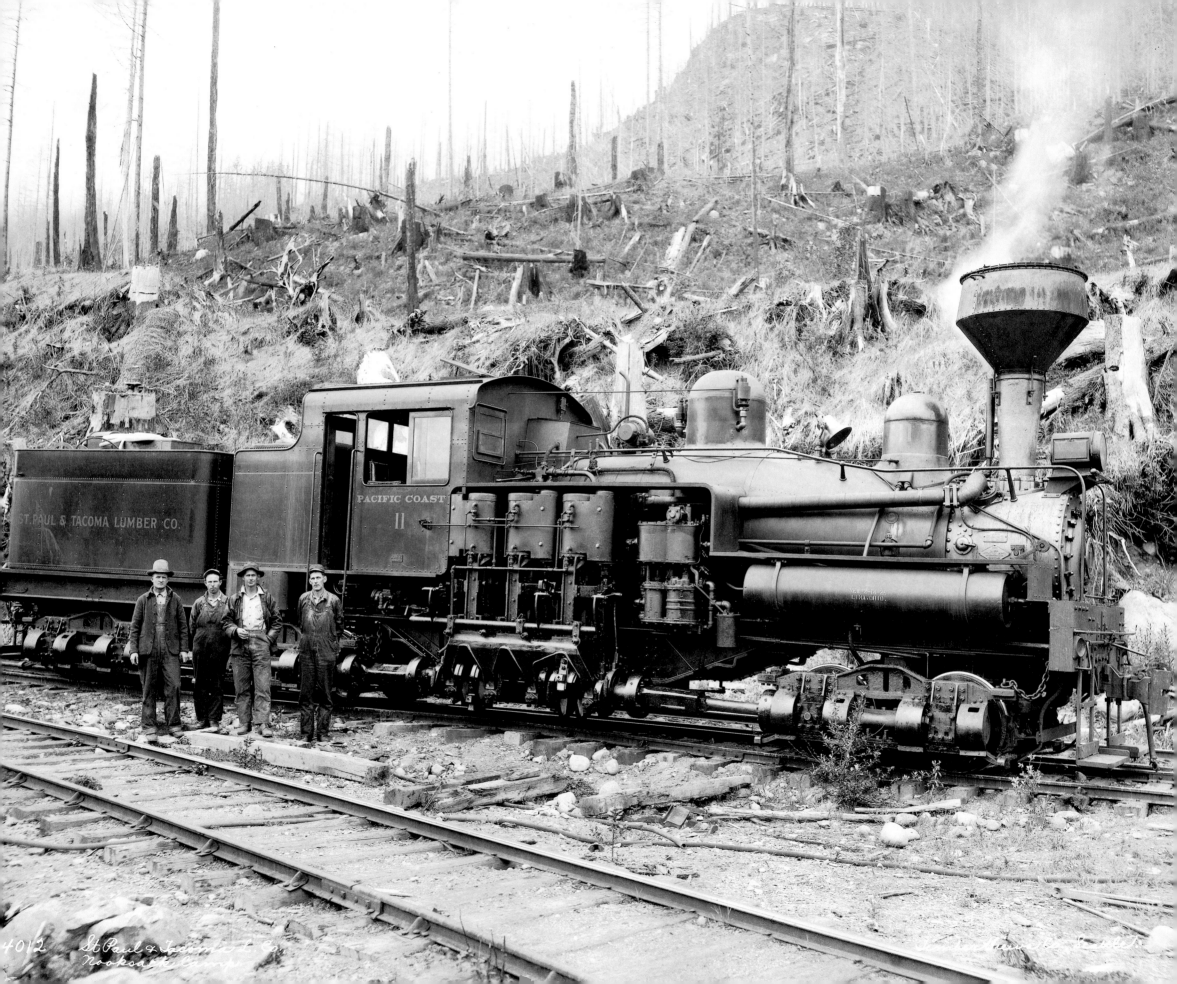

Shay 3-PC-13
Lima Locomotive Works, Inc.
#3330 February 1929
Ninety-ton

The St. Paul & Tacoma Lumber Company, based at Tacoma, was organized in 1884 and incorporated in 1888. One of the more prominent lumbering concerns on Puget Sound, their main logging area lay southeast of Tacoma near Mount Rainier.

In the summer of 1923 they opened a new area along the Nooksack River in Whatcom County under a subsidiary called the Nooksack Timber Company. The camp near Kulshan was designated Camp 7 of the St. Paul & Tacoma Lumber Company. Most of the timber here was cedar, and the camp operated sporadically, depending on the market for cedar products.

Locomotive number 11 was a Pacific Coast Shay, the last and finest design from the Lima works. Weighing about 90 tons, the Pacific Coast was equipped with a superheater, cast steel truck frames, and piston valves. This was Lima's answer to the upstart Willamette locomotives. Road number 11 was turned out in February of 1929 and was assigned to the Kulshan camp on the Nooksack. She served there until the operation was closed in the late 1930s, and was probably transferred to the main St. Paul & Tacoma operation east of Tacoma. In October of 1949 she was purchased by the Victoria Lumber & Manufacturing Company at Chemainus on Vancouver Island, and given road number 8. She ended her career on the Island for MacMillan & Bloedel as their road number 1088. She was scrapped in 1953.

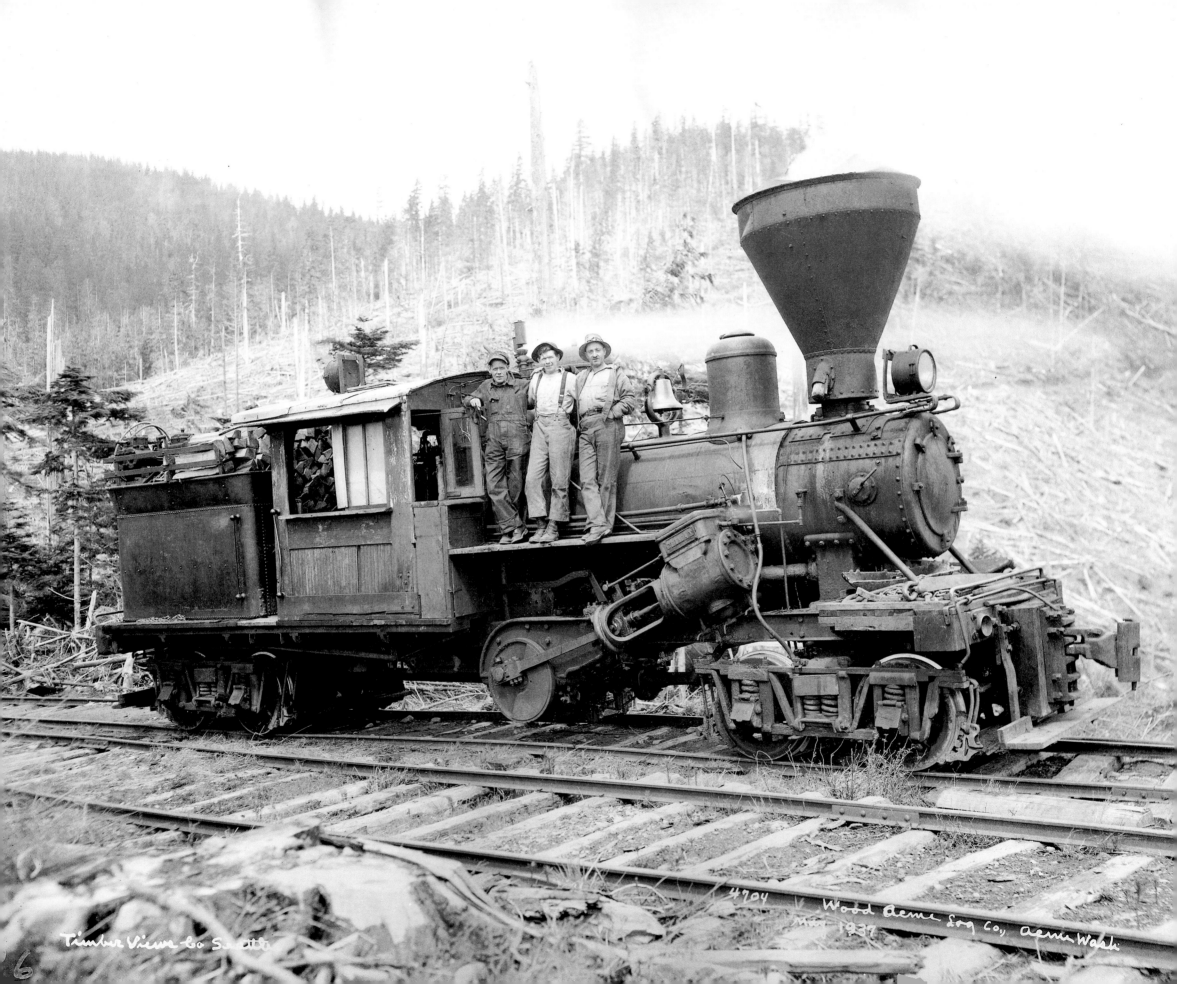

4704

Wood Acme Log Co., Acme Wash.

May 1937

6

Climax
Climax Manufacturing Company
#962 August 1909
Thirty-eight-ton

The Wood-Acme Logging Company was a small concern located near Acme in
Whatcom County. During the 1930s they operated a few miles of track which was
divided into two sections by a sixty-two-hundred-foot incline with a seventy-nine
percent grade. Wood-Acme used a Climax and a Shay, one working at the head of
the incline and the other at the foot.

 Their Climax was construction #962, built in August of 1909, and carried their
road number 2. She had been built originally for the French & Woodin Logging
Company at Bothell, at the north end of Lake Washington, where she served as
their 2-spot. From there she migrated to the Everett Logging Company before
coming to Acme. When Wood-Acme cut out in 1937, she was sold to the Galbraith
Brothers, who had a small logging show nearby.

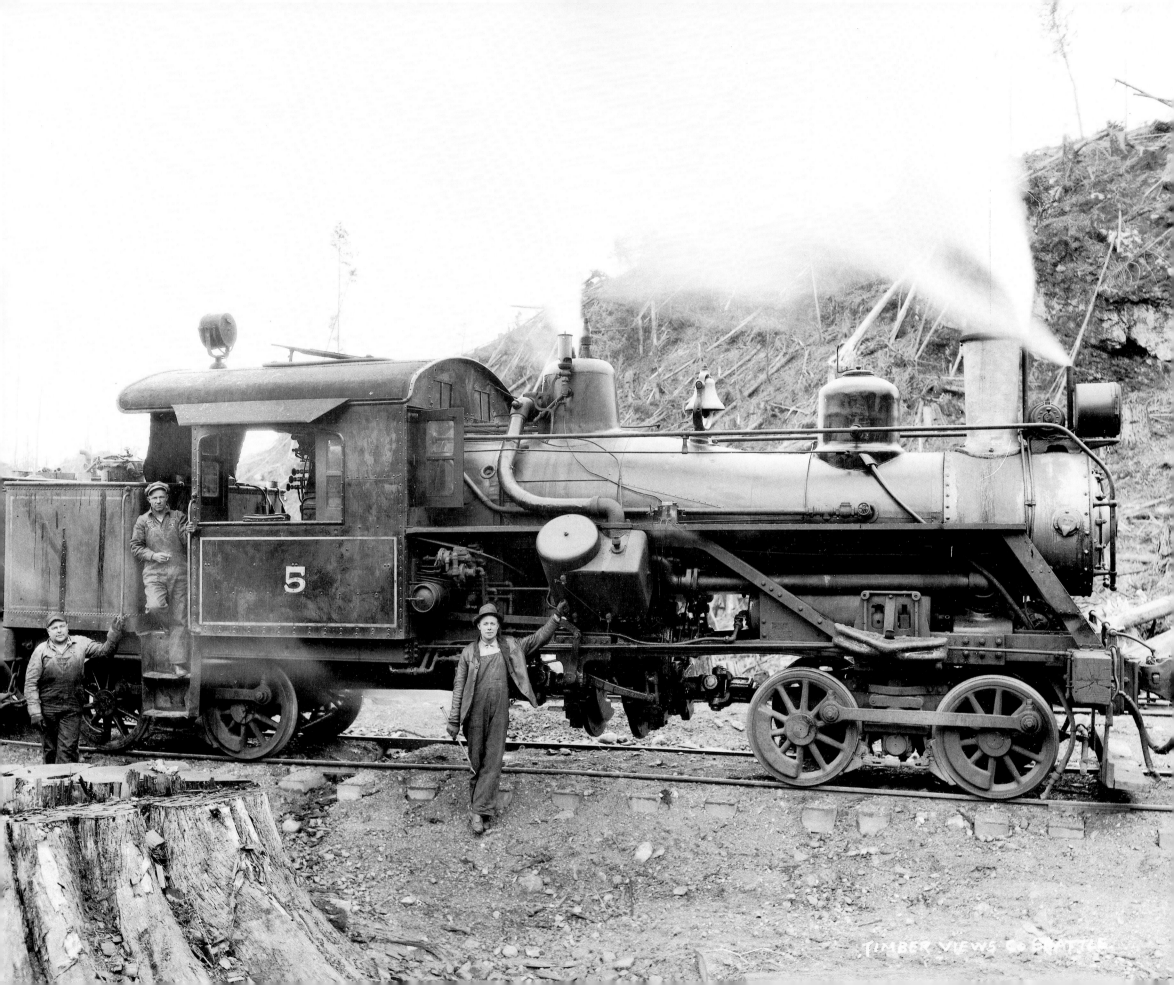

TIMBER VIEWS Co SEATTLE

Heisler
Heisler Locomotive Works
#1487 July 1923
Eighty-ton

George Miller began logging near Sedro Woolley with the purchase of the Day Creek Lumber Company in the spring of 1910. In the years that followed he became associated with a number of other logging operations in northwest Washington. In June of 1923, together with the airplane builder W. E. Boeing and others, he incorporated the Miller Logging Company at Sultan to log in the area of the Skykomish River. Operations there lasted until 1939 when the last of the timber was cut out.

Locomotive number 5, an 80-ton Heisler built in July of 1923 as construction #1487, was acquired new for the company. She served Miller until the end, and about 1940 found a new home in the Queen Charlotte Islands of British Columbia. She worked for the A. P. Allison Logging Company and its successors until 1955, when the railroad operations there were closed out.

Many shingle mills made use of light railroads to bring their cedar bolts out of the woods. Here a load of bolts is about to be transferred to the pond to supply grist for the mill.

The little locomotive was built by H. K. Porter Company. Porter began building small industrial engines in 1866 under the Smith & Porter name. This was changed to Porter, Bell & Company in 1871, H. K. Porter & Company in 1878, and the H. K. Porter Company in 1899. Over the years Porter probably turned out more of these industrial locomotives than any other builder. They claim to have built the first locomotive designed specifically for use in logging, as well as some of the tiniest engines ever designed for commercial use. Porter locomotives still serve American industries today, although they are no longer driven by steam.

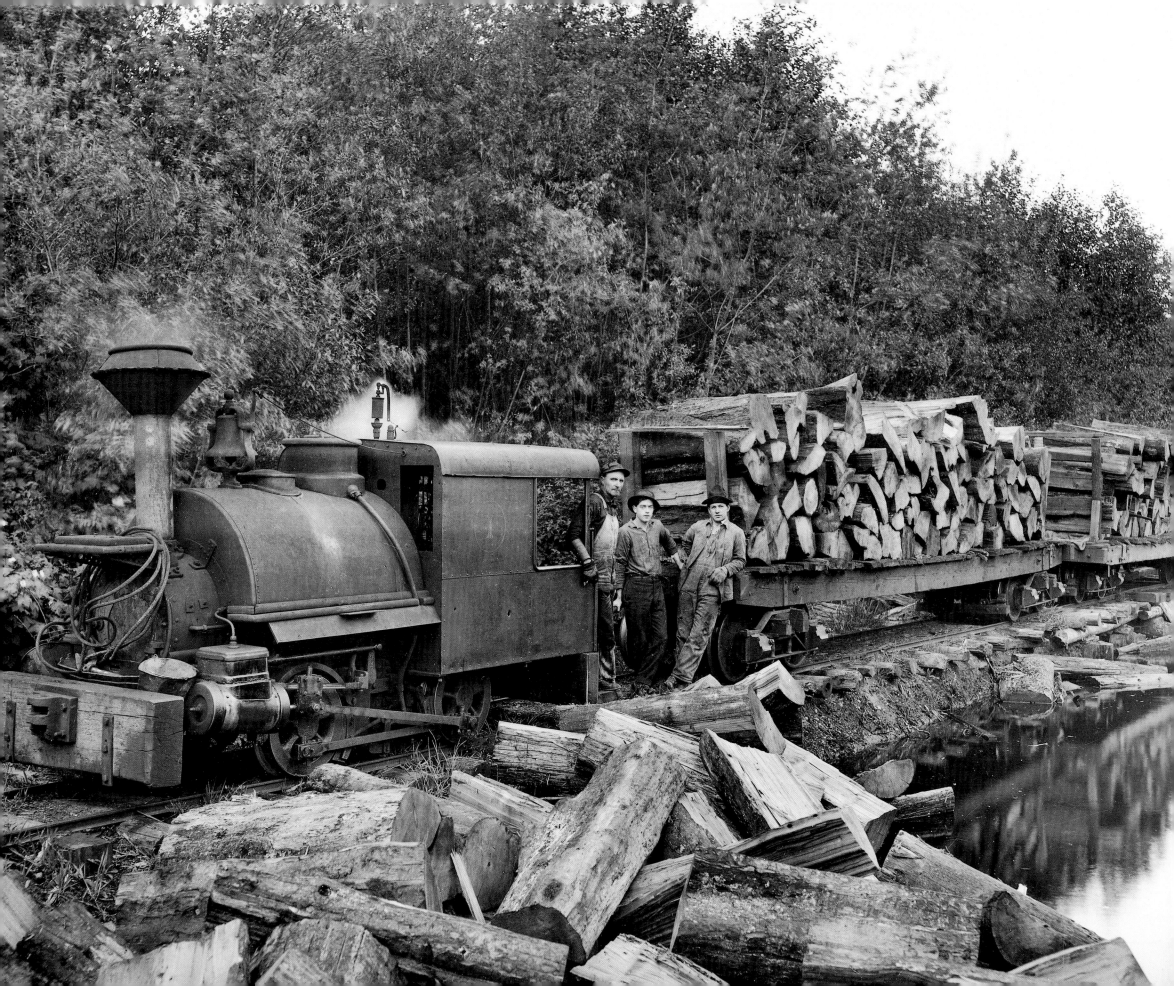

When I went to work out there at Sekiu, in 1958, they were scrapping off the 9-spot and I asked the boss if I could have some stuff off of it. He said, "Oh, I think that can be arranged." So I said that I wanted the spot plate and the builder's plate. He said he'd talk to Bob Cunningham, the superintendent, and Cunningham said, "Yeah, go ahead." So I took them off and brought them home and had them all cleaned up. A month or so later, Cunningham came around and said, "I'm in trouble. I forgot that I promised those plates to Mrs. Warnock." Her husband was the engineer on the 9-spot from the time they brought it out. I said, "No problem. I'll give them back." And then, just kind of joking, I said:

"But I want that," and I pointed to the 2-spot.

"Are you joking?"

"No, not really."

"Well, we'll let you know when the time comes."

And then in 1962, about the end of August, the shop boss out there, Howard Gagnon—he was a sharp guy, always had a scowl on his face and a weird sense of humor—comes up to me and says, "You still want that goddamned locomotive?"

"Yes."

"Then put your goddamned money where your mouth is."

"What will it cost me?"

"You and Cunningham fight that out."

About a month later Bob Cunningham came around, and when I asked the price on the locomotive he said, "One thousand dollars. There's a stipulation on

it, though. You've got to get it out as soon as possible." I said there would be no problem on that, but little did I know. So the day after Thanksgiving I took a certified check down to Hoquiam and paid for it. One thousand dollars sounds cheap, yes, but to move it took me three thousand more dollars and six years of fighting with the damned state.

See, there was no track between Forks and Port Angeles at that time, because the Port Angeles & Western had died in 1952 or 1953. So I had to take it apart and have it pulled in on trucks. There was a guy out in Forks who had a three-axle lowboy, but the Willamette locomotive records were stored somewhere down at Willamette Iron & Steel and nobody knew exactly where, so I couldn't get actual weights on it. A classic bureaucracy deal. Nobody was going to stick their neck out. Well, I finally found an outfit that had all sorts of permits and stuff, and they could handle it. They spent one day out at Forks getting it ready to move, brought it here the next day, and unloaded the following morning. That night it sat out here at trucktown, about half a mile from my property. I spent the night in the back of my pickup to make sure nothing got robbed.

About a year and a half ago I started taking it apart. The tubes and flues and the wood beams on the ends are in bad shape. All sorts of little things need to be done, and some of them turn out to be big and not just little. But like I told the guy who interviewed me, from the newspaper, since they wouldn't let me run an engine out where I worked, I've got my own now and I'm going to run that.

Jim Gertz
Port Angeles

My first experience with the number 100 was in 1967, when Dad and I first met Reed Hatch. Dad had learned about the 100 being up on the White Mountain Scenic in Arizona. Dad introduced himself to Reed and told him of his experience with the 100, as a brakeman when he worked for the Santa Maria Valley Railroad in California, before the war. So Reed invited us for a cab ride between McNary and Apache Springs. Shortly after, in 1968 or 1969, Dad went to work for Reed and I just kind of helped out.

That was my first experience with steam locomotives. I learned to fire and stuff like that. I was thirteen or fourteen. Then, when I was sixteen, I went to work for Reed. We worked 'till 1973 when he went out of business. After that the 100 never ran up there at McNary. It was completely out of service 'till the Heber Creeper acquired it in 1976. I've been here five years, and although I've basically been a fireman I've student run it a couple of times. But this is a hairy railroad. This is not an easy place to run an engine. It's a tricky thing, because from here to Charleston it's about two percent all the way down, and from there it's up and down. It's a lot of throttle work, and then going down into Provo Canyon is really tricky. You've got to be real good with the air. Once you get out of this place you can practically go anywhere and be an engineer.

It's just a good engine. It's sure-footed and they've never had any derailment problems with it. It fires real well. It fires better than anything that I've ever fired. It's just a breeze to learn to fire it. It's got good visibility going ahead. It tracks well. As far as mechanical condition goes it's almost mint, because the boiler is just as clean as a whistle, and the valve gear is in great shape because they've gone all through the rod brasses and the pins, the crank pins, they've all been turned. The only thing that needs to be done to that engine in the long run is tires, because it does need tires. But other than that, everything's been done to that engine. The flues are in good condition, the running gear is in good condition, it's got a lot of new springs on it, the frame is all in tram, the trucks on the tender are tight, the tender [not original] is in good shape, it's not at all rotted out. It's got brand new lagging, brand new jacket.

So compared to a lot of other tourist railroads right now, as far as standard gauge goes, I'd say that engine is in better shape than most.

Eric Douty
Heber City, Utah
April 1984

Plates on the number 100,
at Heber City, Utah

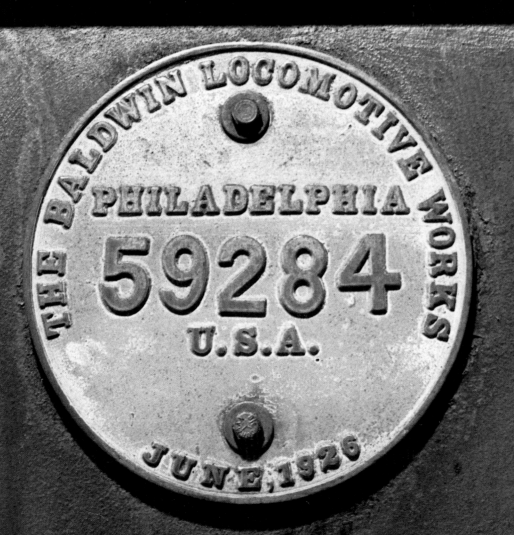

Postscript

My career started with a minimum investment. I bought a truck and trailer and began hauling logs on my own. I hauled under contract for some of the larger companies in Lincoln County on the Oregon coast. This was 1932 at the height of the Depression, and steady work was hard to find, so I often found myself working for the various outfits in a variety of capacities. Sometimes I worked on the railroad firing a Shay locomotive and sometimes I worked in the office as timekeeper and errand boy, which often meant covering the operations on a speeder. But I was never cut out to work for others. At the first opportunity I went to work for myself as a gyppo logger. I located the timber, ran the lines, did my own cruising, and supervised the logging. I had as many as ten trucks hauling for me. Over the years, about the only job I never tried was climbing and rigging the spar trees. But eventually I found myself spending more time looking for timber than manufacturing it, so I disposed of my mills and retired.

It occurred to me then that I had been part of an era that would never be repeated and I was distressed that no one seemed interested in preserving and recording its history. I had known and worked with men who had experienced it all—from the early bull team logging to the coming of the diesel cats and trucks. So I determined to record as much of it as I could while there was still time. I began by talking with the oldtimers and collecting old photographs. I haunted the libraries and historical societies, reading old newspapers and back-issues of the trade magazines. The information was then transcribed onto cards which I filed and cross-indexed until I now have some 500,000, plus thousands of photos. And I still have a tremendous amount of material not yet transcribed.

My interest in model railroading, with emphasis on the logging railroads, led to the introduction of this aspect into the market. The logging locomotives soon captured the imagination of many modelers and this brought new researchers into the field, thus broadening my contacts with others who had been quietly collecting bits of logging history on their own. As the fraternity grew and more information was shared the recorded history burgeoned:

Walt Casler of Corry, Pennsylvania, who had worked for both Climax and Heisler,

was busily recording the history of those enterprises and their locomotives. He was equally interested in the history of logging in the East and South and his work is evident in many publications dealing with these areas. Since he also visited the Northwest as a traveling engineer for Climax and was familiar with many of the western concerns, we found that by pooling our efforts we both profited.

The late Mike Koch of Scarsdale, New York, set about writing the history of Ephraim Shay and the Shay locomotive, working from company files. In order to follow up on the histories of the locomotives, Mike developed a correspondence with other researchers throughout the country and thereby brought together many who had been concentrating on limited regions, and this helped to solidify the research of all.

Another group has been primarily interested in the railroad and locomotive genealogies. Prominent among them is Doug Richter of San Bruno, California, who has compiled extensive rosters of locomotives owned by the western loggers. Bob Lowry of Corvallis, Oregon, is another who has done much to clarify the history, and the late Jack Holst of Portland induced many others to enter the field.

Finally, there are those who have concentrated their efforts on specific areas. Jim Gertz of Port Angeles, an employee of Rayonier, Inc., and Steve Hauff, also of Port Angeles, have done much work in the Clallam County area although not confining their efforts to that county alone. Together they produced a history of the Willamette locomotives. Pete Replinger, who runs a diesel locomotive for Simpson Timber Company at Shelton, has covered northwest Washington with emphasis on the Mason County-Hood Canal area. Dennis Thompson has been working on Skagit County and the area north of Seattle, and Walt Taubeneck has been digging into the history of Snohomish County. In Oregon, Lloyd Palmer has covered Lincoln County, which he recorded in *Steam Towards the Sunset,* while Coos County has been the focus for Lloyd Graham, a former conductor on the railroad of the Smith-Powers Logging Company, later the Coos Bay Lumber Company.

Without the interest, industry, and cooperation of these researchers and many others I have not mentioned, the great saga of steam in the woods might well have been lost to posterity.

J.T.L.

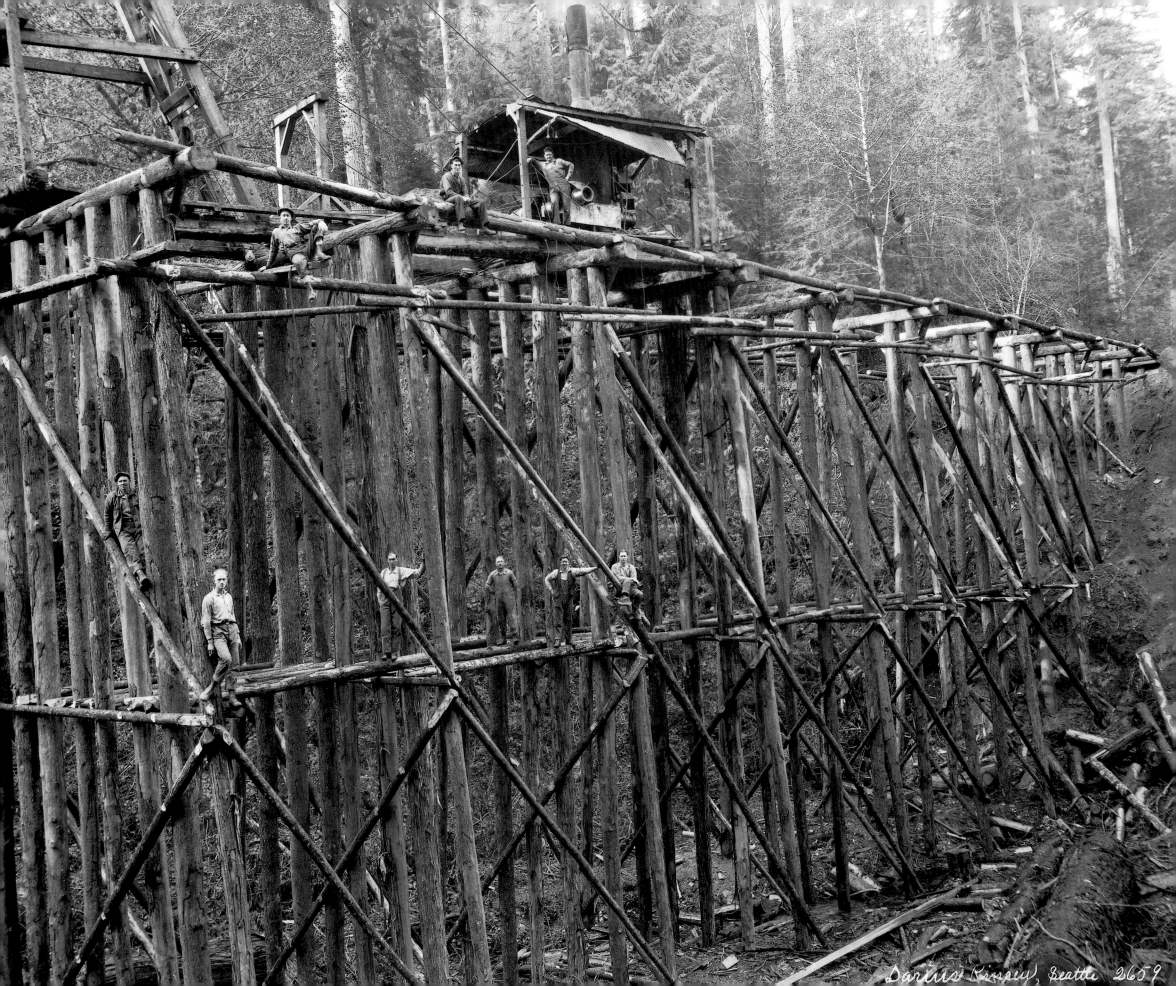

Darius Kinsey, Seattle 2659

The Kinsey Collection

Whether moved by the beauty of the images or by its value as an historical document, those who have had responsibility for the Darius and Tabitha Kinsey Collection have exercised remarkable care. The Collection has always been treated with thoughtfulness and respect. Perhaps this is so because of the shared attitude that a document of a way of life — the substance of the Kinseys' lifework — is something that continues beyond the family; perhaps so because of the deep respect Darius and Tabitha continue to earn; and perhaps so because those who have been "owners" of the Collection have recognized that they are temporary caretakers. Whatever the reasons, the Collection has for almost forty years positively affected those associated with it.

Jesse Ebert of Seattle purchased the collection of negatives, prints, and photographic equipment from Tabitha Kinsey in 1946, one year after Darius' death. Although Ebert later tried to sell the archive for many years, he resisted all offers to buy selected portions of it, realizing the importance of keeping the material intact. Then in 1971 Dave Bohn reviewed the Collection in Ebert's home. Dave recognized the beauty of the Kinsey images and also understood that the Collection represented a remarkable documentation of the history of land, homesteading, and logging in the Pacific Northwest from 1890 to 1940. Dave and partner Rodolfo Petschek shortly thereafter concluded negotiations for purchase, and moved the archive to Berkeley, California.

The Petschek-Bohn partnership was special in that they had the desire, time, and knowledge to undertake a major research and publication effort. Four years of field research, including oral history and archive studies, and daily contact with the 5,000 surviving negatives resulted in the first two volumes of *Kinsey, Photographer* which, in addition to reproducing the exquisite photographs, served to familiarize a wider audience with the story of the remarkable Darius and Tabitha collaboration.

Early in the Petschek-Bohn partnership, Rudi and Dave had agreed that, when it was time for the Collection to leave their hands, they would return it to its home state and only to an institution. I first heard of this possibility by way of an indirect hint from Dave in 1976. I was familiar with the documentary quality of Darius Kinsey's work — from the Superior Press publication *This Was Logging* —

and with the special quality of Kinsey's talent, as encountered in original and copy prints in the permanent collections of the Whatcom Museum. A decision was quickly made; I would make every effort to see that the Museum would be considered as a final home for the Collection should the occasion arise.

In mid-1978 Dave returned to Bellingham and we were able to present a good case for the Museum as a final repository. For the most part discussions focused on issues regarding preservation, on how the Collection would be used, how its integrity would be preserved, and how we evaluated Kinsey as a photographer. Both sides expressed similar attitudes and it seemed that any subsequent working relationship would be compatible. In two days agreement was reached on all key issues, and on the basis of these discussions the Collection was moved to Bellingham in December. At that time we prepared all the appropriate legal trimmings which accompany any purchase of similar scope.

Darius Kinsey made his early negatives on glass dry-plates. The quality of the image was superb but the glass was heavy, bulky, and fragile. Because of this problem, especially for photographers working with large formats, manufacturers were searching for a better system and even as Kinsey was making his early negatives, a flexible film-base was being developed. First available for rollfilm, it was made for the larger formats by 1913, and Kinsey's first negatives on the new base date from 1914. From then on all his work would be done on film.

The new film-base was cellulose nitrate. Although this material was indeed flexible, light, and easy to handle, it was soon learned that nitrocellulose is extremely flammable. This prompted additional research, and safety film, with a cellulose acetate base, became available by the mid-1930s. More recently it has been learned that nitrate film decomposes slowly under ordinary storage conditions and that higher temperatures and higher-than-normal relative humidity will accelerate the process. Further, the gases produced by cellulose nitrate decomposition hasten the decay process unless allowed to escape.

It would probably seem ironic to the Kinseys, who took so much pride in multiple-washings of their prints, that the negatives from which the prints were made would disintegrate in a relatively short time. But we knew, as did Rudi and Dave, that unless preservation measures were taken within a reasonable period, a large number of the Kinsey images would be lost forever. Museum staff thus proposed that a first step as caretakers of the Collection would be to copy onto safety film all of the endangered negatives. This copywork was accomplished by

mid-1980. The production of thousands of copy negatives was time-consuming and very expensive, but was a job critical to the survival of the archive. The staff then began to work on cataloguing and subject indexing, production of a visual reference system, the development of exhibits, and initiated various other steps necessary to make the Collection more accessible to the public.

The Collection is much larger than it was when Tabitha sold it to Jesse Ebert. It grew under Rudi and Dave and continues to grow now. Of note are gifts of vintage prints from the Kinseys' granddaughter, Dottie Parcheski, and her husband Michael Ryherd; Rudi and Dave recently donated some beautiful handcolored prints, tinted by Tabitha herself and Alfreda Kinsey, a niece who helped Tabitha in the darkroom. At last count, more than 6,000 images exist — in negative or original print form.

The Museum is grateful for the assistance that has allowed the acquisition and preservation efforts to be made. Special thanks are due the City of Bellingham, the Whatcom Museum Society, the Whatcom Museum Foundation, ARCO Foundation, the Bloedel Foundation, Georgia-Pacific Corporation, Weyerhaeuser Corporation, Paccar Corporation, Peoples State Bank and others for financial aid. A grant from the National Historic Records and Publications Commission, a division of the National Archives, allowed us to initiate the process of cataloguing the images. Several individuals deserve credit for their efforts to bring the Collection up to its present condition, including former Curator Rod Slemmons, our darkroom specialist Lori Niedenfuer, and photographic technician Craig Garcia. Thanks also to the staff of Pyramid Productions, Bellingham, for their assistance in making copy negatives.

Dave states in Volume Two of *Kinsey, Photographer* that "...field research ended March 29, 1974." Perhaps he thought his efforts were indeed coming to a close then, but this has not proven to be the case. Although the Collection was officially transferred to the Whatcom Museum on December 5, 1978, Rudi and Dave are still part of it and share in the work that accompanies it. For them, thanks cannot convey our appreciation.

The earlier publications, recent exhibits, and *Kinsey, Photographer* volumes have displayed only a fraction of the potential of this remarkable collection. There is a depth of material which will allow many others to bring forward more of the richness and diversity of Darius Kinsey's subject matter.

George E. Thomas, Director
Whatcom Museum of History and Art
Bellingham

Acknowledgments

When authors are involved with every aspect of bookmaking, as was the case with this volume (and the earlier volumes of *Kinsey, Photographer*), then the acknowledgments section is an exceedingly difficult thing to write. Under such circumstances the authors are in virtual daily contact with skilled, energetic, and generous souls who are contributing to the project in one way or another. And as contributors become increasingly enthused about the project, in addition to lending skill they are generous with their time and thus become *participants* in the creation of the book. This state of affairs can exist throughout the entire effort: from the initial discussions with the publisher to establish the basic concept; on through the research, writing and oral history stages; through editing, design, layout and typesetting; through technical preparation of the material leading to printing, and very definitely including those final hours of truth—the press run.

As the book evolves through various stages on its way to the reader, the list of participants grows steadily, and when the book includes a complexity of elements the list can become very long. Long enough, in fact, for concern that somewhere along the line a skilled and generous contributor will be unintentionally omitted. To be sure, keeping track of the above-mentioned list is difficult, as the project moves against an insanity of detail toward the press date—but nowhere near as difficult as the attempt to convey to the reader the gratitude owed numerous souls.

For willingness to be interviewed, we are indebted to those whose contributions appear in these pages, and to those whose conversations also added so much to our knowledge of the logging locomotive: Burt and Mary Anderson of Joyce, Paul and Emma Pauly of Tumwater, Bill and Jessie Pearson of Custer, Harold Reamer of Bellingham, Bart and Penny Robbins of Eldon, and Al and Gladys Walken of Port Angeles.

For direct leads and assistance with information we are grateful to Mrs. Leonard Buck of Shelton, Ed Danielson of Banks, Oregon, Gail Evans (NPS historian, Olympic National Park) of Port Angeles, Ray Freeman of Woodinville, Bill Goodpasture of Hoodsport, Robert Hawley (Western Americana bookseller) of Berkeley, Charles Janda of Port Angeles, Joe Randich of Hoquiam, Ewald Schneider of Longview, and Dennis Thompson (Skagit County railroad historian) of Burlington. Also, a

very special note of thanks to Murl Rawlins, Jr., Craig Drury and Eric Douty of the Heber Creeper at Heber City, Utah, who positioned the Baldwin number 100 to allow for closeup photography.

We are also indebted to our typesetters, Spartan Typographers of Oakland, California, whose astounding accuracy, speed, and clarity of the repros made relatively easy what can become an ordeal; our printer, Dai Nippon Printing Company of Tokyo, whose San Francisco representatives Mikio Shinohara and Rebecca Blatz put up with us on this side of the ocean, and whose International Sales Division (Third Section) representatives Yoshiyasu Kosugi, Manager, and Yoshinori Katoh put up with us in Tokyo; Wendy Calmenson of San Francisco who produced the impeccable mechanicals; and Eddie Dyba (of Professional Photographic Services) of San Francisco who handled the darkroom requirements on our centerspread enlargements.

Regarding the historical side of the project, the book would not have been possible without the combined efforts of three experts: Douglas Richter of San Bruno, California, whose thorough research into the identity and specifications of the locomotives on these pages saved us from more than one misstatement and from the even subtler errors common to the partially educated; Pete Replinger of Shelton, who not only moved a locomotive for us but also placed at our disposal his lifetime study of the logging railroads of the Peninsula, his friendships with the oldtimers who ran the locomotives, and who guided our field research whenever we asked—which was often; and, of course, John Labbe—he of the 500,000 file-cards and enduring patience with the editorial nitpicking.

The relationship between the authors and the Whatcom Museum is very special and can perhaps be characterized as a partnership in matters pertaining to the Darius and Tabitha Kinsey archive. To George Thomas and his staff at the Museum (participating staff have been mentioned elsewhere) our thanks for the spirit of cooperation, use of the darkroom, and technical assistance.

Finally, our unending thanks to Mary Millman, who coordinated correspondence, telephone contact and manuscript adjustments with our Oregon and Washington cohorts. It would not be inaccurate to say that when Mary decides to run with the ball, Mary runs with the ball. Thank heavens!

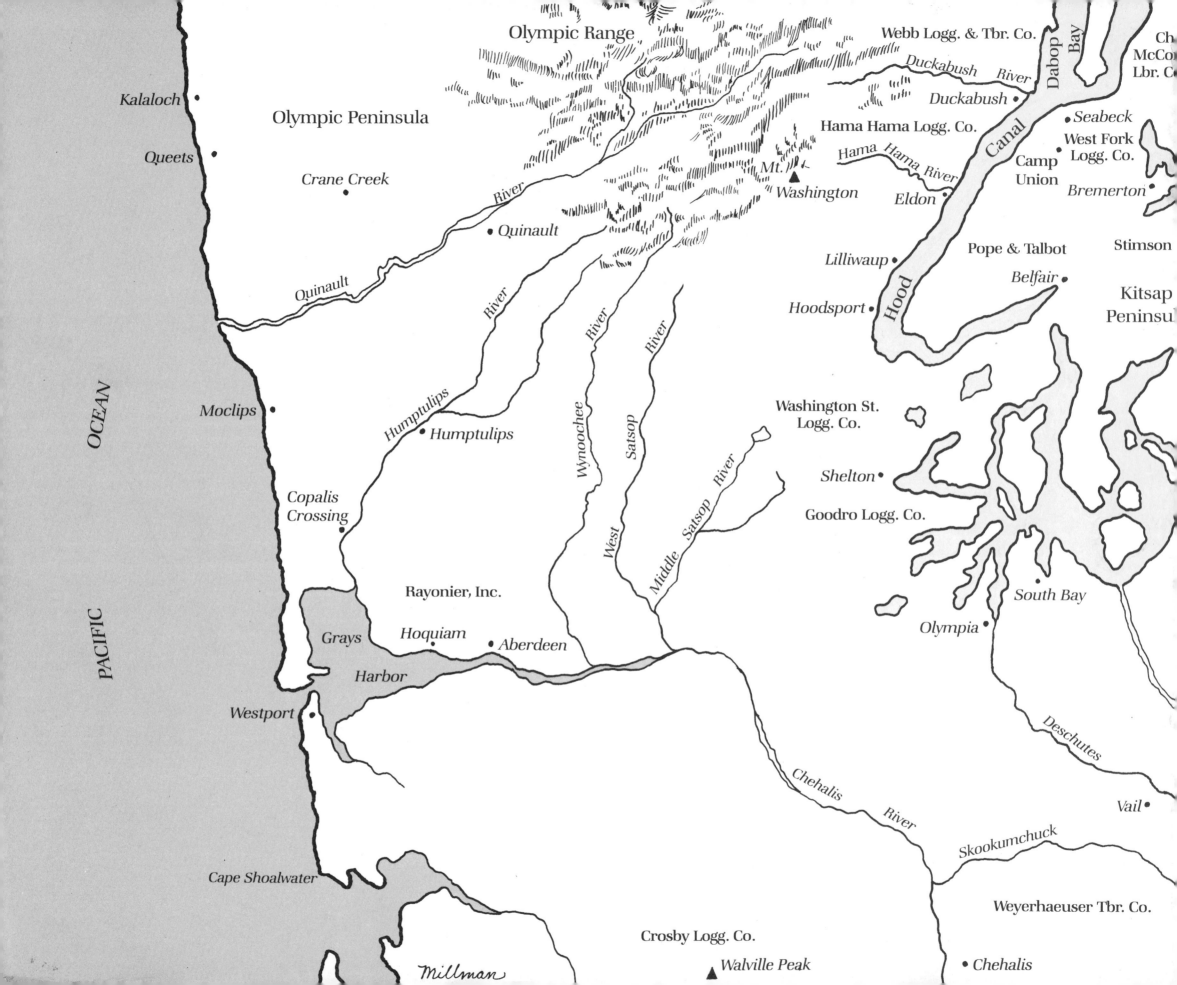